iPhoto® '09
FOR
DUMMIES

D0515005

Getting Familiar with the iPhoto Interface

Whether you're just getting to know iPhoto or are an old hand, here's a convenient guide to where things are in the iPhoto interface.

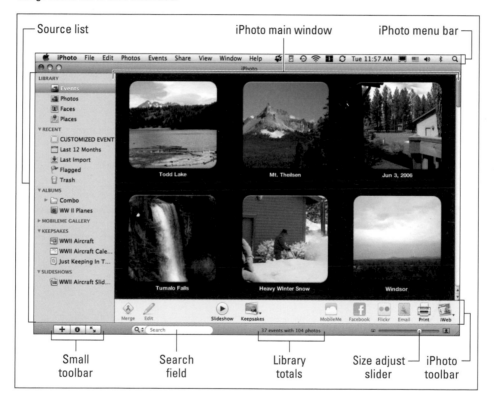

iPhoto Advanced Keyword Search

These otherwise undocumented operations are little known but ideal for constructing multiple criteria searches for particular photos.

Operation to Add	Key to Press and Hold
OR	Shift
AND	Control
NOT	Option

For Dummies: Bestselling Book Series for Beginners

iPhoto® '09

FOR

DUMMIES

Cheat Sheet

Useful Keyboard and Toolbar Shortcuts

Listed below are a number of often-used iPhoto commands and, where available, the corresponding Mac and toolbar shortcuts that can save you a lot of time.

Operation	Mac Shortcut	Toolbar Button
New Album	⌘+N	➕ and click Album
New Smart Album	Option+⌘+N	➕ and click Smart Album
Import to Library	Shift+⌘+I	None
Export	Shift+⌘+E	None
Batch Change	Shift+⌘+B	None
Create Event	None	New Event
Hide Photo	⌘+L	Hide
Duplicate	⌘+D	None
Full Screen	Option+⌘+F	

iPhoto Editing Shortcuts

If you're like me, when you're in the midst of editing, you like to keep your fingers on the keyboard and not shift to find the mouse. These shortcuts are used often enough to make them worthwhile to remember.

Operation	Key(s) to Press
Change the Rotate button direction	Option
See original photo in Edit mode	Shift
Change Reset button to Revert in the Adjust tool	Option
Change Cancel to Reset in Crop	Option

Wiley, the Wiley Publishing logo, For Dummies, the Dummies Man logo, the For Dummies Bestselling Book Series logo and all related trade dress are trademarks or registered trademarks of John Wiley & Sons, Inc. and/or its affiliates. All other trademarks are property of their respective owners.

For Dummies: Bestselling Book Series for Beginners

iPhoto® '09

FOR

DUMMIES®

by Angelo Micheletti

WILEY

Wiley Publishing, Inc.

iPhoto® '09 For Dummies®

Published by
Wiley Publishing, Inc.
111 River Street
Hoboken, NJ 07030-5774

www.wiley.com

For general information on our other products and services, please contact our Customer Care Department within the U.S. at 877-762-2974, outside the U.S. at 317-572-3993, or fax 317-572-4002.

For technical support, please visit www.wiley.com/techsupport.

Wiley also publishes its books in a variety of electronic formats. Some content that appears in print may not be available in electronic books.

Library of Congress Control Number: Library of Congress Control Number is available from the publisher

ISBN: 978-0-470-43371-3

Manufactured in the United States of America

10 9 8 7 6 5 4 3 2 1

WILEY

About the Author

Angelo Micheletti has had a lifelong passion for photography, starting out with a Kodak Brownie 8mm camera as a youth and graduating to a 4 x 5 camera with a digital back as his skills and interests progressed. The owner of Scenes From The West (www.scenesfromthewest.com), Angelo combines his love of photography with an easy-to-understand writing style and a devotion to the Mac since its inception in 1984 to produce well-received lectures, Apple Macintosh training courses, and books.

With an MBA from St. Mary's College in California, Angelo currently resides in Bend, Oregon.

Dedication

This book is dedicated to my family, who gave me encouragement and support throughout this endeavor; and especially to my dad, who taught me from an early age the joy and magic of photography. And to all my friends who offered, countless times, to review portions of the book and give me feedback, I offer my wholehearted thanks.

Author's Acknowledgments

First of all, I want to thank Carole McClendon, my agent, for thinking of me as the perfect author for this book and for her guidance throughout the process.

Thanks go to my excellent Project Editor, Blair Pottenger, for his suggestions and advice; to Acquisitions Editor Kyle Looper for many productive and enjoyable discussions; to Senior Copy Editor Teresa Artman and Copy Editor Heidi Unger for their timely and helpful comments and corrections, to Technical Editor Dennis Cohen for his insight and editing skill, and to the entire Wiley Publishing production team for their professionalism.

Finally, I want to thank all the nuns (many of them posthumously) at Bellarmine-Jefferson High School who taught me the love of art and writing that I've built on throughout my life and who gave me an appreciation for the fact that learning is a lifetime occupation.

Publisher's Acknowledgments

We're proud of this book; please send us your comments through our online registration form located at `http://dummies.custhelp.com`. For other comments, please contact our Customer Care Department within the U.S. at 877-762-2974, outside the U.S. at 317-572-3993, or fax 317-572-4002.

Some of the people who helped bring this book to market include the following:

Acquisitions, Editorial, and Media Development

Project Editor: Blair J. Pottenger

Acquisitions Editor: Kyle Looper

Senior Copy Editor: Teresa Artman

Copy Editor: Heidi Unger

Technical Editor: Dennis Cohen

Editorial Manager: Kevin Kirschner

Media Development Project Manager: Laura Moss-Hollister

Media Development Assistant Project Manager: Jenny Swisher

Media Development Assistant Producers: Angela Denny, Josh Frank, Shawn Patrick, and Kit Malone

Editorial Assistant: Amanda Foxworth

Sr. Editorial Assistant: Cherie Case

Cartoons: Rich Tennant (`www.the5thwave.com`)

Composition Services

Senior Project Coordinator: Kristie Rees

Layout and Graphics: Sarah Philippart, Ronald Terry, Christine Williams

Proofreaders: Laura Albert, Caitie Copple

Indexer: Rebecca R. Plunkett

Publishing and Editorial for Technology Dummies

 Richard Swadley, Vice President and Executive Group Publisher

 Andy Cummings, Vice President and Publisher

 Mary Bednarek, Executive Acquisitions Director

 Mary C. Corder, Editorial Director

Publishing for Consumer Dummies

 Diane Graves Steele, Vice President and Publisher

Composition Services

 Gerry Fahey, Vice President of Production Services

 Debbie Stailey, Director of Composition Services

Contents at a Glance

Table of Contents

Introduction

*G*ot photos? Better yet, want to make your photos (past, present, and future) better? Then you've come to the right place.

You have the iPhoto software and a Macintosh, and you've probably already tried out your camera and have a few photos, maybe quite a few. Taking photographs is lots of fun, and you want to ensure that the ones you take are the best they can be. After all, they're treasured moments you want to preserve and share.

My goal is to make you a better photographer, regardless of the camera equipment you use or your photographic experience, by using iPhoto '09. And you're going to have fun doing it.

About This Book

In this book, I show you how to reach your goals — to make your photos the best that they can be. A number of key areas are discussed, including

- The power and capabilities of iPhoto '09
- Taking your photos from input, through editing, to final image
- Editing tricks to enhance your photographic capabilities
- Printing and electronic sharing
- Creating photo albums, calendars, cards, and slideshows

Along the way, I'll also give you some techniques to apply before you ever press the camera shutter. They'll improve your ability to capture what you see through the lens and enhance the outcome of using iPhoto '09's powerful toolset.

If you can, take this book with you when you're out photographing your favorite subjects. Although not written as a broad digital photography guide, it's a handy reference and is full of information that will make your photographic excursions even more enjoyable and rewarding.

Foolish Assumptions

I tried to make as few assumptions as possible about you, the reader. However, there are some which are inescapable. I assume that

- ✔ **You have a Mac and iPhoto (part of the iLife suite).**

- ✔ **You're familiar with using a Mac:** specifically, that you know how to use menus, dialogs, and windows; that you can open, close, and copy files; and that you know how to navigate the Mac environment.

- ✔ **You have information on your camera's operation.** If an operation with the camera is required, you know how to do it or can look it up.

- ✔ **You're using iPhoto '09,** for which this book is written. This is the latest version available at the time of writing. Although some capabilities that are described will work in multiple versions of the software, others might not.

Conventions Used in This Book

Before you begin your iPhoto adventure, I need to discuss how information will be presented to you in this book. Although pictures are worth a thousand words, it's the words and symbols presented in this book that convey a great deal of information — if you know what you're looking at.

- ✔ **Because this software runs on only a Mac, there are no PC conventions to discuss.** For the Mac, the primary shortcut keys used are the Command (⌘), the Option key, and the Control key. At times, the Shift key will also be used. These keys are used in conjunction with other keys as shortcuts for menu selections and invoking various tools and commands.

 For instance, when you wish to initiate the Print sequence for your photo, there is usually a button in a window labeled Print that you can click. Or, you can select the Print command from the File menu or use a keyboard shortcut (⌘+P). Just remember that any shortcut requires you to hold down all the keys except the last one; then press the last key to make the shortcut work.

- ✔ **Menu commands are given in the order in which you select them:** for example, "Choose File⇨Import to Library."

- ✔ **Options in dialogs use initial caps** even if they aren't capitalized on your screen to make it easier to identify them in sentences. For example, what appears as Check for iPhoto updates automatically in a dialog will appear as Check for iPhoto Updates Automatically in this book.

✓ **Web site addresses appear like this:** www.scenesfromthewest.com.

✓ *Context menus* **are also used from time to time in this book.** They appear at your cursor's position when you right-click (or for those with a one button mouse, Control-click) your mouse.

✓ **I included some information that is somewhat technical.** This information is presented in the book's sidebars. Although this information isn't absolutely required reading, I recommend you give it a quick look and decide for yourself whether to read it. It's all relevant and will enrich your photographic experience.

How This Book Is Organized

This book contains five major parts, each of which is divided into chapters. Each chapter is then divided into smaller pieces to help you quickly find the information you're looking for.

The book covers a logical progression of subjects, and I encourage you to take advantage of all the information available. That being said, I've written this book so that you can read any section without necessarily knowing what was covered in previous sections. If you just want to look up a particular subject, find the chapter you need and go there.

Here's a breakdown of the parts of this book and what you'll find there.

Part 1: Getting Ready to Roll with iPhoto '09

Part I opens with Chapter 1, familiarizing you with the iPhoto '09 interface, discovering where things are, how to move between the various modes of operation, and checking out the technical specifications of the iPhoto software. Chapter 2 gets you using the software by completing a simple iPhoto project, practicing photo importing, simple editing procedures (including cropping and straightening), and printing your first photo. You can download the example photo used for the simple project in Chapter 2 from the book's companion Web site at www.dummies.com/go/iphotofd.

You can begin making the software preferences for iPhoto reflect your own preferences and spend time understanding the import process in detail, including connecting your camera or flash card to your computer, in Chapter 3.

Part II: Manipulating Photo Organization

Organizing is something you know you should do but often don't.

Part III introduces you to the iPhoto tools that produce a well-organized and maintainable archive for your photo collection. Chapter 4 helps you group photos by the event they represent — or, thanks to iPhoto's new facial recognition and GPS technology, uses the Faces and Places features for grouping photos based on the people in them or the location where they were captured. Chapter 5 covers creating Albums, including Smart Albums for having iPhoto automatically organize types of photos in one place. Chapter 6 provides all you need to know about searching so you can find that favorite shot taken at your recent anniversary celebration.

Part III: Making Your Photos Look Even Better

In these four chapters, you can expand your depth of knowledge about the iPhoto editing process. Chapter 7 introduces you to the iPhoto Editor. Then, in Chapter 8, you effectively deal with what I call the usual suspects: photos that are too light or too dark, red eye, and spots or imperfections in the photo.

You see the heart of the editing process, including a concise but useful discussion of the histogram, its meaning, and uses, in Chapter 9. In Chapter 10, take advantage of the advanced editing functions available in the Adjust tool in which you can work with the histogram to correct exposure, contrast, highlights, shadows, and saturation, as well as sharpening and noise removal. You also try out some of the wonderful effects you can create with the simple click of a button and also see how to save the corrections you have made so they can be easily duplicated on other photos.

Part IV: Showing and Sharing Your Photos

It's only natural to want to share your photos with others, and in this part, you'll explore the many ways to do that.

You can send e-mails to your friends and relatives, burn photos onto CDs and DVDs, and — if you have the MobileMe service — exhibit your photos in your own Gallery. You can even send your photos directly to Facebook and Flickr, which are two popular social networking sites. All this is covered in Chapter 11.

Of course, another way to share is by printing your photos, and that's what Chapter 12 is all about. You'll see the entire process, from selecting borders, layouts, and backgrounds to choosing the correct printer settings. But just

making a print isn't the only way to share a hard copy of your photo. In Chapter 13, I show you how to create a photo book (including travel maps showing the location of your photos), a calendar (replete with your photos), cards containing your favorite vacation shots, and even a slideshow set to music.

Part V: The Part of Tens

Traditionally, the last part of a *For Dummies* book is its Part of Tens, whose chapters each contain . . . you guessed it, ten items. This book is no exception.

In Chapter 14, I identify and describe ten terrific Web resources and software add-ons that can help make your experience with iPhoto even more rewarding. Chapter 15 presents ten helpful hints, tips, and shortcuts, all aimed at making iPhoto even more powerful in your hands.

What to Read First

I didn't write this book expecting you to sit down and read it through, cover to cover, in one sitting (although you can do that if you like). It's written and arranged to provide both thorough and practical knowledge of iPhoto and to be a source for finding quick solutions to immediate photographic problems and questions.

To some extent, what you read first will depend on your experience with iPhoto. If you're familiar with the layout, menus, and functionality, you can start with Chapter 2 and become involved with an actual iPhoto project.

If you've been using iPhoto for some time and just want to get help with advanced editing tools and techniques, you can go to Chapter 7 and start there.

To explore sharing photos electronically or in print, go to Chapters 11 and 12, respectively.

The book is ordered in a way I think makes sense, but each chapter stands on its own as much as possible. That said, you might have to go to other chapters from time to time to review the basis for a particular tool or technique being discussed.

Icons Used in This Book

Throughout this book are icons that appear in the left margin that provide extra and often vital information regarding the topic at hand. Here's what the ones I use in the book look like and mean:

These shortcuts and ideas can help you make better photographs or keep you from doing extra work. They're often undocumented operations that I discovered during my years as a professional photographer and want to pass on.

These nuggets are reminders of what *not* to do, or at least what will happen if you do perform an action. They might not always be detrimental actions, but you should at least slow down and tread lightly.

Information denoted with this icon reinforces information that you need to retain. For these topics, it's going to be important later.

This is material that you don't have to read, but I can assure you it's at least interesting and certainly informative. This can vary from information about camera formats and what they mean to how the camera and the eye see things very differently and how that can affect your photos.

I'll do my best to give you all the tools and information needed to enhance your photographic skills and enjoy photography to the fullest. The rest, as they say, is up to you.

Part I
Getting Ready to Roll with iPhoto '09

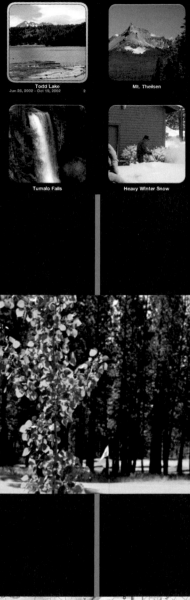

*B*efore you dig into the many capabilities and sheer fun of iPhoto '09, it's important that you have a good understanding of what tools you have available and how you can use them.

Chapter 1 gives you an overview of the iPhoto '09 interface. After all, it's difficult to use the technology if you're not sure where to find the controls and which initial choices you can make. This chapter provides an easy introduction meant to make you comfortable in the iPhoto environment.

But all the information in Chapter 1 isn't going to make you proficient in using the software — you need to get your feet wet, so to speak, and that's what Chapter 2 is all about. When you understand the essentials, you get to work using that knowledge on a simple iPhoto project. Nothing difficult, but it's complete enough to show you how to use your newly found knowledge.

With some comfort in the operation of iPhoto, it's time to start getting your own photos into the iPhoto Library. Chapter 3 covers importing your photos from a variety of sources — and, equally important, adding information to those photos that will make them easier to find and use later on.

Presenting the iPhoto '09 Interface

*A*long with your Mac and all the other software you received or have purchased for it is the software that's the subject of this book — iPhoto '09.

Having been a photo enthusiast for many years using film and standard methods for developing and printing, you can imagine my curiosity, wonder, and finally, pure joy when digital photography arrived on the scene. No more running out of film or having the wrong kind. No more taking photo after photo trying to ensure I got the shot only to discover, after developing the film, that I still didn't get it.

As wondrous as digital photography is, there are still plenty of things for mere mortals to do with it — and iPhoto '09 gives you the power to do them.

In this chapter, I help you discover how to harness that power.

iPhoto — The Big Picture

I believe it's a good thing when those who might describe themselves as amateurs get to use tools that approach professional status. iPhoto '09 is just such a tool. The trick isn't in bringing more and more technology to bear and deal with; it's bringing in more and more technology while keeping the software's operation at a level best described as easy to understand and easy to use.

I'm amazed at how Apple improved iPhoto. Professional photographers are expected to think of things like saving photos to ensure that they're safe, but iPhoto does that for you. And it offers a simple tool for backing them up. When you import your photos into its Library, the original photo files are placed on your hard drive. iPhoto then uses nondestructive editing; as you work on the photos, any edits you make to the photos are kept as lists of operations that iPhoto applies to the original photo files in the Library. The lists of edits are applied to the photos when you view them onscreen or print them, but the original photo files in the Library aren't changed — wonderful!

Facial recognition capabilities and *geotagging* (attaching geographical locations) aren't the kinds of things you'd expect at this level, yet they're present in iPhoto. iPhoto has tools within the editing environment that rival those in far more expensive photographic software, and it possesses photo effects that can make the user look like a graphics genius.

iPhoto '09 also gives you an incredible number of ways to share the photos you're so proud of. Of course, making prints is a snap. What knocks your socks off are the abilities to easily use the major social networking sites on the Internet to display your masterpieces. And turning your art into books, calendars, and greeting cards has never been easier. As I write this book, I find myself stuck making slideshows, not because they're difficult but because I'm having so much fun — syncing music to slideshows has never been easier, and the results are truly outstanding.

Enough with the gushing; time to see how this amazing piece of software does its stuff.

Looking at What iPhoto Can Do

One of the biggest selling points for iPhoto '09 isn't really a feature at all. It's the clever, consistent, and comprehensive way it leads you through the proper steps, in the correct sequence, to ensure that your photos are as professional-looking as they can be (and safe from harmful actions — even yours!)

So why spend hours in a classroom trying to understand the best workflow for photography? Just use iPhoto and this book, and you'll get all the answers.

You do the majority of iPhoto work in these four main areas:

 ✔ **Organizing:** This is a part of photography that everyone tends to put off until "some other day." That tends to make particular photos, like the only time Aunt Sarah ever smiled on camera, very difficult — if not impossible — to find. iPhoto can help you organize the photos that

you've already taken and make organizing new photos incredibly easy and more automatic.

✔ **Editing:** Any camera is capable of taking a good photograph, and if you use good photographic techniques, the outcome is a good photo. If everything is perfect in that 1/100th of a second when the camera shutter is open, there's no need for editing. Alas, in this imperfect world, that rarely happens. iPhoto provides a powerful and easy-to-use edit function that makes up for many imperfections.

✔ **Displaying:** It's only natural for you to want to share your photographic triumphs with family and friends, and iPhoto helps here as well. Whether it's e-mailing Uncle Richard with photos of the new baby, putting those photos in a Shared folder so those you tell can download them, or placing those photos in your Gallery on the Web, iPhoto makes displaying photographs easy and safe.

✔ **Printing:** At the mention of that word, some of you might flash back to thoughts of being in a darkroom manipulating images on paper, surrounded by chemicals that smelled bad and could be dangerous. Banish those thoughts. Digital printing is a joy, and iPhoto takes you through the entire process, with tools and choices you can use to produce first-class prints.

The sections that follow take a look at these four areas, as well as where the controls are located in the iPhoto interface. With a little practice, using the iPhoto buttons, panes, and controls becomes second nature.

Organizing in iPhoto

I'm sure we've all had instances in our lives where we know something exists, but we have no idea where it is or how to find it. And, no, I'm not talking about "senior moments." It happens to everyone because of the sheer volume of things we deal with in this modern world.

Nowhere is it more true than in our collection of photographs. We've all had a particular photo we wanted to show someone but couldn't for the life of us remember where it was. In the digital era, we aren't limited by running out of film, so the number of photos we take can be astronomical. Organizing is key to sanity. Luckily, iPhoto gives us some choices that are truly amazing.

iPhoto provides several ways to organize according to your preferences.

✔ **Events:** The key to organizing in iPhoto is an Event. An *Event* can be any grouping or an occasion, such as a particular date or a birthday. As an example, Figure 1-1 shows a five-photo Event that was grouped by date. You could also group these photos by subject — say, in an Event called House Shots. There are lots of options, so be sure to read Chapter 4 for more details.

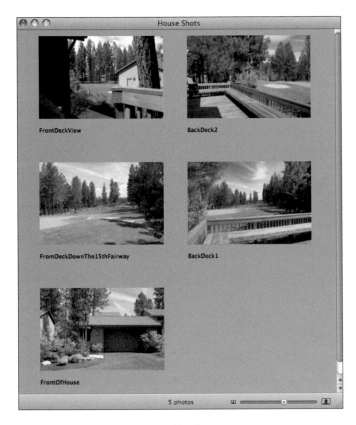

Figure 1-1: Event photos grouped by date.

↪ **Albums:** Suppose you want to take some photos from several Events and group them, under a subject or theme, while still leaving them in their original Events. That's where Albums come in. You can choose any photos from any number of Events (usually they have something in common) and put them in an Album whose name suggests the commonality. The Event groups remain unchanged. You can even use *Smart Albums,* which select their photos based on conditions you can set for them. Any photo matching those conditions is automatically put in that Smart Album. I tell you much more about Albums and Smart Albums in Chapter 5.

↪ **Folders:** Taking organization one step further, suppose that you created several Albums that have a similar subject or theme. You can put all the Albums in a folder. For instance, if you have several Birthday Party Albums covering several years, you can put them all into a folder named Birthdays, making all these Albums easy to find.

- ✏ **Faces:** No, it's not about making faces — it's about recognizing them. It almost sounds like science fiction, but it's a wonderful new part of iPhoto. The software recognizes that one or more faces are in a photo, outlines them, and asks you to name them. It then finds more photos that it thinks match the person, and you can confirm or deny the match. Now you can quickly find all the photos of Grandpa Pete, regardless of when you took them or where they might be in the Library. Neat, huh?

- ✏ **Places:** If your camera puts GPS information into your photos, you can use the new iPhoto Places feature to keep track of it. And with a little help from you, iPhoto provides maps that contain pins marking the location of each photo. There's even a Location browser that lets you search for photos by location. You can also enter location information manually even if your camera doesn't. I show you how in Chapter 3. Good stuff.

Editing in iPhoto

Of the many great things to like about iPhoto, to me, its greatest plus is non-destructive editing. Simply put, the original photo in the iPhoto Library is never changed. Behind the scenes, iPhoto keeps track of all your edits for a photo and applies them whenever you want to view, edit, or publish the photo. Amazing, isn't it?

When you edit, iPhoto compiles an edit list of all the changes you make to a photo. Later, when you re-open the photo, the original has all the items in the edit list applied to it again, to get you back where you left off. You can now make further edits — or, lo and behold! — revert to the original photo if you decide you're going down the wrong path.

And the tools available for editing are impressive, too.

- ✏ **Rotate:** Need to turn a photo in 90° increments? This tool is made just for that.

- ✏ **Crop:** Want to enhance the look of a photo? Sometimes, it just requires removing things that are distracting, and that's what using the Crop tool does.

- ✏ **Straighten:** Held the camera a little crooked when you took the picture, did you? No matter — it's easy to straighten things out by using the Straighten tool and moving a slider.

- ✏ **Enhance:** This is the tool to use to quickly adjust brightness and contrast.

- ✏ **Red-Eye:** You'll have no more photos of people with ghoulish looks when you use the Red-Eye tool in iPhoto.

- ✏ **Retouch:** You'll love this very effective blemish-remover tool.

✔ **Effects:** Use the Effects tool and check out how your photo looks with different toning and viewing effects.

✔ **Adjust:** This tool provides multiple adjustments for light and color that really make your photos sparkle.

Discover more about these editing capabilities in Chapters 8, 9, and 10.

Displaying in iPhoto

You can show off your artistic side by displaying your photos in a number of ways. iPhoto not only helps prepare your photos to look their best, but it also assists you in letting others share in your joy. All the details are in Chapter 11. Some of the displaying possibilities are

✔ **E-mail attachments:** This sharing method is probably the most common way to send out photos. iPhoto has a quick and easy-to-use interface to take your photos from the iPhoto Library into your e-mail client.

✔ **CDs and DVDs:** A great way to share, CDs and DVD are also excellent media for backing up your photos.

✔ **On your Web site:** Want to provide world-wide access to your photos? Whether you're using the iPhoto interface with iWeb or creating a Web page that you can send to a Web server, iPhoto can help you create your own Web site for sharing photos.

✔ **MobileMe:** Apple's service that can synch files on your computer is also a fantastic platform for sharing your photos. You can create your own Gallery on MobileMe, uploading directly from iPhoto. You can allow others to download your photos or add some of their own, and they can access your Gallery via the Web.

✔ **Facebook and Flickr:** You can upload photos to two of the most popular social networking sites directly from iPhoto. Publish to either of them with the click of a button.

Printing in iPhoto

One popular way to share your photos is by printing them for framing, greeting cards, and calendars. iPhoto has a rich assortment of choices when printing a hard copy is the way you want to go. Chapters 12 and 13 provide the details about all the wonderful printing possibilities. Some of the choices you'll find are

✔ **Printing photos yourself:** A large number of photo printers are on the market for home use, with quite a price and performance range. Make sure that any printer you purchase is compatible with Macs (most of them are) and try to get the best value for your money. After all the hard

work you put into your photos, you don't want to shortchange yourself on the print.

✓ **Ordering photo books and prints:** You can use a service available through iPhoto to order a professional, bound book filled with your photographs.

✓ **Turning your photos into greeting cards:** iPhoto gives you a choice of several greeting card sizes and styles for just about any occasion. Just drag your photo into the card format, add your message, and then either print it yourself or send it out directly from iPhoto for professional production.

✓ **Creating a calendar with your photos:** This can be a great birthday or holiday gift. Choose a theme and then begin customizing. You can choose the month the calendar begins, the number of months (up to 24), and which holidays you want to appear. Then just drag in your photos, add or change special dates as you wish, and you're done. You can order a professionally printed calendar or print it yourself, all through iPhoto.

iPhoto's Technical Specifications

iPhoto is very easy to use and gives you wide latitude in how you accomplish your photographic goals. Like with all things in life, you need to have some items in order to use even this very forgiving application. Here's a list:

✓ **A compatible digital camera:** Although, strictly speaking, a camera isn't required to import photos into iPhoto, you're going to want one if you intend to do much in the way of photography. I cover the various ways for importing photos into iPhoto in Chapter 3.

✓ **A Mac with Mac OS X and iPhoto:** This requirement kind of goes without saying, seeing as how iPhoto runs only on a Mac, but I put it in for completeness. I wrote this book for the latest version of iPhoto (iPhoto '09) available at the time of this book's printing.

✓ **Universal Serial Bus (USB) ports:** You'll need one port on your camera and one (at least) on your Mac. These ports allow you to connect your camera to your computer and import your photos into the iPhoto Library.

✓ **An A-to-B USB cable:** This cable connects your camera to your computer (using the USB ports): hence, to iPhoto. This cable probably came with your camera, but if it didn't, you'll have to buy one. Make sure the cable you get has the proper connector on the camera end: They do vary. The USB connector for the Mac is a standard 6-pin USB connector — it's the same for all computers.

Touring the iPhoto Interface

Getting familiar with the look and feel of iPhoto is absolutely required for making your experience and results with the software first class. Figure 1-2 shows the iPhoto main window.

Source list

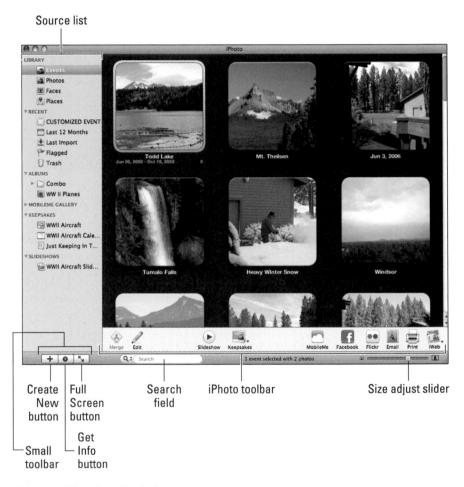

Create New button Full Screen button Search field iPhoto toolbar Size adjust slider

Small toolbar Get Info button

Figure 1-2: iPhoto's main window.

A lot of stuff is contained in the main window, so I break it down, piece by piece, in this section. (You can also refer to the figure on the book's Cheat Sheet, at the very front of the book.)

⮎ **Source list:** This area on the left side of the window shows all the places that can furnish photos for viewing, editing, and so on. This includes

- *Library:* The area of iPhoto into which your photos are loaded and organized, such as Events and Places. Chapter 2 helps you practice accessing and using the Library.

- *Recent:* Allows you to display photos imported at specific times, or photos that you've flagged. I cover flagging and its uses in Chapter 4.

- *Albums:* Displays the contents of specified photo groups that you created. See Chapter 5 for more on Albums.

- *MobileMe Gallery:* Shows the photos that you uploaded to MobileMe. See Chapter 11 for more on this.

- *Keepsakes:* Contains the names of your book, calendar, and card projects. See Chapter 13 for more info.

- *Slideshows:* Lists all your slideshows. See Chapter 13.

⮎ **iPhoto toolbar:** Although not all of the buttons on the toolbar are visible at the same time, this strip at the bottom of the window furnishes most of the popular user choices, including

- *Merge:* Allows you to move photos from multiple Events into one Event.

- *Edit:* Puts the photos from the selected Event into the Edit pane.

- *Slideshow:* Displays the selected Events or photos as a slideshow.

- *Keepsakes:* Button that allows you to choose to construct a book, calendar, or card. If the toolbar has enough room, you will see the individual buttons for Book, Calendar, and Card instead.

- *MobileMe:* Begins the process of choosing how to create and share your collection of photos on MobileMe.

- *Facebook:* Starts the publishing process to the Facebook Web site.

- *Flickr:* Starts the publishing process to the Flickr Web site.

- *Email:* Allows you to choose the photo size and then opens your Apple-supported e-mail application (set in General Preferences) with your attached photos, ready to address and share.

- *Print:* Begins the print process.

- *Set Desktop:* Makes the selected photos your computer Desktop images. When you click this button, your Desktop changes immediately.

- *Order Prints:* Connects you to Kodak Print Services to begin ordering your professional prints.

- *iWeb:* Sends the selected photos to iWeb.

In the lower-left of the main window is what I call the *small toolbar* because it contains some very useful, one-click actions. From left to right, the buttons are

✔ **Create New:** Also referred to as the Add button, clicking this creates a new Album, Smart Album, MobileMe Gallery, book, calendar, card, or slideshow.

✔ **Get Info:** Shows information about the selected photo(s).

✔ **Full Screen:** Clicking this button expands the window to full-screen size.

Toward the center of the iPhoto main window, you can find the Search field that allows you to input your photo search criteria, such as title, description, date, keyword, or photo rating. Chapter 6 discusses the Search field in detail.

On the bottom right of the iPhoto window, the thumbnail size adjusting slider allows you to change the size of the thumbnails over a continuous range.

That's the power and the scope of iPhoto. Taking and processing your photos has never been so much fun.

Putting iPhoto through Its Paces

In This Chapter

▶ Getting your photos into iPhoto

▶ Using quick and easy edits

▶ Printing your photos with iPhoto

▶ Modifying preferences

*A*fter you get a feel for the iPhoto interface, jumping in and trying it out is a great idea. In this chapter, you get started using the program with a simple iPhoto project.

Yes, that's right; dive right in! After you take a photo, you can transfer it to your computer, edit it to improve how it looks, and then create your first print with iPhoto. I guide you through those very steps in this chapter. This process helps you see that iPhoto software is incredibly powerful as well as easy to understand and use.

Also in this chapter, I show you how to modify the default iPhoto preferences so they reflect how you work, thus truly making them your own. As you find out more about iPhoto, you can come back and modify these preferences to meet your needs.

I use a photo named Chapter2Photo in this chapter to demonstrate using iPhoto for editing. If you wish to use this photo, you can download it from www. dummies.com/go/iphotofd. Or you're free to use your own photo because the processes described apply to any photograph needing editing.

Importing Photos into iPhoto

The first thing you have to do to use iPhoto to edit photos is, well, to import some photos. *Importing* simply means downloading photos from your camera

(or other storage device) to your computer. Because you can't work on photographs in iPhoto without importing them first, it's imperative to practice imports so you become comfortable with the process and understand the steps involved.

To import photos, follow these steps:

1. **Open iPhoto and choose File⇨Import to Library.**

 Your hard drive directory structure appears on your screen. Open the folder that contains the photo you want to import.

 For now, import photos from your hard drive. I cover other means of importing in Chapter 3, such as importing from your camera or a flash card.

2. **Highlight the photo's filename by clicking it, and then click Import.**

 One way iPhoto organizes your photos is by what it calls Events. An *Event* in iPhoto is how iPhoto groups photos by the dates they were captured. You can also create groups manually after importing photos. (See Chapter 4 for more on organizing and grouping photos.) Figure 2-1 shows the iPhoto window and the imported photo, which has the temporary name *untitled event.* I know, it isn't very glamorous, but you can change it to a better name right away.

 You can have several iPhoto libraries that you use for importing although you can work with only one at a time. This procedure is explained in detail in Chapter 3.

3. **Click the words *untitled event,* type a name of your choice, and then press Return.**

 Ordinarily, the Event name you choose would signify an event that unifies all the photos contained within it, such as Kim's 10th Birthday, or Jane and Tom's 40th Anniversary Party. In this case, you have only one photo, and the reason for that photo is to understand the editing process. So an Event name, such as My First Edit, is still significant.

 See Chapter 3 for more on importing photos.

Performing Simple Edits

There are many great things to like about iPhoto, but to me, its greatest plus is nondestructive editing. One of the goals of iPhoto is for your original photos to remain just that — original, unchanged, and unharmed. Simply put, the original photo in the iPhoto Library is never changed. Behind the scenes, iPhoto keeps track of all your edits for a photo and applies them whenever you want to view, edit, or publish the photo. Amazing, isn't it?

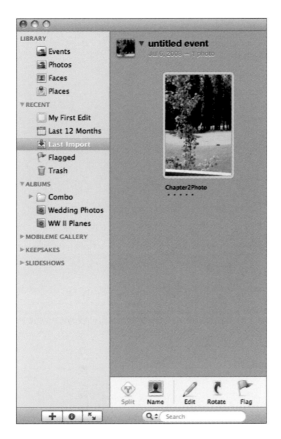

Figure 2-1: Your imported photo, grouped as an untitled event.

To begin to do any type of edit, you must open your photo in the Edit pane (iPhoto's main window in Edit mode). From there, you can see the collection of tools available to you — and quite a collection it is. The Edit window gives you eight tools to help you improve your photograph — tools that handle rotation, cropping, straightening, enhancing, removing red eye, retouching, adding photo effects, and adjusting color. The first six tools provide a lot of editing power that will improve your photos quickly and easily, and it's worth trying them first. Chapter 7 gives you a chance to use the more advanced tools to see what they can do.

To quickly and easily improve your photos, follow these steps:

1. **You can either double-click your image or highlight it; then click Edit.**

 As shown in Figure 2-2, you're now in the iPhoto Edit pane, with all the editing tools displayed on the toolbar at the bottom of the window.

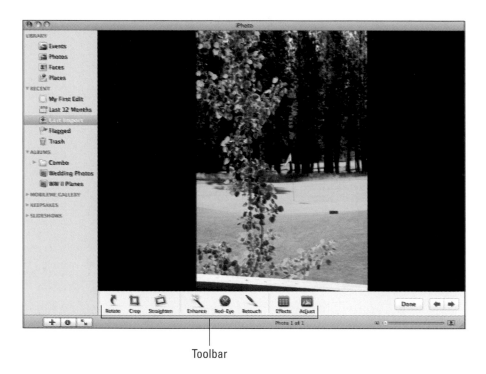

Toolbar

Figure 2-2: The iPhoto Editing pane and toolbar.

For the photo shown in Figure 2-2, no rotating is needed, but it looks like a little cropping, straightening, and exposure adjustment are in order.

In this photo, the wooden railing is distracting and tends to pull the eye down to the bottom of the photo. Every photo you take has something you want the viewer's eye attracted to — a *central focus* — so always be on the lookout for distracting items that negate that focus. Take care of the cropping first.

2. **Click the Crop button.**

 You now have an outline within your photo that has adjustable corners and sides, as shown in Figure 2-3.

3. **Place your mouse on each side, top, and bottom of the cropping rectangle and adjust it so that it covers most of the photo but not the parts you want to remove.**

4. **Click the Apply button (located immediately under the photo) to complete the crop operation and return to the Edit pane, where the newly cropped photo is displayed, as shown in Figure 2-4.**

 If you want to compare this cropped photo with the one you started with, press and release the Shift key to toggle between them.

Figure 2-3: After selecting the Crop tool.

Figure 2-4: The cropped photograph.

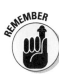

Thank goodness that you can always Undo your last operation by either choosing Edit⇨Undo or by pressing ⌘+Z on the keyboard.

5. **Click the Straighten button to make additional adjustments.**

 As you see in Figure 2-5, the tree and the flagstick appear to be slightly crooked. At the bottom center of the photo, you see a control area with a slider to correct this.

Figure 2-5: The photograph before straightening corrections have been made.

6. **Click and drag the indicator in the center of the slider to the right or left to straighten the photo.**

 To the right of the slider is the degree indicator, which tells you the amount of adjustment. When you're finished, click the Straighten button again to set the correction.

 For the photo in this example, I applied an adjustment of 2.9 degrees to make the correction, as shown in Figure 2-6.

 Now, I do one final edit. The photograph appears a little darker than desirable, but I can fix it with the Enhance tool.

7. **Keep your eyes on the photo — because the Enhance tool works immediately — and click the Enhance button to see the result.**

 Figure 2-7 shows that the grass and trees are lighter.

Figure 2-6: Showing the straightening correction applied.

Figure 2-7: After the Enhance tool adjustment, the photo looks better.

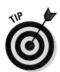

In Chapter 9, you find out that you can do only so much to color and lighting after a photo is captured, but usually you can make it better with iPhoto's tools.

8. **Click the Done button (lower-right) of the Edit pane.**

 This saves your changes, leaves Edit mode, and returns you to the main window.

Creating Your First iPhoto Print

After you improve the look of your photos with the editing tools, you might want to print them. What a great culmination — being in the right place, taking the photo, and editing it to perfection.

Follow some fundamental steps when you're making a print. Make sure that the photo you want to print (for this example, I use Chapter2Photo) is highlighted by clicking it in the main window. Then follow these steps:

1. **Choose File⇨Print from the iPhoto menu, or click Print on the toolbar at the bottom of the main window.**

 Notice the ellipsis (. . .) in the menu item. This always means that there will be more choices to make in the next dialog box.

2. **In the dialog that appears, make the appropriate choices using the pop-up menus for Printer, Paper Size, Presets, and Print Size to match your environment.**

 Figure 2-8 shows what some of these choices are, and you can see the ones that I made. Your mileage may vary, as they say, because the hardware and paper you have might be different.

 Chapter 12 discusses the choices you can make when clicking the Customize button.

3. **Click Print.**

 At this point, you'd expect to hear the sound of your printer starting — or so you thought. What appears is another dialog (shown in Figure 2-9), allowing you to make additional printer- and paper-specific settings.

 These choices are very printer- and paper-specific. They deal with the type of paper, whether to print color or black and white, and other choices. Chapter 12 deals with all this in detail. For now, you can use the default settings.

4. **Click Print.**

 Voilà! Your first print is created.

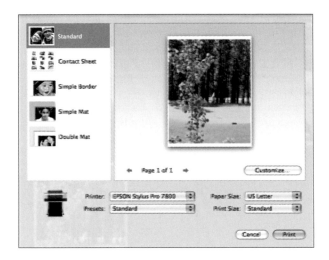

Figure 2-8: The first print dialog.

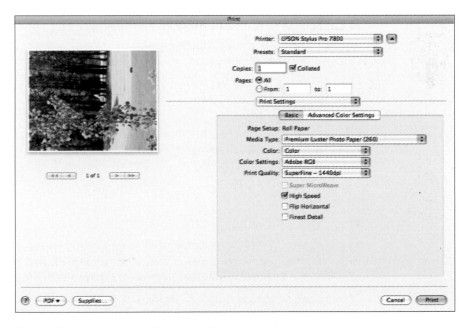

Figure 2-9: The second print dialog, showing more choices.

In Chapters 12 and 13, I discuss additional techniques you can use to print your photos.

If you started at the beginning of this chapter and have followed along up until now, congratulations — you just completed your first iPhoto project! Although this is a simple project, the techniques and tools that you used are similar to the ones you'll use in any iPhoto project you might undertake in the future.

As Monty Python would say, "Now for something completely different." Making iPhoto conform to how you want to work with your photos is accomplished by modifying iPhoto's Preferences settings. It's easy to do, and I show you how in the next section.

Making iPhoto Preferences Your Own

Most software provides a large number of settings for the user to choose from to determine how it will operate. Although the user can change them, the software usually makes initial selections for these settings. These are the *default settings,* and the software operates just fine using them. However, defaults might not reflect how you operate or be the settings you want — you need to make them your own. Remember that regardless of the choices you make at any time, you can always update and change them as you learn more about iPhoto.

To open and view the iPhoto Preferences, choose iPhoto⇨Preferences. The following sections show you each of the six Preferences panes, in order. I tell you what settings are available for you to adjust, as well as which settings I choose and why. Remember, you can make your changes in any order you wish.

General Preferences pane

After you choose iPhoto⇨Preferences, click the General button to open the General Preferences pane (shown in Figure 2-10). These preferences deal with your iPhoto software's fundamental operation. As you progress in your understanding of iPhoto and work with the software, you might decide to change these values several times.

The General Preferences pane contains the following settings:

- **Sources:** Selecting the Show Last x Months Album check box places an Album that contains all the photos that fall within the indicated time span on the left side of the main screen under the Recent heading. Selecting the Show Item Counts check box indicates how many items are contained within each icon at the left side of the main screen. I leave it deselected because I don't find the number very important.

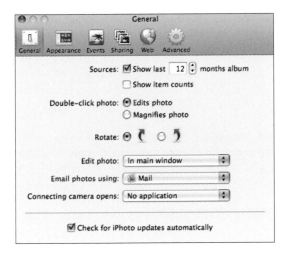

Figure 2-10: The General Preferences pane.

- **Double-Click Photo:** When you double-click a photo, the default setting, Edits Photo, causes iPhoto to open the photo in Edit mode. I like this choice, but you can set it so that double-clicking simply enlarges the photo, making it easier to examine, by selecting the Magnifies Photo radio button.

- **Rotate:** You can choose to have iPhoto rotate pictures clockwise (the first radio button) or counter-clockwise (the second radio button) when you click the Rotate button. I prefer a clockwise direction of rotation for photos, but you can choose counter-clockwise. Which one you prefer depends on how you normally orient your camera when shooting photos and can always be changed by pressing the Option key while clicking the Rotate button in the Edit pane.

- **Edit Photo:** Here you have three choices, which define how you like to operate in Edit mode.

 - *In Main Window:* Selecting this option means that editing is done within the confines of the current or main window. This is my preference because I like to keep the number of open windows at a minimum.

 - *Using Full Screen:* This option enlarges the editing area to encompass the entire screen with pop-up editing controls on the bottom. This hides everything else on the Desktop.

 - *In Application:* This setting allows you to choose a separate, photo-oriented application (such as Photoshop Elements) to use for editing. Doing this makes iPhoto an efficient repository for your photos.

- ✓ **Email Photos Using:** This setting allows you to choose Apple Mail, Entourage, America Online, or Eudora.

- ✓ **Connecting Camera Opens:** You can choose to have iPhoto open automatically when you connect your camera to your computer, have Image Capture (which simply reads the photos on your hard drive) open, or have nothing at all open (which means you must drag photos from the camera to your hard drive manually).

- ✓ **Check for iPhoto Updates Automatically:** I recommend enabling this option because it's a good idea to keep your software up to date. If selected, this happens every time iPhoto opens.

Appearance Preferences pane

To view the Appearance Preferences pane, click the Appearance button. The settings shown in Figure 2-11 are the defaults, and they usually work very well. Whether you decide to change them is up to you.

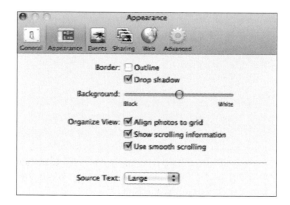

Figure 2-11: The Appearance Preferences pane.

- ✓ **Border:** This determines whether your thumbnails are displayed with an outline (border), a drop shadow, or neither. (Simply don't select either check box to choose the implied Neither option.) Purely a matter of taste.

- ✓ **Background:** Use this slider to adjust the shade (from dark to light) of the area around your photo in the main window. A medium gray, at about the mid-point of the slider, isn't distracting, and it's usually best as a background for photos.

- ✓ **Organize View:** Selecting the Align Photos to Grid check box forces the thumbnails to align themselves both horizontally and vertically and keeps the window uncluttered. Selecting Show Scrolling Information gives an indication of where you are in the sort order of the photos

when you click your mouse on the scroll bar. The Use Smooth Scrolling option smoothes out the scrolling action of the windows.

✔ **Source Text:** Adjusting the text size to Large helps those who need a little visual help (myself included) to more easily read the text associated with the photos. The other option is Small.

Events Preferences pane

Figure 2-12 shows the default settings for the Events Preferences pane, which you can access by clicking the Events button. I've found the default settings to be good choices unless I have a specific reason to want a different action.

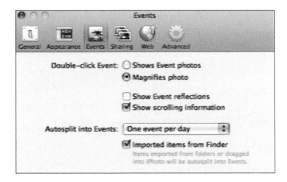

Figure 2-12: The Events Preferences pane.

✔ **Double-Click Event:** In General Preferences, you can choose the outcome of double-clicking a photograph. This setting, however, sets the outcome of a double-click for an entire Event.

 • Selecting the *Shows Event Photos* radio button causes the thumbnails for all photos in the event to appear in one window. From there, you can double-click an individual photo to put it in Edit mode, if that's the response you chose in the General pane.

 • The *Magnifies Photo* option works differently. As your mouse moves across the event window, the key photo (see Chapter 3 for more details) changes to display each of the photos contained in the event. When you see the one you want, you can double-click to open that photo for inspection, editing, and so on. Click that photo, and it closes. You can continue to browse and open key photos for the entire event. I prefer this choice because with one double-click, I get the photo of interest into Edit mode.

✔ **Show Event Reflections:** Selecting this check box causes a small reflection of the photo to appear beneath the thumbnail. This choice is strictly a matter of taste.

✔ **Show Scrolling Information:** This check box serves the same function for events as it does in Appearance Preferences for individual photos. It provides an indication, in the center of the window, of where you are in the sort order when scrolling through many events.

✔ **Autosplit into Events:** In Chapter 1, I introduce the concept of *Events,* which is a very handy way of organizing and collecting newly imported photos. But suppose that not all your photos correspond to one event? This pop-up menu is used in conjunction with the Imported Items from Finder check box beneath it to remedy that situation. Importing from a hard drive and selecting the check box means your that photos are split into different events according to the pop-up menu setting as I describe in the bullets that follow. If the check box isn't selected, all photos imported at the same time, from the same folder, are in the same event. The pop-up menu settings are

- *One Event Per Day:* All photos taken on the same day are grouped into one Event.

- *One Event Per Week:* This does the same for photos taken within one week of each other, starting with the first photo.

- *Two Hour Gaps* and *Eight Hour Gaps:* Split groups of photos into Events based on the timespan when they were taken.

Sharing Preferences pane

Click the Sharing button to view the Sharing Preferences pane. The settings for the Sharing Preferences pane are shown in Figure 2-13. By default, all these settings are *deselected,* meaning that they're turned off. Sharing of any type of information must be done carefully, and when you don't need to share specific information, turn off these settings.

I deal with sharing in more detail in Chapter 11. I recommend using the default settings.

Web Preferences pane

MobileMe is the new name for Apple's .Mac service. MobileMe allows you to access and manage your e-mail, contacts, calendar — and, most importantly for our purposes, your photos via the Web and across various hardware devices including Macs, PCs, the iPhone, and the iPod Touch. As such, it isn't a part of iPhoto, and it's something you must pay an annual fee to use. If you don't have this service and aren't interested in finding out what it can do in conjunction with iPhoto, skip this section.

I discuss this service in more detail in Chapter 11, including how to subscribe to MobileMe Galleries.

Click the Web button, and the Web Preferences pane appears, as shown in Figure 2-14.

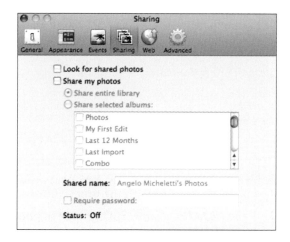

Figure 2-13: The Sharing Preferences pane.

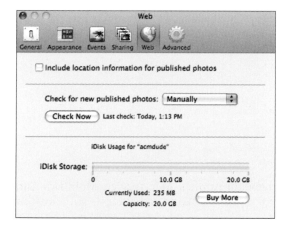

Figure 2-14: The Web Preferences pane.

The Web Preferences available to you are the following:

- **Include Location Information for Published Photos:** If this check box is selected, the location information in the photos is uploaded along with the photos.

- **Check for New Published Photos:** This pop-up menu allows you to check for photos in MobileMe Gallery Albums you subscribe to at these chosen intervals:

 - *Manually:* Occurs when you click the Check Now button

 - *Automatically:* Occurs immediately when new photos are published

 - *Every Hour:* Starts at the time you set this option

 - *Every Day:* Starts at the time and day you set this option

 - *Every Week:* Starts at the time and day you set this option

- **iDisk Storage:** This indicator shows how much of your allotted storage you've used; click the Buy More button to buy more storage directly from MobileMe.

Advanced Preferences pane

The last Preferences pane is the Advanced Preferences pane, as shown in Figure 2-15. The choices in this pane are very important to understand because they can dramatically affect your operation with iPhoto.

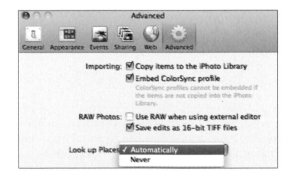

Figure 2-15: The Advanced Preferences pane.

The Advanced Preferences pane includes the following settings:

✔ **Importing:** When you import photos into your library, iPhoto either imports a copy (when the Copy Items to the iPhoto Library check box is selected) or imports only a reference to the original photo (when the Copy Items to the iPhoto Library check box isn't selected). In either case, subsequent changes made in iPhoto don't affect the original photograph, and that's important! So what difference does it make then?

When iPhoto is working with a reference, it must gather information from the original photo each time you open iPhoto. That means that if you modify the original — or even worse, move it to another volume or delete the original — iPhoto can no longer find it or work with it. You'll still see the image when you look at your Events in iPhoto, but it's really just a "picture of a picture," and you can't share, edit, or print the image. This is guaranteed to make you very uncomfortable!

My advice is to leave the Copy Items to the iPhoto Library check box selected to ensure that you have a copy imported.

Selecting the Embed ColorSync Profile check box allows your image's colors to be displayed properly on either a monitor or printer. If your photo doesn't have a profile already attached to it, iPhoto assigns one. If you're sure you want to assign your own profile at some later time, leave the check box deselected.

If you're not sure what all this means, you definitely should leave the Embed ColorSync Profile check box selected.

✔ **Raw Photos:** If you'll be using an external editor (such as Photoshop) and want to have the Raw image transferred to that editor, select the Use Raw When Using External Editor check box. (I discuss Raw images in detail in Chapter 9.) Selecting the Save Edits as 16-bit TIFF Files check box ensures that your edited files preserve their highest resolution.

✔ **Look Up Places:** When this option is set to Automatically, iPhoto uses the GPS coordinates that specify the location where that photo was taken and drops a marker pin for that location name on your map in Places, in the Source list. This occurs at the time of import or whenever location information is updated. If the option is set to Never, iPhoto never looks up location names. Places are explained in detail in Chapter 3.

You can change Preferences at any time, and the changes are usually the result of you changing how you interact with the software.

Importing Your Images into iPhoto

In This Chapter

▶ Hardware methods for bringing photos into your computer

▶ Troubleshooting the import process

▶ Understanding all your import options

*S*imply defined, *importing* photos is the process of downloading your photos from your camera (or other storage device) to your computer. Lately, the photographic software industry has begun calling the process of importing photos into the computer *ingesting*. For me, that conjures up scenes from old science fiction thrillers where monsters satisfied their needs at the expense of the local inhabitants. I assure you that isn't an accurate description of what happens at import time, and I'm going to continue to use the term *import* in this book.

Those of you who already have your photos imported to your computer are likely wondering what all the fuss is about. Case closed, right? No, this idea of importing is more than just physically bringing the photographic file onto your hard drive. It's about safety, backup, and nondestructive editing.

Take a look at this chapter and the import process, and you'll see what I mean.

Importing Your Photos from Your Camera

You can use any of several ways to import your digital photos from your camera to your computer. They all work, but some are preferable — depending on the source of the photos and how you like to work with them — and I want you to understand why. The possibilities are as follows:

- ✔ **Importing from a memory card reader**
- ✔ **Importing directly from the camera**
- ✔ **Importing from an external hard drive or any other data storage device, such as a CD or DVD or a USB flash drive**

 Typically, this method is for photos saved previously or for photos PhotoCDs from film developer companies

Face it: You've taken a great deal of time and care to capture events that are important to you, and the last thing you want is to negate that effort and lose your photos. It's important to remember that at this point in time, the only places where these photos exist are in your mind and in your camera. Unfortunately, iPhoto can't do a mind-meld, but with proper care, it can ensure the safety of what's in your camera.

I'll start with what I consider the best choice.

Importing using a memory card reader

Like many professional photographers, I'm not in favor of doing a direct, camera-to-computer import. I recommend removing the flash or SD memory card from your camera and inserting it into a card reader, which is connected to your computer using the computer's Universal Serial Bus (USB) port. This lessens the possibility of damage to your camera, and it's certainly as fast as a direct connection. Nearly every digital camera comes with a removable card of some kind. If the camera also has internal memory, I recommend that you set the camera to use its removable memory card for photo storage. The particular card reader shown in Figure 3-1 can handle several different types of cards. Make sure the card reader you choose can read the type of card your camera uses.

Figure 3-1: A typical flash/SD card reader.

Importing from a memory card is just as simple as importing from a camera. To use a card reader to import photos, follow these steps:

1. **Remove the flash or SD card from your camera, using your camera manufacturer's instructions.**

 Most likely, those instructions include turning off the camera power and opening a small door in the camera body to remove the card.

2. **Plug the card reader into a USB port on your computer.**

3. **Insert your flash or SD card into the card reader.**

4. **Start iPhoto, if it isn't already running.**

 A window similar to the one in Figure 3-2 opens and displays the name of the camera that the card came from in the Source list (under Devices) on the left side of the window and the photos on the card in the iPhoto main window.

 To automatically start iPhoto before importing (which means that it starts when you connect a device to the computer), see the section "Automatically Starting iPhoto Before Importing" later in this chapter.

The name of the camera the card came from Photos on the card

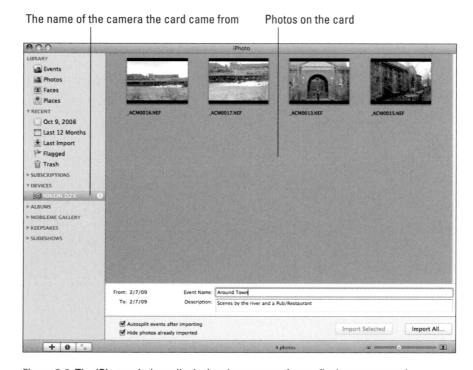

Figure 3-2: The iPhoto window, displaying the contents from a flash memory card.

5. Fill in the Event Name and Description.

This is your chance to give the Event a name that signifies the theme of the photos and set a longer description of the Event.

6. Determine the actions for the check boxes.

- *Autosplit Events After Importing:* Select this check box if you want iPhoto to divide your photos into separate Events based on the date and time you took them.

- *Hide Photos Already Imported:* Select this option if you already imported some of the photos on the camera. The duplicate photos won't appear in the iPhoto window, so they won't be imported again.

In the example import in Figure 3-3, some photos were taken more than two hours apart. Because the Autosplit Events After Importing option was selected and because I has set the limit in Event Preferences (see Chapter 2 for more on Event Preferences) as Two-Hour Gaps, two Events are produced even though all the photos were taken on the same day.

Figure 3-3: Importing photos with the Autosplit Events option and two-hour gaps.

7. **Click the appropriate Import button.**

 If you wish to import only some of the photos, select them and then click the Import Selected button. Otherwise, click the Import All button. When the import is complete, iPhoto asks whether you want to delete the photos in the camera. I find it best and safest to do this action separately, using the controls in the camera (see the camera owner's manual for instructions), so click No in the dialog.

8. **(Optional) If you used the Autosplit Events After Importing option to create multiple Events, click the additional *untitled event* titles and change them to what you want.**

 Because the import window has a place for only one Event name, you must change additional Events after the import.

9. **Remove the card from the card reader by clicking the Eject button next to the camera name under Devices in the Source list.**

 Always use the Eject button to do this. If you just pull the card out of the card reader, you risk problems, including lost data.

10. **Disconnect the card reader from your computer.**

Importing directly from your camera

If you don't have a memory card reader or prefer a more direct method, you can easily import your photos into iPhoto. Here's what you do:

1. **Connect the small end of the USB cable to your camera.**

 The USB connection on a camera is usually under some kind of rubber flap to keep out dirt. Because each camera is different, you need to use the camera's owner's manual to determine where this connection is. One end of the USB cable is much smaller than the other, and the smaller end is the one that connects to the camera.

2. **Connect the larger end of the USB cable to your computer.**

 Connect the USB cable directly into a USB port on the computer. You can connect to a USB hub if necessary although this doesn't always work.

3. **Turn the camera on, if it isn't on already.**

4. **Start iPhoto, if it isn't already running.**

 If everything is connected properly, you see your camera appear in the Source list under Devices on the left side of the iPhoto window, as shown in Figure 3-4. You will also see all the photographs contained within the camera in the iPhoto main pane.

TIP

To automatically start iPhoto before importing (which means that it starts when you connect a device to the computer), see the next section, "Automatically Starting iPhoto Before Importing."

The name of the camera connected Photos on the camera

Figure 3-4: iPhoto with a camera connected.

5. Fill in the Event Name and Description.

Give the Event a name that signifies the theme of the photos and set a longer description of the Event.

6. Determine the actions for the check boxes.

- *Autosplit Events After Importing:* Select this option if you want iPhoto to divide your photos into separate Events based on the date you took them.

- *Hide Photos Already Imported:* Select this check box if any of the photos on the camera have already been imported. As a result, they won't be imported again.

7. Click the appropriate Import button.

If you wish to import only photos that you selected, click Import Selected; otherwise, click Import All. When the import is complete, iPhoto asks whether you want to delete the photos in the camera. Again,

I find it best and safest to do this action separately, using the controls in the camera. So click No in the dialog.

8. **(Optional) If you used the Autosplit Events After Importing option to create multiple Events, click the additional untitled Event titles and change them to what you want.**

 Because the import window has a place for only one Event name, you must change additional Events after the import.

9. **When you imported all photos, it's safe to Control-click (or right-click) your camera icon in the Source list and choose Unmount. Or, you can drag your camera icon into the iPhoto Trash.**

 Only when this is done is it safe to turn off your camera and then physically disconnect it from your computer.

10. **Disconnect the camera from the computer.**

Importing your photos from a CD or hard drive

Importing photos from external media is almost as easy as importing from your camera or memory card. This is a big advantage for many reasons. You might have photos that you took sometime in the past, and they're already saved to your computer. You might have a 35mm or medium-format camera that uses film, which you had processed, digitized, and saved on a disc. Or the photos might have come to you attached to an e-mail, either with the Apple Mail client or even Web mail. Whatever the scenario might be, now you want to organize your old, existing photos in iPhoto. The import process goes like this:

1. **If the photos aren't already on a hard drive or disc, put them there.**

 I don't recommend dragging photos into iPhoto — there's too much chance for error. Instead, highlight the photos and save them to the appropriate location.

2. **Open iPhoto and choose File⇨Import to Library.**

 iPhoto imports file formats such as JPEG, TIFF, and RAW. You can read more about file formats in Chapter 7.

3. **Navigate to the place where the photos are stored (shown in Figure 3-5) and select the photo file(s)/folder(s) you want to import.**

 By using List view in the Finder, as shown, you can select multiple files/folders at one time.

4. **Click the Import button.**

 The photo file(s)/folder(s) is imported. The last Event imported appears in iPhoto under Last Import in the Source list, as shown in Figure 3-6. (Your import(s) also appear in the Events window.) The Last Import pane shows the last photo(s) that were imported.

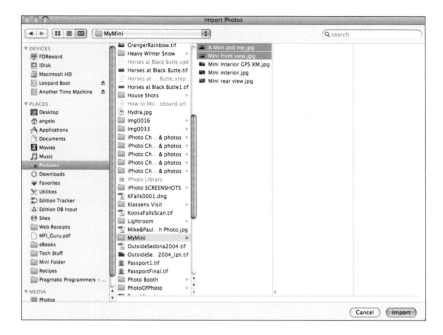

Figure 3-5: Importing a folder from the hard drive.

Last Import in the Source list Photos from the Last Import

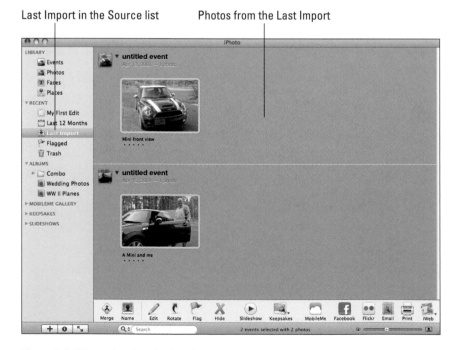

Figure 3-6: iPhoto showing the Last Import pane.

5. **(Optional) In this case, I didn't give an Event name at Import time. However, you can always change an Event name by clicking the Event Name area (in this case, it reads *untitled event*) and typing a new name.**

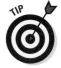

Events are created for your photos depending on the settings you make in Events Preferences (discussed in Chapter 2). If the Imported Items from Finder check box isn't selected, Events are created based on the folders the photos are imported from, regardless of the date on which you took them (the *capture date*). That means that all photos in any folder are in one Event, with the folder name as the Event name. If the Imported Items from Finder check box is selected, all photos with the same capture date, regardless of the folder they're in, are placed in the same Event, and the Event name is the name of the first folder in the batch to be imported. If the photos are not in a folder, *untitled event* will be used.

Automatically Starting iPhoto Before Importing

If you're the kind of person who gets aggravated each time you connect your camera or card reader, only to realize you haven't started iPhoto yet, the solution is very simple. If this doesn't apply to you (come on — 'fess up; you know it does), feel free to skip this section, secure in the knowledge that you're far above the rest of us.

To set iPhoto to open automatically before importing photos from your digital camera, follow these steps:

1. **Open iPhoto and choose iPhoto➪Preferences.**

2. **Click the General button on the toolbar.**

 This opens the General Preferences pane.

3. **Near the bottom of the General Preferences pane, you see a Connecting Camera Opens option. Set it for iPhoto, as shown in Figure 3-7.**

 This ensures that whether you connect a camera or the card reader, iPhoto will open.

4. **Close the dialog.**

 This saves your selection.

Select iPhoto

Figure 3-7: Set this preference to open iPhoto automatically.

Adding and Editing Keywords in iPhoto

Keywords are labels that you can add to your photos to provide additional information about the subject — and, more importantly, make searches more efficient. I discuss iPhoto's searching capabilities in detail in Chapter 6, but at this point, during the import process, I encourage you to add your keywords. If your imported photos already have keywords, you might want to edit them to ensure more accurate retrievals.

You can use these two ways to view keywords in iPhoto:

- ✔ **Move your mouse over the photo.**
- ✔ **From the iPhoto menu, choose Window⇨Show Keywords.**

When you find the photo's keywords (or find that they don't have any yet), you can edit (or add) them. Take a look at both of these methods in more detail. First, try moving your mouse over the selected photo. To do so, follow these steps:

1. **Select Photos in the Source list, find the photo of interest, and simply move the mouse over it.**

 If you move your mouse over a photo that has no keywords, you see *add keywords* beneath the photo, as shown in Figure 3-8. If you see keywords, proceed to Step 3.

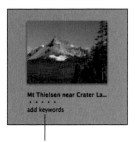

Add your keywords here

Figure 3-8: Photo showing where to add keywords.

2. **To add keywords to a photo that doesn't have any, click *add keywords* and type in your keywords, separating each with a comma.**

 That's all there is to adding keywords.

3. **To edit existing keywords, click any one of the keywords. Double-click the one to be edited to highlight it; then type your changes. Then press Return if you're finished editing, or double-click another keyword and edit it.**

Another way to add or edit keywords is to use this second method:

1. **Choose Window⇨Show Keywords.**

 The Keywords dialog shown in Figure 3-9 appears, showing all current keywords and providing a means for editing them and creating new ones. To create a new one, continue with the steps that follow.

Figure 3-9: The Keywords dialog.

2. **Click the Edit Keywords button.**

 You see the Edit Keywords dialog, as shown in Figure 3-10.

Figure 3-10: The Edit Keywords dialog.

3. **Click the + button in the dialog to create an Untitled keyword entry space. Type the new keyword and click OK.**

 The keyword automatically gets a shortcut assigned (usually the first letter of the keyword, or the second letter if the first is already taken, and so on) and is placed in the Quick Group at the top of the dialog.

 In Figure 3-11, I added *Crater Lake* for the keyword.

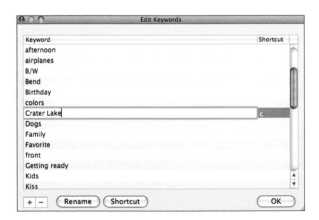

Figure 3-11: Showing the new keyword.

4. **Select the appropriate photo in the iPhoto main window, and then click the Crater Lake keyword button you just created.**

 The keyword appears beneath the photo.

Figure 3-12 shows the *Crater Lake* keyword applied to the photo.

5. **To edit a current keyword, click Edit Keywords, highlight the keyword to be edited, click the Rename button, and make your changes. If you want to change the shortcut, click the Shortcut button and make your change. When you're finished, click OK.**

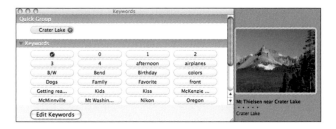

Figure 3-12: The new keyword added to the photo.

 Another way to add or delete keywords from a photo is to select the photo, open the Show Keywords dialog, and click a current keyword to delete it or click a new keyword to add it. There's even some animation that goes along with these actions.

 I recommend adding and/or editing keywords right after you import your photos. Of course, you can add and edit keywords at any time.

Adding Places to Your Photos

During the capture of your photos, your camera, if it's suitably equipped, can attach GPS data to your photos. (Check your camera's manual to find out whether your camera has this feature.)

If your camera isn't so equipped, all is not lost — as long as you can remember where you were! I recommend adding this location data right after you import your photos. Of course, you can add and edit location information at any time.

 Any location information added by your camera or by you becomes part of the metadata for the photo. That means that it can be viewed by anyone having access to that photo. If you don't wish to share this information, don't enter it manually. Also, check your camera manual to see how to turn off the GPS capability.

To add locations to your photos manually, follow these steps:

1. **Select the photo, photos, or Event to which you want to add a location.**

 When you move the mouse pointer over a photo or Event, a small, white Information button appears in the lower-right corner.

2. **Click the Information button.**

 The photo or Event flips to the back so that you can enter information. If you select multiple photos or an entire Event, entering location information for one photo enters it for all.

3. **Click Enter Event Location, and then type the name of the place where you took the photo.**

 This is why I said you have to remember where you were.

 As you type, a list of matching locations appears, as shown in Figure 3-13. If necessary, scroll to find the correct name and select it.

 If you're not connected to the Internet, you won't be able to complete the next steps in this section, which require that you are. As soon as you do connect, finish these steps by using Places Maps and the My Places dialog.

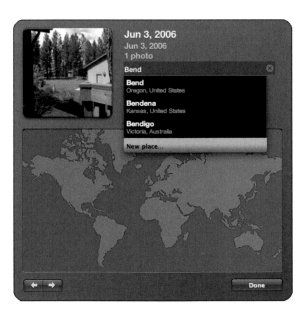

Figure 3-13: iPhoto's Location list.

If you don't see a location match in the list, follow these steps:

a. *Click New Place.*

The Edit My Places dialog appears, as shown in Figure 3-14.

Type as much address information as possible and then press Return. One or more matches appears. Select the one you want, and a blue pin marks the spot on the map.

Type the location's address here

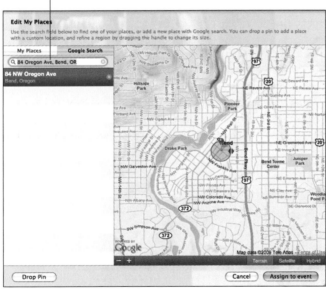

Figure 3-14: The Edit My Places dialog.

b. *Move the pin manually to fine-tune the location. Drag the arrow on the circle to increase or decrease the circle size.*

c. *Add this new location to My Places by clicking the + button next to the address in the list.*

Adding a location to My Places makes it available to be chosen in other photos taken at the same place.

d. *When you're satisfied, click the Assign to Photo button. (This is called the Assign to Event button if you're adding the location to an entire Event.) Proceed to Step 4.*

iPhoto enters the name and produces a map with a pin in it depicting that location, as shown in Figure 3-15.

You can click the plus or minus buttons to zoom in or out. Use the Terrain, Satellite, or Hybrid buttons to change the display. When you're finished, click Done.

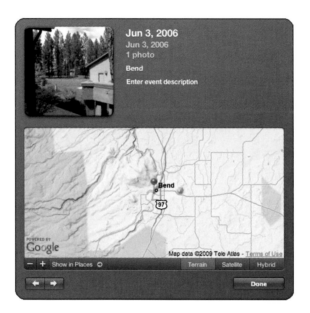

Figure 3-15: The map displaying the selected location.

4. **Select the photo, and then choose Photos⇨Show Extended Photo Info.**

 As you see in Figure 3-16, the actual GPS coordinates for the location name you picked have been filled in.

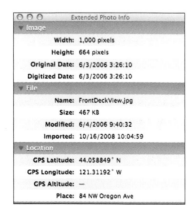

Figure 3-16: The Extended Photo Info dialog.

You can even add and name a personal location that might not have an address. Suppose you have a photo that you took at your friend's cabin near Crater Lake. Here's how you can set that location.

1. **Select the photo (or Event, if all the photos were taken at the same place) and click the small Information button.**

2. **Click New Place.**

3. **Click the Google Search button.**

 You can drag the map up, down, left, and right, and use the + and – buttons to zoom in and out in order to get the approximate place you're looking for.

4. **Click the Drop Pin button, and then drag the head of the pin to position it where you want it, as shown in Figure 3-17.**

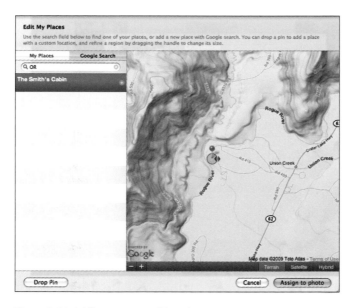

Figure 3-17: Adding a personal location.

5. **The new location is added to the list on the left and appears as New Place; click it, type the name for this location, and then press Return.**

6. **Click the Assign to Photo button. (This is the Assign to Event button if you're adding the location to an entire Event.) Click the plus sign next to the name.**

 This adds the location to My Places.

To remove a location from any photo, move the mouse over it, click the white Information button, and then select the location name. Click the small X button at the right side of the location name.

Adding Ratings To Your Photos

Ratings are a very subjective way of classifying your photos. It's kind of like a Hollywood critic judging a movie — only in this case, you're the critic. As you can see in Chapter 6, making a rating can help find those photos you want to have a closer look at, or those where you want to do more intense editing. Ratings can be changed at any time. To set them, do the following:

1. **Select a photo or photos for which you want to set ratings.**

 If you select more than one photo, when you set a rating, it will be applied to all the selected photos.

2. **Either right-click or Control-click any of the photos. In the menu that appears, choose My Rating and then choose None or 1 to 5 stars.**

 Alternatively, you could also choose Photos⇨My Rating and choose None or 1 to 5 stars. Figure 3-18 shows the menu choices.

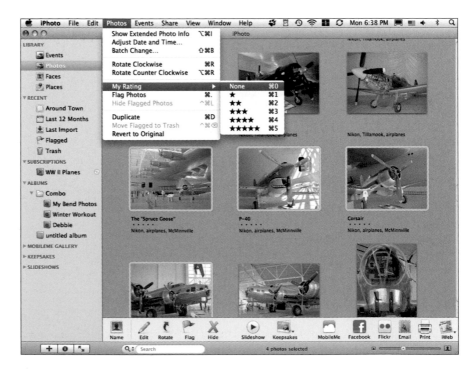

Figure 3-18: Choosing a rating from the menu.

3. **You can also simply click one or more of the dots that appear beneath the photo thumbnails to set the rating.**

If you click a star already set for a photo, it will be canceled, and the rating will be one less. This is the easiest way to add or delete stars for individual photos.

Setting the Key Photo for an Event

When you look at all the Events in your Library, you see that only one photograph is displayed per Event (see Figure 3-19) even though the Event contains several photos. This photo is called the *key photo,* and it's meant to give an indication of the type of content within that Event folder.

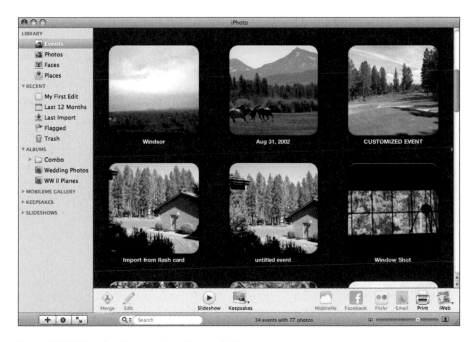

Figure 3-19: Showing the key photo for each Event.

By default, the first photo imported into an Event becomes the key photo, but you might prefer another photo. To change the photo used as the key photo, follow these simple steps:

1. **Click Events in the Source list and then move your mouse across the Event slowly.**

You see all the photos in the Event displayed one after the other.

2. **When the photo you're interested in appears, simply right-click (or Control-click) your mouse and choose Make Key Photo. Or, even more simply, just press the spacebar.**

 The photo you selected now becomes the key photo.

Another way to do this is as follows:

1. **Double-click the Event to open it in another window and show all the photos.**

 This allows you to more easily choose the likely candidate for key photo.

2. **When you determine which one you want, highlight it and choose Events⇨Make Key Photo.**

 Any time you change your mind, you can make this selection again and choose another photo.

Handling Import Problems

Sometimes, no matter how careful you are, things happen that cause problems during the import process. They might occur because of inadvertent errors you made or because the software or hardware simply can't do what you want it to do. iPhoto can handle up to 250,000 photographs in its Library. Sounds like you shouldn't have any worries, but you don't have unlimited hard drive space or computer memory, so the theoretical limit might be much lower for you — and that can be a problem. Depending on the situation, here are some things to try:

- **Make more storage space available.** One obvious solution is to buy more hard disk space. Before doing that, though, you can try an easier and less-costly solution. You can back up your Library or part of your Library to a CD or DVD and then delete those less-often used photos from the Library, gaining back that space. When necessary, use the procedures in this chapter to import those photos back to the Library from the CD or DVD you backed them up on.

- **Check your camera to ensure that it's on and properly set to transfer photos.** If the camera is connected properly but doesn't appear in the Source list, perhaps some camera-specific settings are incorrect for file transfer. Also check to ensure the USB cable is seated in the connector properly. If you have another USB cable, try substituting that one, and plug the cable into another USB port on your computer.

✔ **Quit other programs to speed up the process.** Depending on your operating environment, you might find the import operation to be running slowly. If you have other programs open, try quitting them to see whether that helps.

✔ **If you have multiple USB ports on your computer, use one that doesn't have other devices connected to it if possible.** This will eliminate any contention among devices for time on the port. Also, use a USB 2.0 port, if available, rather than a slower USB 1.1 (commonly found on your keyboard).

There's another operation you can perform regarding the Library that can serve two purposes. You can physically move the iPhoto Library to another hard drive that has more room; that way, you don't have to worry about backing up to a disc and then deleting less-frequently used photos. You can also use this to create multiple iPhoto Libraries so that you can separate photos that cover different time frames. For instance, one Library can have all photos you imported with dates prior to 1999, and another one covers 2000 to the present.

Whatever your reasons, here's how to move the iPhoto Library:

1. **Close iPhoto if it's open.**

2. **Open the folder where the iPhoto Library is stored and drag it to a new location.**

 The default location for the Library is in the Pictures folder on your hard drive.

3. **Hold down the Option key and open iPhoto.**

 You see the dialog in Figure 3-20, asking you to create or choose a Library from the list iPhoto found.

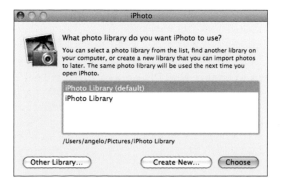

Figure 3-20: Choose or create an iPhoto Library.

4. **Click a Library name in the list or click the Other Library button.**

5. **Find the location where you moved the Library in Step 2, select it, and click Open.**

Creating a new iPhoto Library is a similar process.

1. **Close iPhoto if it's open.**

2. **Open the folder where the current Library is stored and either rename it or move it to another location.**

 Because iPhoto can work with only one Library at a time, you must break the link to the current Library before you can create a new one.

3. **Press and hold the Option key and open iPhoto.**

 The dialog in Figure 3-20 again appears.

4. **Click the Create New button.**

5. **Type a name of your choice for the new Library and choose a location to store it.**

6. **Click Save.**

 An empty iPhoto Library is created at the location you chose and with the name you typed.

At this point, all future imports will place the photos into this moved/new Library.

Never move or rename the current iPhoto Library when iPhoto is open. This would likely cause corruption of the file and, potentially, permanent damage to the Library contents.

That's it. With the techniques in this chapter, importing from any medium the Macintosh accepts is easy, and the photos that mean so much to you and your family are secure.

Part II
Manipulating
Photo Organization

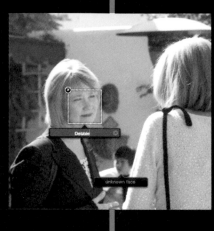

*I*n this part of the book, I talk about getting and keeping your photo collection organized. With the advent of digital photography, we're encouraged to take lots of photos. No more worries about running out of film at a crucial time, which used to make us ration our shots. Now, using relatively inexpensive memory cards instead of film, you can shoot to your heart's content.

Is there a downside to this bountiful harvest of cinematic endeavor? Sort of. All these hundreds and hundreds of photo files can become unwieldy — and what's worse, irretrievable. How frustrating it is to know that you have a photo of a particular event or person, but you can't find it?

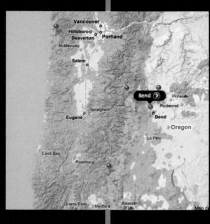

Chapter 4 discusses all the different ways you can organize your photos, whether by the event, place, and even the faces in the photo! Chapter 5 takes organization one step further, enabling you to take several groups of photos and combine them into an Album. The part concludes with Chapter 6, providing everything you need to know about searching for your photos and backing them up.

4

Events and Faces — Grouping Your Photos

*T*he feature that iPhoto '09 uses to allow quick and accurate grouping of your photos is *Events.* Events reflect the baseline concept that photos taken at nearly the same time can be related under the heading of date and time, if nothing else.

For those of you upgrading from older versions of iPhoto, Events might be a new term for you. Events are similar to *Film Rolls* — the organization used in previous versions of iPhoto — that provide easier access to your photos. When you upgrade from iPhoto 6 or earlier, iPhoto converts all your Film Rolls into Events.

Of course, the time for a series of photos can't be exactly the same, but you can set up a time span of hours, days, or weeks into which your photos will be gathered, forming an Event. There's a lot of latitude in how Events are named and displayed, as well as how Event contents can be changed after they're created.

For your photos that contain people, you can also use facial recognition technology — *Faces* — to not only group photos containing the same person but also make them all easy to find. Sounds like stuff out of a spy novel, doesn't it? But it's actually part of iPhoto's capability. Time to get up close and personal with Events and Faces.

Understanding iPhoto's Default for Creating Events

A great deal of information is generated by most cameras and stored as part of the photographs you take. This information can comprise the type of camera; the lens' focal length, shutter speed, and aperture; and a host of other details, including the date and time of the photo capture. All this info is vital for iPhoto because this is how (by default) it first creates Events. And for cameras so equipped, this information can also contain GPS coordinates and location, which can be used by Places in iPhoto.

The information generated by the camera — *metadata* — is included within the image. This metadata goes by the name EXIF, which stands for Exchangeable Image File data. It generally contains date and time, camera settings, copyright information, and much more.

Figure 4-1 shows a sample of this metadata information. Just highlight a photograph in iPhoto and choose Photos➪Show Photo Info.

Figure 4-1: Viewing a photo's metadata.

Because the original date and time of capture are embedded, it doesn't matter what day you import your photos into iPhoto or whether you download from a Flash card or the camera itself (via USB cable) to import the photos — the date of capture is preserved in the photo.

And here's one other important thing to know about the default grouping — it isn't forever. At any time after import, you can change the name of an Event and alter the Event contents. I'll show you how to do that.

Creating Groupings Using Your Events

All of us have experienced milestone events in our lives. The ones that are important to you will define how your iPhoto Library is constructed. Regardless of how Events were assembled and named in iPhoto initially, you might want to redefine and rearrange how your photos are stored, thus creating a customized Event. In iPhoto, that's easy and straightforward.

To create a customized Event

1. **Select Photos from the Source list in iPhoto.**

 With this selection, you can now view all the photos in all Events in your Library.

2. **Select all the photos you want to include in your customized Event.**

 To select nonconsecutive photos, hold down the Command key (⌘) and click the photos you want. To select consecutive photos, hold down the Shift key, click the starting photo, and then click the ending photo. Figure 4-2 shows a sample of how this might look when selecting nonconsecutive photos.

3. **Choose Events⇨Create Event.**

 The Create New Event dialog opens, as shown in Figure 4-3.

 You see a warning message in the dialog reminding you that photos can be in only one Event — and, therefore, the selected photos will be moved to the new Event and removed from the Event they were previously grouped in.

4. **Click Create and then select Events from the Source list.**

5. **A new *untitled event* appears containing the photos you selected, as shown in Figure 4-4.**

 Photos will retain their original capture dates despite being moved from one Event to another. This way, unless you choose to change the dates you can always tell, in the future, exactly when the photos were taken.

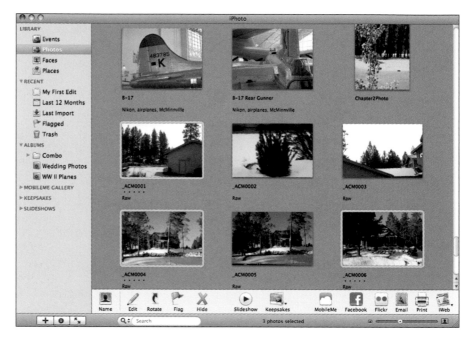

Figure 4-2: A nonconsecutive photo selection.

Figure 4-3: The Create New Event dialog.

6. To change the name of the Event, click the name *untitled event* and then enter a new name.

If the photos in the new Event were taken on different dates, a date range will display beneath the Event name. In iPhoto, you have the opportunity, using the Batch Change option, to make the date and time of all the photos in an Event the same, or to change just the date. You can also modify the photo's Title, Time, and Description.

7. To use the Batch Change option, make sure the Event is still selected and then choose Photos⇨Batch Change.

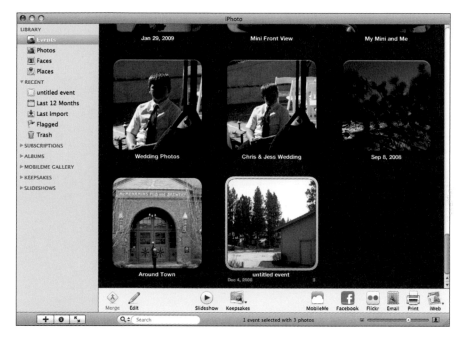

Figure 4-4: The new *untitled event*.

Figure 4-5 shows an example of a date change to be made. This change affects only the currently edited state of your photos in the Library. If you want to modify the originally imported photos as well, select the Modify Original Files check box.

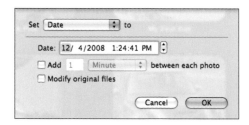

Figure 4-5: Use Batch Change to edit an Event's date.

8. **Click OK.**

The change is made.

Figure 4-6 shows the changes applied. Notice that after the change, the date shown for the entire Event is the new date you chose.

The new date for the Event

Figure 4-6: An Event with a new date applied.

9. **Another way to make date and time changes is to choose Photos⟹ Adjust Date and Time.**

With this command, the date and time of each photo is shifted, based upon the new date and time for the first photo in the Event. The original files may also be changed if desired. For example, if the photos in the Event are each one day apart, changing the first one by one month will simply shift all photos in the Event by that amount. There will still be a one day difference between them, though. This capability is shown in Figure 4-7.

Although you can't see all the photos, the photo dates originally spanned Jan 3, 2005 to Feb 3, 2007. Note in Figure 4-8 that they will now span Jan 3, 2006 to Feb 3, 2008.

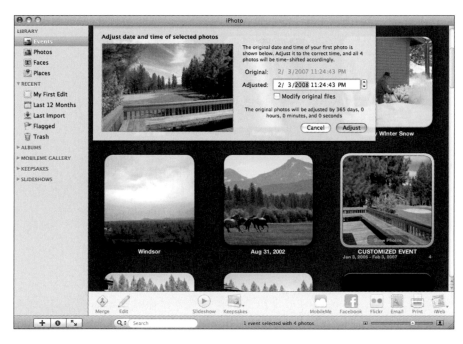

Figure 4-7: The Adjust Date and Time dialog.

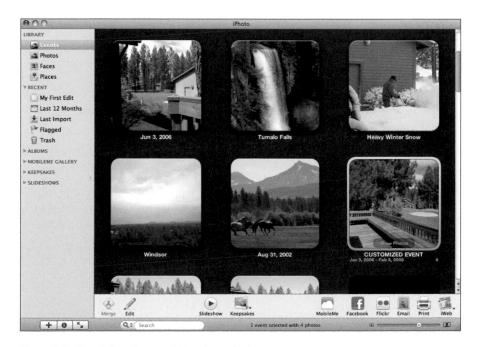

Figure 4-8: After Adjust Date and Time is applied.

Dealing with Multiple Same-Day Events

The idea of separating photos taken on different days into different Events works very well. Events can be a birthday, wedding, trip to the lake, visit to Uncle Harry, and so on. But what happens if you do more than one of these on a single day? Turns out that iPhoto can be of some help there, too.

As you see in Figure 4-9, you can choose to Autosplit into Events in Events Preferences (see Chapter 2 for more on Events Preferences) based on a 2- or 8-hour gap in capture time on the same day. If the Events you're dealing with don't fit that time frame, you have to use the techniques described in this chapter to move photos between Events to restore the Event separation you desire.

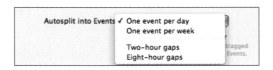

Figure 4-9: Setting 2- or 8-hour Event gaps.

Merging Events

Another way to manually manipulate Events is to merge two or more Events into one. Perhaps you photographed a lake scene at two different times of the year and would like to merge the photos into an Event called A Change of Seasons at the Lake. To merge Events

1. **Select Events from the Source list.**

2. **⌘-click to select the two or more Events you want to merge.**

3. **Either click the Merge button (bottom-left of the iPhoto toolbar) or choose Events⇨Merge Events, as shown in Figure 4-10.**

4. **In the dialog that appears, click Merge Events.**

 The first Event selected becomes the one into which all other selected Events will be merged.

5. **You can now rename the merged Event by clicking the Event name and typing a new one.**

 You can also use the Information (the lowercase "i") button (lower-left corner of the iPhoto window) to do this.

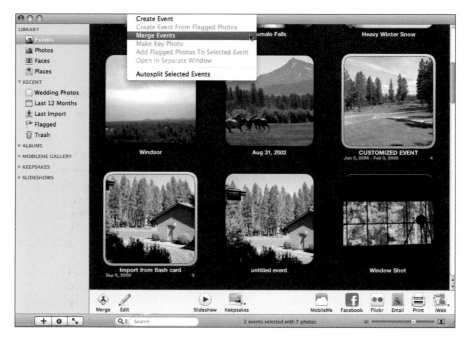

Figure 4-10: Merging two Events.

You can also merge two or more Events by simply dragging them onto the Event you want to merge them with. As is often the case in iPhoto, there are multiple ways to accomplish the same result. Dragging and merging works like this:

1. **Select the Event or Events, using ⌘-click, to be merged into another.**

2. **Click and drag onto the Event to be merged with.**

 A dialog appears, verifying the operation that's about to begin, as shown in Figure 4-11.

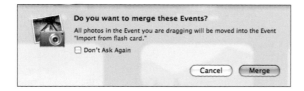

Figure 4-11: Merging Events by dragging.

3. **Click the Merge button.**

 The selected Event(s) will be merged, in order, into the Event they're being dragged onto.

Splitting Events

Another technique you can use to manipulate how your photos have been stored is to split an Event. This can be useful if, for instance, you were photographing multiple happenings on a single day but they weren't more than two hours apart. When you import into iPhoto, the photos would be stored as part of one Event. Using iPhoto's Split feature for splitting them apart works like this:

1. **Set the Double-Click Event option in Events Preferences to Shows Event Photos.**

 For more on Events Preferences, see Chapter 2.

2. **Select Events from the Source list and then double-click the Event you want to split.**

 This displays all the photos in the Event.

3. **Select the photos that will constitute the second Event.**

 You can use either standard Macintosh way of selecting:

 - *Hold the Shift key and then click the first and last photos that are consecutive.*
 - *Press ⌘ and then click nonconsecutive photos.*

 Figure 4-12 shows the Event and the highlighted photos.

4. **Click the Split button on the iPhoto toolbar or choose Events⇨Split Events.**

 The photos you select are moved to a new *untitled event,* as shown in Figure 4-13.

5. **Click the name Untitled Event and type in a meaningful name.**

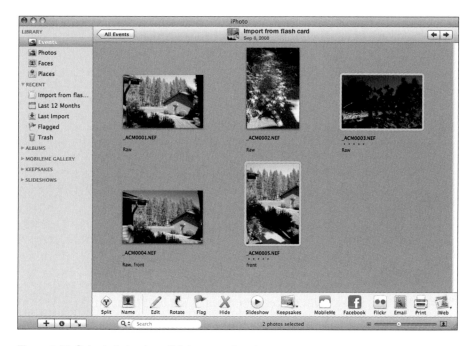

Figure 4-12: Select photos to split into a new Event.

Figure 4-13: The new Event after applying a split.

Hiding Photos in Events

Maybe you have photos within an Event that you want to keep in it but don't want to appear when the Event is opened. Hiding a photo can be useful if you don't want to use it or see it, but you're not sure you want to delete it. "Magic!" you say? Not really. Just an easy way to change the look of an Event without losing any photos. As you might have guessed, you can hide a photo. Refer to Figure 4-13 as I show you how to hide one of the photos in the *untitled event*. Here's how easy it is to do. These steps can be applied to any photo you want to hide.

1. **To hide a photo, select it and either click the Hide button on the toolbar or choose Photos⇨Hide Photo(s).**

 The second photo in CUSTOMIZED EVENT becomes hidden, as shown in Figure 4-14. Notice the wording to the right of the Event name in the figure — Show 1 Hidden Photo — letting you know that there is one photo in the Event that isn't displayed in the Event pane.

An Event with 1 hidden photo

Figure 4-14: An Event with a hidden photo.

2. **Click Show 1 Hidden Photo.**

 The photo reappears.

 Figure 4-15 shows the photo reappearing with an X in its upper-right corner, denoting that it's a hidden photo.

 Notice that the wording toggles to Hide 1 Hidden Photo. Click that, and the photo disappears again.

Figure 4-15: A hidden photo revealed.

3. **If you want to see all the hidden photos in the iPhoto Library, click Photos in the Source list and then choose View⇨Hidden Photos.**

 The hidden photos will appear with an X in the upper-right corner. They are now visible but are still marked as Hidden. To hide them again, choose View⇨Hidden Photos again to uncheck the selection.

4. **To unhide the photos, select one or more of the hidden photos and then click the Unhide button on the iPhoto toolbar, or choose Photos⇨Unhide Photo(s).**

 This makes them visible regardless of any other settings.

iPhoto always lets you know whether there are hidden photos, so there's no fear of losing track of them — and, you can always bring them back to view if circumstances change.

Flagging Photos

Here's another way of grouping some of your photos without really incurring any extra overhead. You, quite literally, put a flag on the photos. This flag is visible in the corner of the photo's thumbnail. It's like sorting through a stack of photos and setting some aside for further review. A special heading under Recent — Flagged — contains any flagged photos. So why bother to do this?

- ✔ **You can create a temporary grouping while you browse through one or more Events.**
- ✔ **You can create a new Event from the flagged photos.**
- ✔ **You can move the flagged photos to another Event.**

To flag photos

1. **Select the Event you want and then open it. Or you can go to Photos in the Source list and see all the photos at once.**

2. **Select the photo or photos you want to flag.**

3. **Click the Flag button on the iPhoto toolbar or choose Photos⇨Flag Photo(s).**

 The flag indicator appears in the thumbnail. Figure 4-16 shows the indicator.

The Flag indicator

Figure 4-16: Flag indicator on a thumbnail.

4. To look at all your flagged photos, select Flagged in the Source list.

Figure 4-17 shows the flagged photos. Notice that the number of flagged photos is indicated next to the word Flagged.

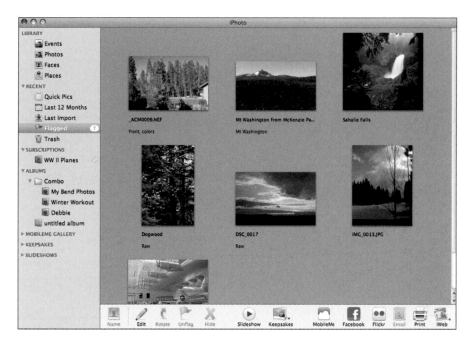

Figure 4-17: Flagged photos are grouped together.

To create a new Event with the flagged photos

1. Choose Events⇨Create Event from Flagged Photos.

Because a photo can only be in one Event at a time, a warning dialog alerts you that the photos will be moved to the new Event.

2. If you're satisfied, click the Create button.

An *untitled event* is created containing these photos. If you change your mind, you always can Undo.

3. You can now name the Event as you like.

You can also move flagged photos to an existing Event. After you flag the photos

1. Select the Event you want to add them to.

2. Choose Events⇨Add Flagged Photos to Selected Event.

The photos are moved to the selected Event. If you change your mind, you can always Undo.

If you wish to Unflag any photos, simply select them and then click the Unflag button on the iPhoto toolbar or choose Photos⇨Unflag Photo(s).

Grouping Photos Using Faces

A wonderful feature of iPhoto, straight out of the high-tech world, is the facial-recognition technology called *Faces.* iPhoto can detect all the faces in the photos that you imported into your Library. When you start iPhoto '09 for the first time, it will scan your iPhoto Library to find photos with faces in them. Depending on the number of photos you have, this could take some time. It will then ask you to name the persons it finds and to suggest additional photos that have that person in them. You can also add the full names and e-mail addresses of the persons recognized by iPhoto. This provides a clever way to see all the photos of a particular person across any span of time and, perhaps, many Events.

After a face is recognized and named, it can be viewed on the Faces corkboard by selecting Faces from the Source list. Even better, you can delete a face from the Faces corkboard without deleting the photo from the iPhoto Library.

This section on the operation of Faces is correct as of the time of this writing. You can check the Apple iPhoto Discussion Forum from iPhoto for any software updates by choosing Help⇨Service and Support, and check this book's Web site at www.dummies.com/go/iphotofd for any minor updates or changes to the Faces operation described in the book.

Here's how Faces works.

1. **Click Faces in the Source list to open the Faces pane and corkboard for the first time, as shown in Figure 4-18.**

 If there are no photos in the Faces pane, you either don't have photos with faces, or they weren't recognized by iPhoto. As I mentioned earlier, whenever photos are imported into iPhoto, they're scanned automatically to see whether there are faces to be recognized. If iPhoto didn't recognize any faces but faces do exist in the photo, no problem! — you can manually address them.

2. **Click Photos in the Source list and select a photo that shows someone you want to name.**

3. **Click the Name button on the iPhoto toolbar, as shown in Figure 4-19.**

Select Faces to get started

Figure 4-18: Opening the Faces pane for the first time.

The Name button

Figure 4-19: The Name button in the toolbar.

4. A pane similar to the one in Figure 4-20 opens, displaying the photo.

iPhoto will mark, with a pointer, each area it recognizes as a face. Each of these areas are marked as Unknown Face. As you move the mouse pointer over a face, a rectangle appears.

5. Click the words Unknown Face, type in the person's name (Debbie, as shown in Figure 4-21), and then press Return.

If there is more than one face and you know all the names, add them the same way. However, you don't have to name every face; you can remove the face-positioning rectangle from any face you want to ignore. Simply click the face and then click the X in the rectangle.

6. Click Faces in the Source list to see how the corkboard has changed; see Figure 4-22.

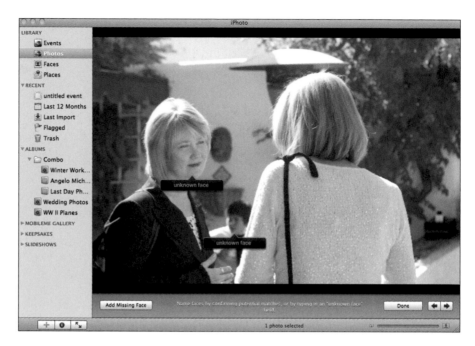

Figure 4-20: iPhoto denoting faces in the photo.

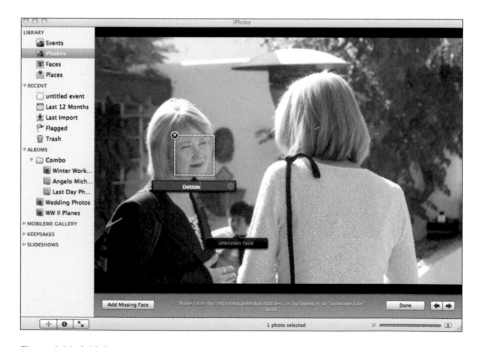

Figure 4-21: Add the person's name.

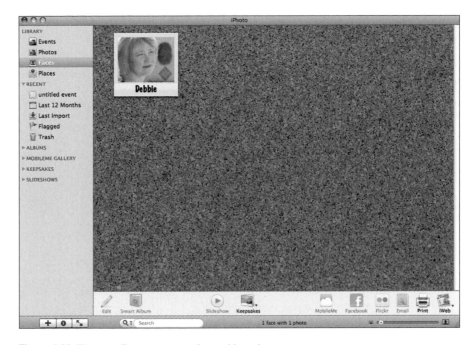

Figure 4-22: The new Faces entry on the corkboard.

7. **(Optional) To add more information about this person, put your mouse on the photo you named and then click the small information icon that appears in the right-hand corner.**

 The photo will flip over and allow you to enter a full name and e-mail address for the person, as shown in Figure 4-23. Then click Done.

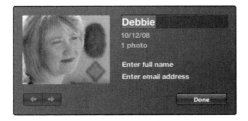

Figure 4-23: Enter information for the new Face.

8. **To search for other photos of this person, double-click the photo.**

If iPhoto finds any other photos iPhoto thinks this person is in, those photos appear below the line in this same pane, as shown in Figure 4-24.

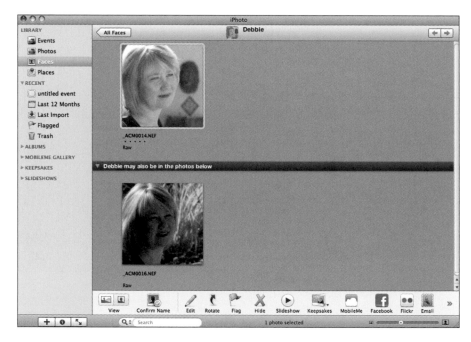

Figure 4-24: iPhoto showing a potential match.

9. **To confirm that this is the same person, click the Confirm Name button on the iPhoto toolbar.**

 The pane changes to the one shown in Figure 4-25.

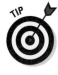

10. **To confirm the bottom photo, click the text Click to Confirm (directly beneath the photo), and then click the Done button in the bottom-right corner of the pane.**

 To confirm a photo, you can also just drag the photo above the dividing line.

11. **(Optional) If this isn't the correct person, click the bottom photo twice.**

 Click to Confirm will change to Not Debbie, and the photo will not be added.

Figure 4-25: Confirming a name.

12. **Click Done when you're finished.**

 Figure 4-26 shows the result of confirming the name in this example. Two photos are now identified as Debbie.

13. **Click the All Faces button to stack the photos on the corkboard. To open them again, just double-click the stack — or *tile*, as it's sometimes called.**

 In the lower-left corner of the iPhoto toolbar is a button named View, with two halves. Clicking the right half shows the photos in Faces zoomed in as shown in Figure 4-26. To see the person as they appear in the original photo, click the left half of the button, which is the Photo View portion. Figure 4-27 shows the difference.

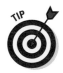

If you want to delete a stack from the Faces corkboard, drag the stack to the iPhoto Trash, or select the stack and choose Photos⇨Move to Trash.

You find out more about using Faces to search for photos in Chapter 6.

The All Faces button

Figure 4-26: The result of confirming the name.

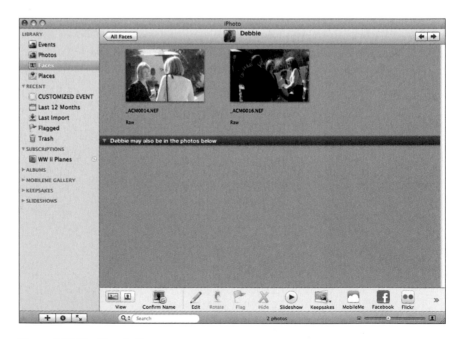

Figure 4-27: The View button.

Combining Photos into Albums

In This Chapter

▶ Making an Album

▶ Creating a Smart Album

▶ Making changes in Smart Albums

▶ Creating Smart Albums from Places and Faces

▶ Arranging your albums

▶ Adjusting photo order in an Album

▶ Deleting photos from an Album

1'm sure many of us have turned pages in an old photo album (or at least have seen relatives doing so). You might wonder about the relevance for albums in the digital world in which we live. This chapter has the answer.

If you've read this book to this point, you already know about Events and how iPhoto organizes your imports into Event-specific groupings. The order inside an Event, though, is governed by the order of import into iPhoto. You can't really change that order after the fact. One of the benefits of an old, physical photo album was you could move your photos around until you had them in the order you wanted, and then paste them in place. In Events, you can't really do that — but with iPhoto's Albums feature, you can.

In addition to letting you manually change the order of photos, iPhoto's Albums let you put multiple, often related, Events or photos into one place. So, for instance, you might have several Events representing your child's birthdays over several years. With Albums, you can put them into one Album — say, called Johnny's Birthdays or Megan's Birthdays — and keep them all in one place, making them easy to find and view.

Take a look at how this all happens.

Creating an Album

I want you to understand one very important point about Albums: No matter how many different Albums you put a photo into, *the photo file is never stored in the iPhoto Library more than once.* That means you're not wasting space when you place a photo in more than one Album. This also means that if you delete a photo from an Album, the photo is still in the iPhoto Library — and still in its original Event. Great stuff, huh?

The reverse is not true. If you delete photos or Events from your iPhoto Library, they will automatically be deleted from any Album(s) they are in.

Albums always appear in the same place in iPhoto, in the section called Albums, in the Source list. When you create an Album, you can either select the individual photos or Events to put in it, or create the Album first and then add photos and Events.

If you start by choosing an Event, the Album you create will have the name of the Event as its name with the word Album appended: for example, April's Birthday Album. Of course, you can change the name.

To create a standard Album without first selecting any photos or Events to place in it, follow these steps:

1. **Click the Add (the + symbol) button (on the small toolbar in the bottom-left corner of the main iPhoto window).**

 This brings up a dialog (shown in Figure 5-1). You can also choose File⇨New Album to obtain the same dialog.

Figure 5-1: The Create New Album dialog.

2. **Click the Album icon at the top of the dialog, type in the name you want to give the album (as shown in Figure 5-1), and then click the Create button.**

 The check box labeled Use Selected Items in New Album will be discussed shortly. For now, leave it unchecked.

The new Album is created and now appears under Albums in the Source list.

3. **To add content to the new Album, select and drag it into the new Album in the Source list.**

 Figure 5-2 shows an Event selected and in the process of being dropped in the Album.

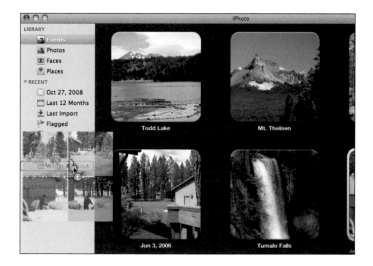

Figure 5-2: Placing content into an Album.

In addition to selecting an entire Event and dragging it onto the Album, you can add content to an Album by

- *Opening an Event, selecting just the photos, and dragging them onto the Album.*

- *Clicking Photos in the Source List, choosing what photos you want from the entire Library, and dragging your selections onto the Album.*

Figure 5-3 shows the resulting content of the Winter Workout album after dragging the one Event.

If you already selected the items you want to add into a new Album, follow these steps:

1. **With the items you want to add to a new Album still selected, choose File⇨New Album from Selection. Or, click the Add button.**

 The dialog shown in Figure 5-1 appears.

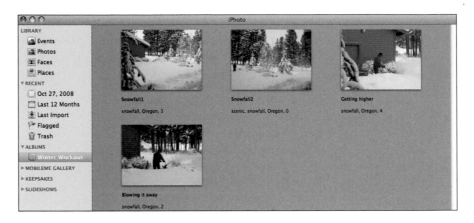

Figure 5-3: The newly added photos in the new Album.

2. **Type in the name you want to give the new Album, make sure that the Use Selected Items in New Album check box is selected, and then click Create.**

 The items you selected are added to the new Album, and the new Album's name appears in the Source list, under Albums.

Here are some other ways to get content into an Album:

- ✔ **Dragging from another Album:** Dragging one or more photos from one Album into another will leave both Albums with the photos.

- ✔ **Dragging from a CD, DVD, or hard disk:** Adding photos from a CD, DVD, or hard disk (drive) to an Album will also cause the photos to be automatically imported into the iPhoto Library, thus causing an Event (or Events) to be created as well. This happens because no photo can be in iPhoto unless it's in the Library and is an Event.

- ✔ **Dragging a folder of photos from the Finder into the Source list in iPhoto:** This method actually creates a new Album instead of placing the content into an existing Album. The Album created will have the same name as the folder from the Finder. (This can be changed, of course.) Although all the photos will be in one Album, one or more Events will be created, depending on the Events Preferences settings for Autosplit into Events (see Chapter 2 for more details). If set for One Event Per Day, for instance, and the photos cover a span of two days, two Events will be created.

To delete an Album, select it in the Source list and do one of the following:

1. **Drag the Album icon to the iPhoto Trash.**

2. **Right-click with your mouse (or Control-click) the Album icon and then choose Delete Album.**

3. **Choose Photos⇨Delete Album from the iPhoto menu.**

 Performing any one of these actions will bring up the warning dialog shown in Figure 5-4.

Figure 5-4: This dialog appears when you delete an Album.

Deleting an Album or any photos in an Album does not delete anything from the iPhoto Library, as shown in Figure 5-4.

Making Smart Albums

The problem with Albums is that you must decide on the content it contains and manually make any modifications to the content either by adding or removing photos. Wouldn't it be nice if you could decide, just once, what kind of photos you want to be in the album and forever after iPhoto would take care of things automatically? Well, your wish has been answered, and that answer is Smart Albums.

Smart Albums allow you to fill them with specific photos from your iPhoto Library, both now and in the future, based on such parameters as specific keywords, ratings, the specific type of camera, shutter speed, date captured, Faces, Places, and many more.

As you can imagine, the possibilities are nearly endless. And the best part is that this is all done automatically: Photos that qualify are added; those that don't qualify aren't. No dragging or selecting of individual photos is necessary.

If you haven't already, create useful keywords for your photos so the Smart Album has something to work with. Adding and editing keywords is discussed in Chapter 3.

To create a Smart Album, follow these steps:

1. **Click the Add (the + symbol) button to open the dialog shown in Figure 5-5. Then click the Smart Album icon at the top of the dialog.**

You can also choose File⇨New Smart Album; or right-click (Control-click) in the empty space in the Source list and then choose New Smart Album to open the same dialog.

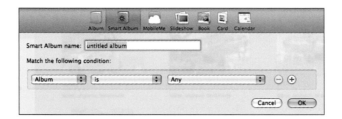

Figure 5-5: The Create New Smart Album dialog.

2. **Type a name for the Smart Album.**

 I'm calling mine Winter Workout.

3. **Begin to set up your photo-candidate expressions — *filters* — for the Smart Album by making a selection from the first pop-up menu.**

 Each expression contains an entry from each of the pop-up menus and tells iPhoto what photos qualify to be in this particular Smart Album, now and in the future. Be aware that even if you select a number of photos for a Smart Album but some of them don't fulfill the expression, they won't appear in the Smart Album.

 I'm going to choose Keyword as the first part for this example. Some other choices are filename, title, date, place, description, camera model, and quite a few more.

4. **Select a verb from the second pop-up menu.**

 These choices will vary, depending on your choice from the first menu.

 I'm going to select Is, for this example.

 What the third pop-up menu contains is dependent upon the selections you make in the first two pop-up menus. Because I chose Keywords and Is, the third pop-up menu contains a listing of all the keywords that have been used in my iPhoto Library, as shown in Figure 5-6. Your list will be different.

5. **Make a selection from the third pop-up menu.**

 I'm selecting Snowfall. Suppose you want to have several expressions that must be satisfied before a photo can appear in the Smart Album? No problem.

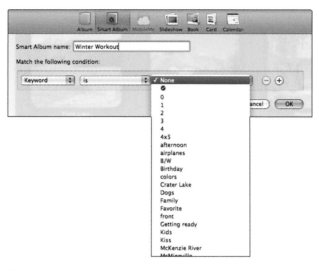

Figure 5-6: Choose from a list of keywords.

6. **Click the Add (the + symbol) button to the right of the expression you just completed to add another expression to the Smart Album.**

 Again, choose from the three pop-up menus to complete the expression. For this example, I made a second expression by choosing Keyword, Is, and Oregon. Figure 5-7 shows the two expressions for the Smart Album.

 When you add a second expression, a new pop-menu appears above the expressions. This menu gives you the choice of whether All or Any of the expressions have to be true for the photo to qualify for inclusion. In Figure 5-7, it's set for All, which means that both expressions must be true.

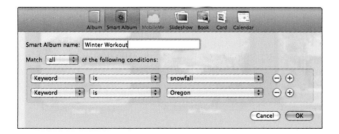

Figure 5-7: The Create Smart Album dialog with expressions added.

7. **Click OK when you're finished adding expressions and ready to create the Smart Album.**

The Smart Album with the name you assigned will be created in the Source list and populated, automatically, with every photo in the iPhoto Library that satisfies the expressions you created, as shown in Figure 5-8.

The icon for a Smart Album has a gear on it to make it easier to distinguish.

The new Smart Album

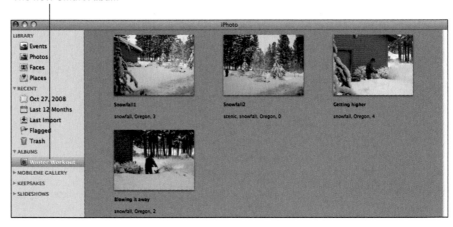

Figure 5-8: The new Smart Album and its contents.

This is very cool stuff, and it just keeps getting better. The Smart Album gets updated automatically and instantly whenever a photo that matches your Smart Album settings (in the example, it would be the keywords of Snowfall and Oregon) is added or removed from your iPhoto Library. If you find another photo that belongs in a Smart Album, make the necessary edits to meet the Smart Album's conditions, and it will be added to the Smart Album (in the example, it would require adding the keywords Snowfall and Oregon to the photo in the Library).

Because of this capability, I recommend adding keywords, Places, Faces, or any other descriptor to all your photos when you import them (see Chapter 3 for more details). Then later, when you want to get them into separate Albums, just make your Smart Album settings, and it's done.

Editing Smart Albums

There are several ways to edit the content of Smart Albums. When you edit a photo in your iPhoto Library, as soon as you exit Edit mode, iPhoto replaces the previous version of the photo in your Smart Album(s) with the new, edited version of the photo. You never have to worry about getting things out

of sync. You can also change a Smart Album's expressions to edit the content it contains.

To edit the expressions of a Smart Album, follow these steps:

1. **From the Source list, select the Smart Album you want to change and then choose File⇨Edit Smart Album.**

 You can also right-click (Control-click) the Smart Album in the Source list and then choose Edit Smart Album.

2. **The dialog (refer to Figure 5-7) opens, from which you can change, add, or remove expressions to change the content of the album.**

 • *To change an expression,* use the pop-up menus and choose a different item from the list.

 • *To add an expression,* click the Add (the + symbol) button next to an expression and begin entering the information for a new expression.

 • *To remove an expression,* click the Remove (the – symbol) button next to the expression. It will be removed.

3. **Click OK when you're finished — and watch the fun begin.**

 Depending on how you set your expressions in Step 2, the number of photos in the Smart Album will increase, decrease, or go to zero.

Using Places and Faces to Create Smart Albums

Among the newer capabilities in iPhoto are technologies called *Places* and *Faces.* (I discuss these in detail in Chapters 3 and 4.) With these capabilities, you can create Smart Albums that automatically contain only photos of particular people or locations. How great is that?

In Chapter 3, I discuss that in order to see and use the Maps capability in Places, you must be connected to the Internet. You might want to read that chapter (if you haven't already) or at least keep that fact in mind.

To use Places (when you're connected to the Internet) to create a Smart Album, follow these steps:

1. **Select Places from the Source list.**

2. **Make sure the View button in the bottom-left corner of the Places pane has the left side of the button (World View) selected.**

 You see a map showing pins at locations for your photos that have GPS information, as shown in Figure 5-9.

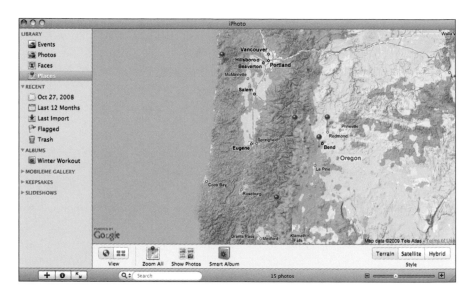

Figure 5-9: The Places pane showing locations on the map.

Notice in Figure 5-9 the Zoom All button on the toolbar. This is used when you want to see all the pins for all the locations you have set. When you click this button, the map automatically zooms out and shows all your pin locations.

Click the Show Photos button to change the pane from displaying the map to display all the photos for the locations that were currently visible on the map. Very handy. To go back to Map view, click the large arrow icon named Map in the upper-left corner of the pane.

3. **With the map displayed in the pane, select a specific location by clicking the appropriate red pin.**

 The pin turns blue, and the location attached to it will show up, as shown in Figure 5-10.

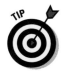

If you want to use a region or country instead of a specific Place pin to create a new Smart Album, use the zoom slider in the bottom-right corner to zoom in and out, and then drag the map around until only those locations you're interested in are showing on the map (as shown in Figure 5-11).

4. **Click the Smart Album button at the bottom of the pane.**

 A new Smart Album appears in the Source list, and the pane displays the photos it contains.

5. **Type a different name for the Smart Album.**

 In the example in Figure 5-12, I named the Smart Album with the name of the location where the photos were taken.

Selecting a location on the map

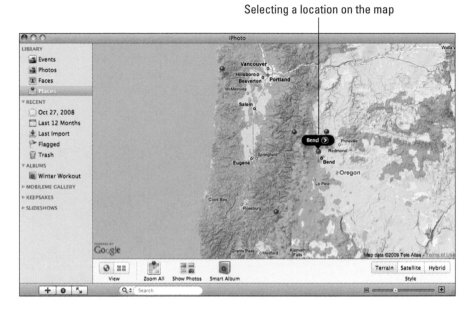

Figure 5-10: Selecting a Place pin.

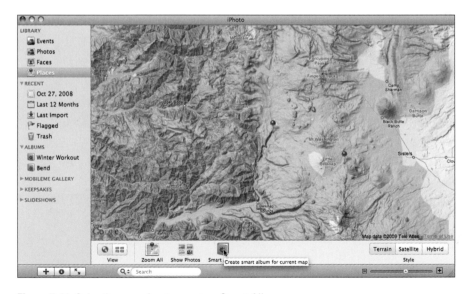

Figure 5-11: Selecting a region to create a Smart Album.

The new Smart Album

Figure 5-12: The new Smart Album based on a Place.

If you're not connected to the Internet, don't worry. Even though the map won't display in the Places pane, you can still create Smart Albums using the Places feature by following these steps:

1. **Click the Add (the + symbol) button.**

2. **In the dialog that opens, click the Smart Album icon at the top of the dialog, type a name for the Smart Album, and set the expression for the Smart Album (see Figure 5-13) as follows:**

 a. *Choose Place from the first pop-up menu.*

 b. *Choose Contains from the second pop-up menu.*

 c. *Type the name of the place on which you want to base the Smart Album.*

3. **Click OK.**

 A new Smart Album appears in the Source list, as shown in Figure 5-14.

What a great way to organize photos from different locations — and it's easy, too! Like all Smart Albums, as photos get added to your Library with these locations, they're automatically added to the appropriate Smart Album.

Enter the Place name here

Figure 5-13: Setting a Place expression in the Smart Album dialog.

The new Smart Album

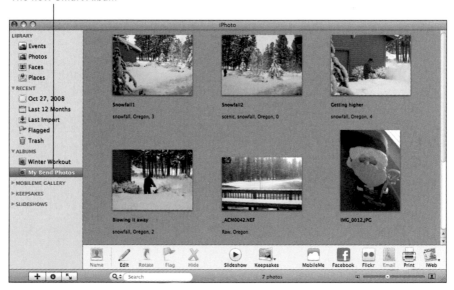

Figure 5-14: The new Smart Album in the Source list.

So, how about Smart Albums for Faces? Yes, iPhoto has them, too. Again, there are three ways to use Faces to create Smart Ablums. Here's the first way:

1. **Select Faces in the Source list to open the Faces pane, as shown in Figure 5-15.**

2. **The easiest way to create a Smart Album is to drag the Faces tile (in the example, Debbie) to an empty space in the Source list (in this case, at the bottom of the Source list).**

Magically, a Smart Album named Debbie appears under Albums, as shown in Figure 5-16.

Couldn't be easier.

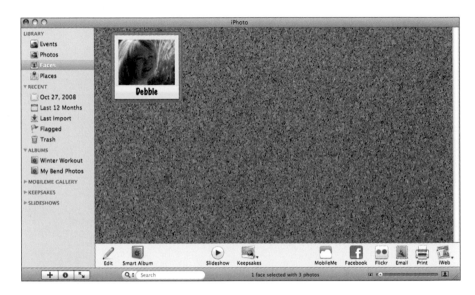

Figure 5-15: The Faces pane.

The new Smart Album

Figure 5-16: The new Smart Album based on a Face.

The second way to use Faces to create a Smart Album is to select the Faces tile of the person from the Faces pane and then click the Smart Album button at the bottom on the toolbar. The results are identical — a new Smart Album based on the selected Face is created.

The last way to do this is the same way I show you how to create regular Smart Albums, earlier in this chapter:

1. **Click the Add (the + symbol) button.**

2. **Click Smart Album icon on the top of the dialog and then type a name.**

3. **Choose Name from the first pop-up menu, Contains from the second menu, and then type the name of the person in Faces that you want to create the Smart Album for.**

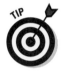

 If you want to collect photos that have more than one person, make sure you set the Match pop-up menu to

 • *Any:* To collect photos that show any of the named people

 • *All:* To show only photos where all named people are present

4. **To add more people, click the plus sign next to your first condition and repeat Step 3.**

5. **Click OK.**

 The Smart Album appears.

Using Faces and Places is not only fun, but makes keeping track of your favorite people a lot easier.

Organizing Your Albums

As your collection of photographs grows and you create more Albums and Smart Albums, your Source list might get very crowded.

If that's the case for you, consider grouping several albums together that have something in common. For this purpose, you can create folders in the Source list. To do this, follow these steps:

1. **Choose File⇨New Folder, or right-click (Control-click) in an empty space in the Source list, and then choose New Folder.**

 Folders are always created under the heading Albums in the Source list, as shown in Figure 5-17.

Creating a new folder

Figure 5-17: A new, untitled folder.

2. **Name the folder as you wish and then press Return.**

 For this example, I'm naming it Combo.

3. **Now just drag an Album(s), regular or Smart, into the folder.**

 Folders can also be embedded within other folders. To do this, repeat Steps 1 and 2 and then drag the second folder you created into the first folder you created.

4. **The Albums appear indented under the folder, as shown in Figure 5-18.**

 Clicking the arrow beside the folder closes it and also saves viewing space in the Source list.

Figure 5-18: Three Albums in one folder.

Changing the Photo Order in Albums

The ability to change the order of photos in Albums depends upon the type of Album you're dealing with. You can change the order in standard Albums in three ways:

- **Use the View menu in iPhoto and sort the photos by one of the following criteria:**
 - *Date*
 - *Title*
 - *Rating*
 - *Keywords*

- ✔ **After you select the criteria, you can sort the photos in ascending or descending order.**

- ✔ **You can also very quickly try different photo orderings by simply dragging photos within the Album and placing them where you want them to appear.**

The order of photos in Smart Albums can be changed using the first two methods for standard Albums — by Date, Title, Rating, and Keywords; and by ascending or descending order.

However, in Smart Albums, you can't manually drag the photos into a different sort order. (No manual operations of that type are allowed in Smart Albums.) About the only thing you can do is to perhaps add a numeric keyword to each photo (for this to work, the numeric keyword must be the first Keyword for the photo), then view the photos based on Keyword and sort them in Ascending order to force the photos to be sorted in a numerical order you have contrived.

Removing Photos from One or More Albums

There are significant differences in how deleting photos works in standard Albums and Smart Albums.

To delete a photo or photos from a standard Album

1. **Select the Album from the Source list.**

2. **Click appropriately to select the photos to be deleted.**

3. **Press the Delete key on the keyboard to remove the photos from (only) that Album, or drag the photo(s) to the Trash in the Source list.**

 The photo(s) will be removed from the Album but will not appear in the Trash in the Source list — *you are removing them only from the Album and not from the Library.* As usual, you can choose Edit⇨Undo to restore the photo(s) to the album.

Because standard Albums are populated manually by you, removing the instance of a photo from one Album does not remove it from any other standard Album or from the iPhoto Library.

Deleting a photo or photos from a Smart Album requires more effort and more care. Remember that Smart Albums content is created automatically based on conditions that you set. You can't just drag a photo to the Trash because the very next time that the conditions are checked in the iPhoto Library, that photo would qualify and would be placed back in the Smart Album you had just deleted it from. There are three ways to remove a photo from a Smart Album:

↙ **Change the criteria in a photo that's causing a match, such as the key-word, rating, description, or whatever is causing the photo to be in the Smart Album.**

↙ **Change some part of the expressions for the Smart Album to exclude the photo or photos you want to remove from it.**

You could include a expression that uses Is Not to pinpoint the photo or photos to be excluded. An example of an edited set of conditions is shown in Figure 5-19. In the example, if any photo has the title Snowfall2, it will be excluded from the Smart Album.

↙ **Do what I call a "special delete" that removes the photo from the Library.**

This special delete will remove the photo from the iPhoto Library and thus from every Album in which it appears. After the Trash is emptied, there is no Undo.

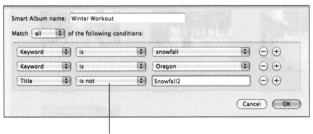

Using the Is Not condition to remove a photo from a Smart Album

Figure 5-19: Excluding a photo from the Smart Album.

To do the special delete, follow these steps:

1. **Click on the Smart Album in the Source List to see the contents. Select the photo or photos to be deleted.**

2. **Press and hold ⌘+Opt+Delete.**

 The photo or photos will appear in the Trash in the Source list.

3. **If you change your mind, choose Edit⇨Undo Move to Trash, and the photo will be restored to the Smart Album. Otherwise, empty the Trash to complete the operation.**

6

Searching for Your Photos

In This Chapter

▶ Searching based on photo properties

▶ Using complex keyword searches to find photos

▶ Making sure you have something to search for

*D*epending on the size of your iPhoto Library (or libraries; I talk about multiple iPhoto libraries in Chapter 3), you might have a difficult time finding that one photo you're looking for. You can organize your photos in lots of ways so that the iPhoto main window doesn't look so cluttered. (See Chapters 4 and 5.) When you're searching, somewhere within all that organization is the one photo you're looking for. The question is how to find it easily and efficiently.

The good news is that this chapter shows you a number of ways to find what you're looking for — including one I tell you about that isn't really documented.

The chapter concludes with helping you ensure that you'll always have something to search for. I know you've probably heard that backing up is vital — I'm restating the obvious. But believe me, the exasperation you might feel at having this repeated to you is nothing compared with the feeling of despair and helplessness you'll experience when you search for a photo you cherish only to find out that it has disappeared and is irretrievable.

In this chapter, I first show you some search methods. Then, I deal with backup techniques to keep your precious photos safe.

Using Photo Properties to Narrow Your Search

Whether your iPhoto Library is very large, it's always a good idea to have the capability of searching quickly for the photo or photos you need to find. iPhoto's capabilities allow you to search using text, keywords, dates, and ratings, in addition to some more complex search methods. (See the section "Constructing Complex Keyword Searches" later in this chapter.)

For any search, if you have knowledge that the photo you're looking for is in a particular Event (or any other type of grouping, such as Faces, Places, Albums, or folders), you can narrow the search by concentrating on just that Event.

Before performing your search, it's also helpful to choose View from the iPhoto menu and select the options to have iPhoto display titles, keywords, and rating for each photo. This allows you to get more information from the search, and it can help you more easily decide when you have what you want.

Searching based on text

You use the Search field located beneath the iPhoto toolbar at the bottom of the iPhoto main window (see Figure 6-1) to search the Library for photos. To search for text assigned to a photo, you must select All from the Search field pop-up menu. iPhoto then searches the title, description, keywords, and rating of the photos in the Library for the text you key in. As you're typing text in the Search field, iPhoto works with whatever you've typed and finds as many photos that match.

To find a photo using text, follow these steps:

1. **Select Photos from the Source list to set the scope of the search.**

 You can narrow the focus of the search by selecting another Source in the list, such as Events or Last 12 Months, if you're sure that what you're looking for is contained there.

2. **Choose the All option from the Search field pop-up menu. Then, in the Search field, type the word or phrase that you're searching for.**

 For this example, I'm searching for the word *winter*.

 iPhoto begins to display photos that match the term you're entering after just a few letters.

 As shown in Figure 6-2, I've typed only **win**, and iPhoto is already starting to find and retrieve photos. At the bottom of the window, you see that eight photos qualify at this point. They have the letters *win* in their titles, descriptions, dates, keywords, and/or ratings.

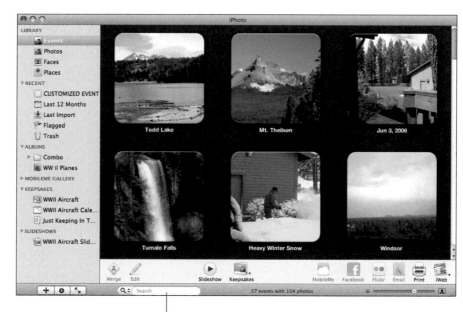

iPhoto's Search field

Figure 6-1: The iPhoto Search field.

Figure 6-2: Results begin to appear before the search term is completely entered.

3. **To guarantee that you get only results that perfectly match your search, finishing typing the entire search term.**

As you can see in Figure 6-3, I added another letter to the Search field (it now reads *wint*), and the search continues to narrow the results.

Figure 6-3: Final candidates for text search.

4. **Continue typing the search term until the photo(s) that you're looking for is displayed in the results.**

You might find the photo(s) that you're looking for after typing just a few letters, but typing all the letters in your search term provides exact results.

5. **To cancel the search and begin again, simply click the Reset button (the X in the far-right side of the Search field).**

What about searching for photos based on other types of photo properties? You continue to use the Search field and set its pop-up menu to those properties you want to search. Read on.

Searching based on dates

Say, for instance, you want to search for a photo based on a certain date. To do so, follow these steps.

1. **In the Source list, choose the Source you want to search within, such as Events or Photos.**

2. **Set the pop-up menu in the Search field to Date.**

 You'll see all the months for a particular year listed. If you don't, just click the small button in the top-left corner of the calendar, and the year appears. The months that are highlighted actually have photos in your Library with those dates, as shown in Figure 6-4.

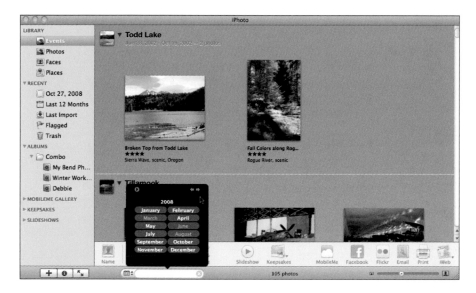

Figure 6-4: Using the year calendar for a date search.

3. **Choose a month to search by clicking it.**

 Use the right arrow and the left arrow at the top-right side of the calendar to cycle through the months of the year. As you might have guessed, high-lighted dates mean that you have photos for those dates. See Figure 6-5.

4. **Click a day in the month, and the photos that match appear, as shown in Figure 6-6.**

5. **To select more than one consecutive date, press and hold the Shift key and then select the beginning and ending date.**

 All dates between the beginning and ending date are automatically be selected, and the search results are displayed.

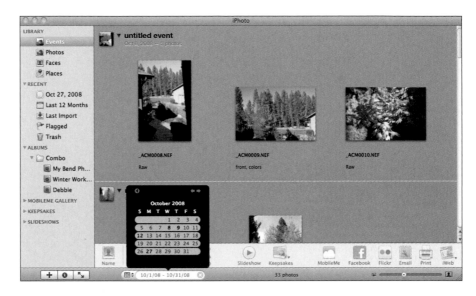

Figure 6-5: Using the month calendar for a date search.

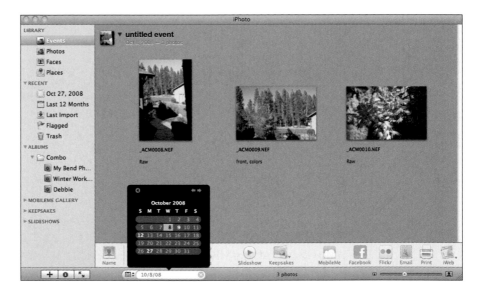

Figure 6-6: Using a day for a date search.

6. **To select nonconsecutive dates, press and hold the ⌘ key and then select dates.**

 Only the dates selected are highlighted, and the displayed results encompass only those dates.

7. **To cancel the search and begin again, simply click the Reset button (the X in the far-right of the Search field).**

You have to admit that even just searching by text or date can make retrieving your photos of interest a lot easier. But there's more. Read on for details on keyword searching.

Searching based on keywords

Keywords are labels that you can add to your photos to provide additional information about the subject of the photo — and, more importantly, make searches for particular photos more efficient.

Keywords are usually added to photos when you import them into iPhoto, but you can also add or edit them at any time. (See Chapter 3 for instructions.) Why edit them? Well, during import, you might add many keywords at one time, and it could be that you misspelled a few. (You won't get many search hits that way.) Or you might later discover that a keyword isn't specific enough, making the search less effective.

Okay, now I tell you how to use keywords to retrieve the photo or photos you want to find. To search based on keywords, follow these steps:

1. **Select either Events or Photos from the Source list.**

2. **Set the pop-up menu in the Search field to select Keyword.**

 A list of all the keywords in your iPhoto Library appears.

3. **Hover your mouse over each keyword, and the indicator tells you how many photos have that keyword, as shown in Figure 6-7.**

 Notice that because no keyword is selected at this point, the iPhoto main window shows all the Events and their content.

4. **Select the keyword you wish to use for the search.**

 In this example, I clicked Crater Lake, and the photo with that keyword appeared, as shown in Figure 6-8.

5. **To cancel the search and begin again, simply click the Reset button (an X on the right side of the Search field).**

You can construct more complex keyword searches. See the "Constructing Complex Keyword Searches" section later in this chapter for more details.

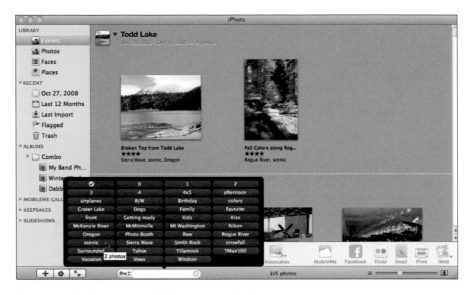

Figure 6-7: The Search list of all keywords in the Library.

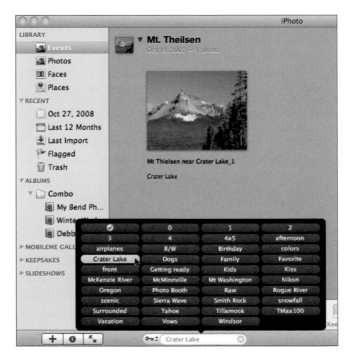

Figure 6-8: Result of a keyword search.

Searching based on ratings

iPhoto's Ratings scheme is based on 1–5 stars, and like most other proper-
ties for photos, you can set or change them at any time. The ratings are, of
course, completely subjective, but they can help at editing time to cull those
you think are worthy of further work. Setting the ratings is discussed in
Chapter 3.

iPhoto gives you two ways to search based on ratings:

 ✔ **Choose elect All from the Search field pop-up menu. In the Search
field, type the number of stars you're searching for.**

You enter a star in the Search field by pressing Shift+8 on the keyboard.

✔ **Choose elect Rating from the Search field pop-up menu and click the
number of stars you're searching for in the Search field.**

It's important to realize that these two ways, although they seem very simi-
lar, provide different results, as I'm about to show you.

Here's how to perform a search based on ratings using the first method I just
mentioned:

1. **Make sure the pop-up menu for the Search field is set to All.**

2. **Press Shift+8 to begin entering the number of stars you want to
search for.**

 iPhoto returns results for only those photos with *exactly* that rating.

 Figure 6-9 shows a sample result for a one-star search.

This means that if you want to find an exact match to the rating entered, you
should type it in. But what happens if you use the second method? iPhoto
shows you all photos with the range of stars that you select. For example,
you can choose to display all photos with at least three stars, which will
show you all those photos with three, four or five stars.

To perform a search based on rating using the second method, follow these
steps:

1. **Set the Search field pop-up menu to Rating.**

2. **Using the mouse, click the first of the five indicators (they look like
dots) in the Search field.**

 The indicator (dot) changes to a star. If you click the second indicator,
 the first two indicators change to stars, and so on.

 iPhoto's results show all photos with *at least* one star, as shown in the
 example in Figure 6-10.

Figure 6-9: Results from typing one star in the Search field.

Figure 6-10: Results of setting the Search field to Rating and indicating one star.

If you clicked the second indicator in Step 2, the results would show all photos with at least two stars. (Photos with only one star would not appear in the results.) That's quite a difference from the first method.

So, iPhoto gives you two methods for searching by Rating, one exclusive and one inclusive. Choose wisely when using these search methods.

Searching based on location

There's a convenient new tool in the Places feature that allows searching based on the locations that you or the camera have set in your photos. It's quick and simple to use, and very handy. (See Chapter 3 for more information about using the Places feature.)

To search based on location, follow these steps:

1. **Click Places in the Source list.**

2. **Click the right half of the View button on the toolbar to bring up the Location browser, as shown in Figure 6-11.**

 The Location browser lists all the locations that you or the camera have entered in your iPhoto Library.

Click this side of the View button to... ...open the Location browser

Figure 6-11: Using the View button to open the Location browser.

3. **Click the location that you're searching for, and the results are displayed, as shown in Figure 6-12.**

 When the Location browser first appears, it shows all photos from all locations. Each column breaks the locations down further so that specific places and their associated photos are easier to find. In the example in Figure 6-12, the first column lists United States. The second column breaks down United States into California and Oregon: The country in column one is divided into that country's states in column two. You can see that column three breaks the states into cities, and column four breaks the cities into places within those cities.

Figure 6-12: Selecting the location you want.

One more tool (the complex Keyword search) can make your photographic life simpler and more efficient.

Constructing Complex Keyword Searches

Earlier in this chapter, in the "Searching based on keywords" section, I mention a more complex keyword search. That section tells you how it's possible to use keywords to search for photos based on single and multiple keywords. But what if you need to be a little more exclusive than that? No problem. You

can use three special keys to construct more complex keyword searches. The keys are

- **Shift key:** Represents the logical operator OR
- **Option key:** Represents the logical operator NOT
- **Control key:** Represents the logical operator AND

This means that you can create a search that says something like, "Show me all the photos that have keywords *scenic* AND *Oregon* and NOT *snowfall*." In fact, I try that out in the steps that follow to show you what happens.

To perform a complex keyword search using the OR, NOT, and AND operators, follow these steps:

1. **Choose Keyword from the Search field's pop-up menu, and then select a keyword.**

 In this example, I selected *scenic* for the first keyword, and three photos match the search criteria so far, as shown in Figure 6-13.

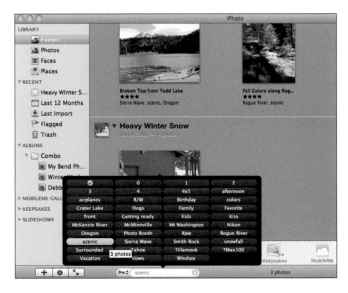

Figure 6-13: Select the first keyword.

2. **Press and hold the Control key to add the AND operator, and then click the second keyword.**

 I selected *Oregon* for the second keyword. Because I held the Control key when selecting the second keyword, the AND operator is applied,

and a search string of *Oregon and scenic* is created. The number of quali-fying photos is now two, as shown in Figure 6-14.

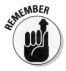

As you hover your mouse over a keyword, a white box appears telling you how many photos in the Library contain that keyword. When per-forming a complex keyword search, don't confuse this number with the number of photos in the Library that actually match the complex key-word search string. This number is listed as the Library totals. (Refer to the figure on the Cheat Sheet, located at the front of this book.)

Figure 6-14: Using the AND operator in a keyword search.

3. **Press and hold the Option key to add the NOT operator, and select the third keyword.**

 I selected *snowfall* for the third keyword. Because I held the Option key when selecting the third keyword, the NOT operator is applied, and the words *and not snowfall* are added to the end of the search string, thus cutting the number of qualifying photos to one, as shown in Figure 6-15.

Always check the text that appears in the Search field while you're clicking keywords to set up the search. Make sure that iPhoto is setting up the search how you want it.

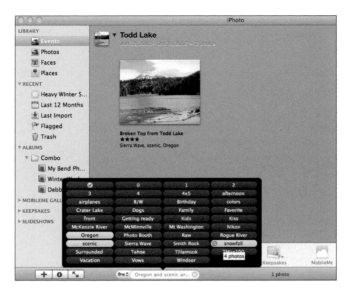

Figure 6-15: Adding the NOT operator to the search.

Ensuring You Have Something to Search For

Searching for particular photos in what may be a large iPhoto Library is a fairly common occurrence. iPhoto has great capabilities for finding exactly the photos you're looking for — if they exist. Ooh, maybe you haven't thought a lot about that situation, but I assure you that it's an all-too-common occurrence. You might have inadvertently deleted a photo, or maybe a software glitch corrupted part or all of the Library. If that's the case, it doesn't matter how extensive the search capabilities are in iPhoto; they just won't get you the results you want. So what can you do to prevent this? Back up your iPhoto Library regularly.

Saving changes

If you've been using iPhoto, you might have noticed that you haven't been using a Save command as you usually do with software packages. iPhoto does several things for you to make the environment more secure, including the following:

- **iPhoto automatically saves changes to anything you work on (a photo, Event, Album, and so on) as you work.** This frees you to concentrate on your artistic endeavors rather than the administration of your Library. This is why there's no Save command in iPhoto.

- **iPhoto lets you revert to the original version of the photo.** While you're working on a photo, you can choose Photos⇨Revert to Original and get

back to square one. This is a wonderful feature when you decide to try some new editing technique but discover that it's a disaster.

✔ **iPhoto makes Library backup and switching easy.** I discuss this in Chapter 3, but it's important enough to go over these details again. See the next section.

Backing up your iPhoto Library

I can't emphasize enough the need to make Library backup something you routinely do. And it's a great opportunity to use iCal (or any other calendar software you use) to remind you to perform the backup. How often you do a backup is really an individual choice. Do it often enough to give you a warm and comfy feeling, whether that's once weekly, once monthly, or once every three months. The more valuable your photos, the more often you should back them up. And the more photos you upload between backup intervals, the more you have to lose.

The iPhoto Library is located on your computer in the Pictures folder, and it's aptly named iPhoto Library.

You can use any of these three main ways to back up your Library:

✔ **Copy the iPhoto Library to another disk.**

✔ **Copy the iPhoto Library to a CD or DVD.**

✔ **Use Apple's Time Machine software (if you're running Mac OS X version 10.5 or later) or another backup solution (like the Backup program that comes with MobileMe).**

Copying onto another disk is fairly straightforward. Just follow these steps:

1. **Go to your Pictures folder on your computer and select the iPhoto Library file.**

2. **Choose Edit⇨Copy iPhoto Library, as shown in Figure 6-16.**

Figure 6-16: Copying the Library from the Edit menu.

3. **In the Finder, select the disk to which you want to copy, and then choose Edit⇨Paste Item.**

 This stores a copy of your iPhoto Library on the selected disk. Remember where this is. (You might want to put the copy into a new folder you create, called My iPhoto Backup or something similar.)

To copy your iPhoto Library onto a CD or DVD (depending on how large your Library is), do the following:

1. **Go to your Pictures folder on your computer and select the iPhoto Library file.**

2. **In the Finder, choose File⇨Burn iPhoto Library to Disc, as shown in Figure 6-17.**

Figure 6-17: Starting the burn process.

3. **When the Burn Disc dialog appears, insert an appropriate, blank disc.**

4. **When the next dialog appears (see Figure 6-18), type a descriptive name for the CD or DVD in the Disc Name field, select an appropriate burn speed, and then click Burn.**

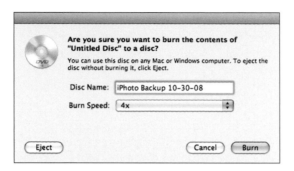

Figure 6-18: Naming the backup CD or DVD.

Last, but certainly not least, you can do backups using Apple's Time Machine software, if you're running Mac OS X version 10.5 or later. You might already use it — in which case, there's nothing to do. Saving iPhoto and the Library is done at whatever interval you have set for Time Machine. Time Machine uses a separate hard disk to back up your entire hard disk — or some portion of it that you specify. It keeps

- **Hourly backups for the past 24 hours**
- **Daily backups for the past month**
- **Weekly backups until your backup disk is full**

The operation of Time Machine is described under Mac Help on your Macintosh computer and on the Apple Web site. (Description of all Time Machine topics and uses are beyond the scope of this book — check one of the two mentioned locations. You can also check out *Mac OS X Leopard All-in-One Desk Reference For Dummies,* by Mark L. Chambers, Wiley.)

Accessing the backup information on Time Machine is easy. Follow these steps:

1. **With iPhoto open, choose File➪Browse Backups.**

2. **When Time Machine opens, you can select dates in the past where a lost or corrupted photo exists and retrieve that information.**

Part III
Making Your Photos Look Even Better

The 5th Wave By Rich Tennant

"Well, well! Guess who just lost 9 pixels?"

*1*n this part, I show you how to get the most bang out of the photos you've taken and give you some tips for making those you take in the future the best that they can be. How do I do that?

Chapter 7 shows you how the powerful iPhoto Editor works and how to get the most out of it and your photos. And I give you the fixes for the most common problems affecting photos in Chapter 8. Sometimes that's enough, but if not, Chapters 9 and 10 show you how to use iPhoto's advanced tools to work magic — including changing color and light levels, correcting exposure (after you take the photo, that is), modifying color saturation levels, sharpening, and a host of other professional adjustments — to raise your photographic experience to the highest level.

Then, just for fun, you see how selected effects can make your photos more interesting and rewarding.

Exploring the iPhoto Editor

*T*he iPhoto Editor is a combination of one-click, quick-fix tools and advanced editing capabilities for everything from exposure and saturation to noise reduction and color balance. No matter what level of editing you need to perform, the iPhoto Editor provides the tools.

If you've already been through Chapter 2, you completed a simple iPhoto project and were introduced to some of the editing tools available. In this chapter, I show you in more depth how to use all the editing tools.

Sometimes, because of the subject or the lighting, you have to quickly take a photo. You just might not have time to get the composition precisely how you want it. iPhoto can help you compensate for that, too, allowing compositional changes after the fact.

That's enough talk — time to get busy understanding how to make your photos better.

Understanding the Editor

Taking the perfect photograph is a lofty goal and nearly impossible. Light never falls evenly on all parts of a photo, or you make a simple error in camera settings in the heat of the picture-taking moment, or your composition isn't quite right.

Luckily, almost all these errors can be corrected, at least to some extent. Figure 7-1 shows the main window in Edit mode, and this is where the magic happens.

Take note of the little Navigation window, which appears any time you zoom in within the photo. Sometimes you zoom in so much to make a correction that you lose track of where you are in the photo — and that's what the Navigation window is for. You can put the mouse inside it and click and drag to move the photo around. Or, you can put it away by clicking the Close button in its upper-left corner. If you don't zoom, you don't see the Navigation window.

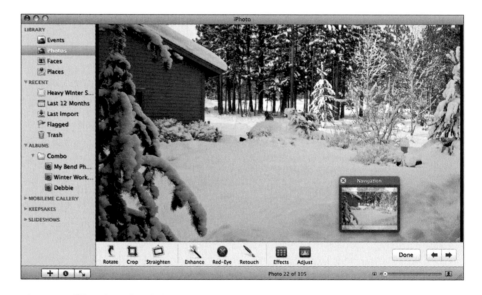

Figure 7-1: iPhoto's main window in Edit mode.

About this time, you might be muttering something like, "So many tools, so little time." Well, don't worry. Stay right here for my tips on how I approach editing every photo. I'm sure these tips will help you, too.

Here's an overview of my approach to editing. I start with what I call the "tidying-up phase":

1. I select the photo to edit and then click the Edit button in the toolbar at the bottom of the iPhoto main window.

 If necessary, I use the Rotate button to rotate the photo.

 Pressing and holding the Option key when clicking the Rotate button will change the direction of the rotation.

2. There's no sense working on parts of a photo that I don't want, so I use the Crop button and crop the photo, if required, before doing anything else.

3. Finally, I straighten the photo, if necessary, using the Straighten button.

Although this upfront part of the photo-editing process might not seem very exciting or artistic, tidying up is important and will save you time later. You'll see what I mean when you read Chapter 8.

After tidying up, I decide how much editing I will do with the specific photo. The next group of tools — Enhance, Red-Eye, and Retouch (see Chapter 8 for more details) — can often be used when higher-level editing is not required. I call these tools E.R.R. (and to err is not only human, it is often enough for your photo).

How do you know whether using these tools will be enough to fix your photo? Well, you can certainly try them and use the Undo feature if they don't work out. It's really a matter of judgment based on experience and whether you like the look of what has been changed. If I decide to use these tools, here's how I use them:

1. I normally start with the Red-Eye tool if there are any people in the photo with this problem.

2. Next I use the Retouch tool to remove any blemishes or dust spots that were on the lens — and thus in the photo. These two tools (Red-Eye and Retouch) are necessary whether you're planning to use the Enhance tool (see the next bullet) or not. Even if you're going to do advanced editing, you want to use these two tools first.

3. Last, but certainly not least, I click the Enhance button. This tool brightens the picture and makes contrast changes to lighten the mood of the photo. There are no adjustments you can make, and one click is all you need.

But say you have a few photos that are your prizes — the ones you want to look as good as possible — and you don't mind spending more time and care getting them to look the way you want. You've done your tidying up, and used Red-Eye, Retouch, and Enhance. Now, click the Adjust button, and the world of advanced photo editing opens. Figure 7-2 shows the Adjust tool window. Check out the ten sliders here that you can use to modify exposure, contrast, saturation, and a host of other parameters. Chapter 10 is devoted to using the Adjust tool.

When you finish using the Adjust tool, you might want to revisit the earlier-mentioned tools to correct any errors just discovered. Otherwise, you're ready to print or display.

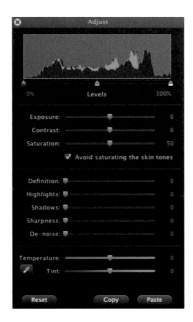

Figure 7-2: The Adjust tool window.

This is my overall workflow with iPhoto. I recommend trying editing this way first to see how it works for you. Afterward, don't hesitate to modify it to suit yourself — but do that based on your experience.

This approach covers a lot of work, but what if you decide at some point you don't want any of these changes? Good question, and it deserves an answer right now.

Preserving the original photo

iPhoto uses a technique called *nondestructive editing* to ensure that your original photo's look and feel is never lost. Instead of changing your photo directly, iPhoto keeps track of your modifications (keeping a list of things to do) and applies them to your original photo each time you open it for viewing, further editing, or printing. Operating in this way has several advantages:

- ✔ **You can use the Undo and Redo features multiple times in any editing session without fear of corrupting the original photo.**

- ✔ **At any time after editing, you can choose Photos⇨Revert to Original and go back to square one.** Figure 7-3 shows the warning dialog after this choice is made.

Are you sure you want to revert to the original version?

All changes will be lost.

Cancel OK

Figure 7-3: Heed the Revert to Original warning.

After you go back, all edits are lost.

If you're editing a photo in RAW format (explained in detail in Chapter 9), the command path is Photos⇨Reprocess RAW.

✔ **Unlike some photo-editing software, it makes no difference in what order you make your edits.**

✔ **Whenever you make an edit (or series of edits), you can compare the result against the original photo by simply pressing the Shift key.** This really helps when you've made several changes and aren't sure whether you've made things better or not. (Believe me, this question pops up more often than I care to admit.) Just keep pressing and releasing the Shift key to compare the changed photo and its original until you make the call.

Editing in Full Screen mode

Whenever you're editing a photograph, always try to have it displayed as large as possible on your computer screen. (This is especially true when sharpening a photo.) If you don't do this, you might make editing changes that aren't apparent at the time but will be detrimental when printing at a larger size. Full Screen mode also allows you to better compare two similar images to see which you prefer to edit.

To edit in Full Screen mode, follow these steps:

1. **Select the photo you wish to edit.**

2. **Click the Full Screen button (see Figure 7-4) or choose View⇨Full Screen.**

3. **Edit your photo using the tools on the toolbar at the bottom of the iPhoto window, as shown in Figure 7-5.**

 If the toolbar isn't showing (you did ask for full-screen viewing of your photo, after all), simply move your mouse to the bottom of the screen to make it appear. Chapters 8–10 cover editing in detail.

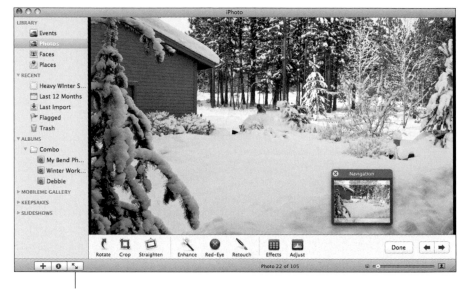

Full Screen button

Figure 7-4: The Full Screen button in the small toolbar.

Figure 7-5: The toolbar and its numerous editing tools.

Notice the two choices that appear on the far left of the toolbar. Clicking the Info button gives you information about the photo. Clicking the Compare button allows you to compare the current image with the next one in order in the Event it's located in: If they're similar photos, you can choose which one to edit.

When in Full-Screen mode, if you move the mouse to the top of the screen, you will see a film strip (of sorts) that shows thumbnails of all the photos in the current Event.

4. **To exit from Full Screen mode, click the X button on the far-right of the toolbar or press the Escape (Esc) key on your keyboard.**

Zooming in and out

When viewing your photo in Edit mode, you can zoom in or out on a photo. I always recommend that when you're cropping, retouching, working on red eye, and sharpening, zoom in and enlarge the area in question before performing the edits. Here's how you zoom in and out:

1. **Select the photo you want to edit and then click the Edit button.**

2. **Do one of the following:**

 • *Use the size adjust slider to zoom in and out.* Drag the size slider in the lower-right corner (see Figure 7-6) and use the scroll bars to bring the correct part of the photo into view. You can also click the icons at either end of the slider to go to the extremes immediately.

 • *Use the keyboard to zoom in and out.* Using your keyboard, press Option+1 to zoom to 100% or press Option+2 to go to 200%. You can also place your mouse pointer over the portion of the photo where you want to center the zoom and then press the 1 key for 100% or the 2 key for 200%. Press Option+0 (the zero key) to zoom out.

The size adjust slider

Figure 7-6: Zoom with the size adjust slider.

Changing the Composition After Taking the Photo

The thing about composition is that it's critical to getting a really good photograph. However, most people don't consciously think about it — or, if they do, they forget about it in the heat of the photograph-taking moment.

Poor composition is often caused by including too much in the photo, preventing the viewer from focusing on the main feature and causing distractions. Another cause is having something bright and distracting in the photo that pulls your eyes away from the main subject. Cure these two problems, and the improvement to your photos is huge.

Luckily, you have the technology to fix some composition errors after the fact. Two of the best iPhoto tools to correct these kinds of problems are the Cropping tool and the Adjust tool.

Because this is a book about iPhoto, I don't have room for a lengthy discussion of the theory and practice of compositional techniques. However, I will mention three techniques that can dramatically improve the results of your picture-taking and lessen the need for extensive editing.

- ✔ **The Rule of Thirds is easy to comprehend and to use.** Simply imagine that the scene you are going to photograph is divided into thirds, both vertically and horizontally. The rule, simply stated, is that you typically want to place the focus or main subject of the photo at or near one of the intersections of the vertical and horizontal lines (called *power points*). The horizon would be placed on or near one of the horizontal lines. Placing the main subject directly in the middle is boring and to be avoided if at all possible. Figure 7-7 shows what I mean. Here, the bush in the middle of the river is very near a power point and gives a pleasing composition. Just remember that this is not an exact science. It's still art, so use your judgment.

 Using the Crop tool can be very helpful here if the composition isn't quite right.

- ✔ **Distracting elements in a photo can be a disaster.** Strive to have the eyes of the viewer flow naturally to the main subject. If that doesn't happen, maybe you have bright objects that pull the viewer's eyes away, or perhaps a tree limb that inadvertently got in the photo.

 Strive to arrange the elements of your photograph to lead the viewer's eye into the photo and to the main subject. Remove distracting elements from the photo by using the Crop tool (to crop them out) or the Adjust tool (to lessen the effect).

- ✔ **Close one eye when first looking at the scene you want to photograph.** Humans — because we're binocular — inherently have depth perception. Often, it's that depth perception that makes a scene something we want to capture in a photo. But a camera only has one eye, its lens. Depth can be lost in the photo unless we use some elements (for example, trees, rocks, or a hill in the near foreground) to give the illusion of depth. If you close one eye, you'll see the scene as the camera will see

it — and you'll also know whether you have to do something to save the shot. If your camera has an LCD screen, you can check it to see what the camera will see albeit on a small scale.

This is something that no tool can really fix. Make doing this a habit before you shoot.

Figure 7-7: Use the Rule of Thirds.

If the subject of composition really fascinates you, check out *Digital Photography For Dummies,* 6th Edition, by Julie Adair King and Serge Timacheff (Wiley). The time taken to get comfortable with this aspect of photography is well worth the effort.

Applying Your Changes to Multiple Photos

One of the major advantages of digital photography is that pixels are free! No more buying film, having film so old that photos are ruined, or running out just when things are going well. Camera memory cards are relatively inexpensive; plus, you can erase photos that are obviously poor while you're shooting, thus saving room for more good photos.

My point is that digital photography encourages us to take lots and lots of photos. Suppose, though, that in your haste to capture a particular moment, you make some consistent errors in your camera settings. Perhaps you take 25 shots and realize afterward that they're all underexposed, just by enough to be bothersome. That's a lot of editing to do.

Wouldn't it be great if you could fix the problem one time and then just let it trickle down to all the other photos having a similar problem? You can, thanks to iPhoto coming to the rescue.

In Chapter 10, I give you an in-depth discussion of the Adjust tool, but for now, allow me to just plant the thought that this tool is the key to easily editing multiple photos.

Here's how:

1. **Select a photo affected by the recurrent problem and then click the Edit button to open Edit mode.**

2. **Select the Adjust tool; in the Adjust tool window that opens, use the sliders to make your changes.**

 Note the Copy and Paste buttons in the bottom-right corner of the Adjust tool window (see Figure 7-8). This is the good stuff.

The Adjust tool window

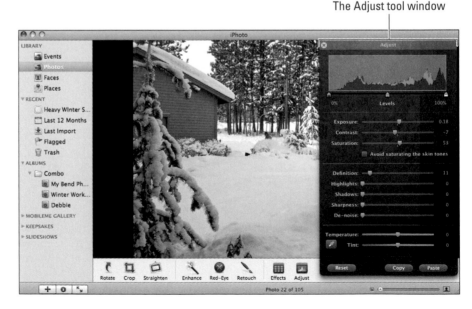

Figure 7-8: Edit mode and the Adjust tool window.

3. **When you're satisfied with the edits, simply click the Copy button.**

 This copies all the changes you made ready for you to Paste. This works just like how Copy and Paste do in other Mac applications.

4. **Still in Edit mode, click the right-arrow button on the far-right of the toolbar to bring the next photo into view.**

 If the Adjust pane is in the way, just click the top bar of the pane and drag it to somewhere more convenient on the screen.

5. **Click the Paste button, and the same changes from Step 3 will be applied to this photo.**

 The Copy and Paste buttons work only with the changes made in the Adjust tool window, and not with any of the other tools.

6. **Continue to click the right-arrow button. As each photo comes into Edit mode, click the Paste button to apply the edit.**

 This technique does require some manual effort, but if the edits are extensive, this is still quite a timesaver.

Making Basic Photo Adjustments

· ·

In This Chapter

▶ Manipulating the size and shape — rotate, crop, and straighten

▶ Correcting the most common photo faults

· ·

*A*nsel Adams used to say that if he got 10–12 quality photographs a year, it was a good year. Only those shots were worth the time, effort, and materials he would expend to deliver a classic photograph. We're not likely to be in his league. So what's my point?

My point is we can mimic a professional approach to obtain the best photos we can. That means

- **Take lots of photos of a subject.**

- **Be aware of how each photo looks and try to make each one better by altering location, exposure, composition, and so on.**

- **Be critical when reviewing photos — reserve the best for advanced editing and the others for basic editing to make them the best they can be.**

I cover advanced editing in detail in Chapters 9 and 10. But before you do anything advanced, you need to understand and practice basic editing, and that's what this chapter is all about.

The editing examples are shown within iPhoto's Edit mode. While Edit mode is a perfectly fine way to apply edits to a photo, I recommend you do any editing that has to be *exact* in Full Screen view — this makes it much easier. See Chapter 7 for more on Full Screen view.

When you use any of the tools described in this chapter (Crop, Rotate, Straighten, Enhance, Red-Eye, or Retouch) to edit a photo, the result of using that tool is applied to the photo in the iPhoto Library. This means that whatever editing you do to the photo affects that photo anywhere else it appears in your Library — every Album, Book, Calendar, Card, and so on. If that isn't your intent, select the photo you want to edit, choose Photos⇨Duplicate, and use the tool on the duplicate file.

Let's get started.

Adjusting the Photo's Size and Shape

In the sections that follow, I discuss some aspects of composition that include altering the size and shape of a photo. The iPhoto tools for performing these alterations are the Rotate, Crop, and Straighten tools.

Rotating

Depending on the orientation of your camera when you take a photo, you may need to rotate the photo to have it appear properly in iPhoto. The Rotate tool allows you to rotate photos in 90° increments. To use the Rotate tool, follow these steps:

1. **Select the photo to be rotated and click the Edit button to open it in Edit mode.**

 You can also double-click the photo to open it for editing.

2. **Click the Rotate button on the toolbar at the bottom of the Edit pane.**

 Each click of the Rotate button rotates the photo in that direction 90°.

 You can choose to rotate in the opposite direction by pressing the Option key and then clicking the Rotate button. You'll see the arrow on the Rotate button change direction.

 You can also set the direction of rotation by selecting Photos⇨Rotate Clockwise or Rotate Counter Clockwise, as shown in Figure 8-1.

3. **When you're finished, click the Rotate button again to turn off the Rotate tool.**

4. **Click the Done button on the toolbar at the bottom of the Edit pane to exit Edit mode.**

Figure 8-1: Using the menu to set the direction of rotation.

Cropping

Cropping is an area in which your choices, intuition, and artistic skills can really make a difference. People are sometimes hesitant to cut anything out of a photo, but I assure you, doing so often makes a mediocre photo into one that's stunning.

Before you actually begin cropping, I recommend that you spend a few minutes just looking at the photograph in question. Ask yourself these questions:

- ✒ **What am I trying to say with this photo?**
- ✒ **What's the main subject?**
- ✒ **What distractions do I see in the photo?**

Answering these questions helps you create a plan for making the photo the best it can be. It's amazing how many creative errors you may make when taking a photo, but you can often correct them afterwards in iPhoto when you recognize what you need to do.

The photo I chose for this example (see Figure 8-2) isn't particularly memorable. In fact, I took it only to document an event. But it's bad enough, from a composition perspective, to provide a great way of showing the editing power of iPhoto.

In Figure 8-2, you see the photograph prior to any editing. Before I do anything, though, I answer my three questions. For sake of argument, let's say that what I'm trying to communicate in this photo is the beauty of this golf hole and fairway. The main subject is the flag on the green. The distractions are numerous, starting with the orange tape in the lower-right corner, the extensive foreground, the deck railing, and the tree and white stick on the far left. Wow, there's lots to do! Follow these steps to correct one of your photos with similar issues:

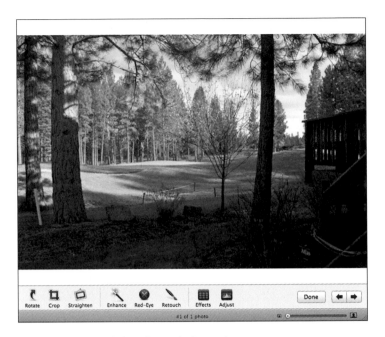

Figure 8-2: Unedited photo in need of cropping.

1. **Select the photo to be edited and click the Edit button to open it in Edit mode.**

 You can also double-click the photo to open it for editing.

2. **Click the Crop button on the toolbar at the bottom of the Edit pane.**

 The first thing to notice is the white rectangle indicating where the crop will occur. This is a moveable boundary that you can adjust either manually or by selecting a size from the Constrain pop-up menu, as shown in Figure 8-3. In this example, I do the crop manually.

3. **Move the mouse over one of the white lines you want to adjust until the cursor changes to a pair of lines with two arrows; then press and hold the mouse down while moving the line where you want it to go.**

 In Chapter 7, I mention the Rule of Thirds. Notice that when you begin to move the white line, a Rule of Thirds grid is superimposed on the photo (see Figure 8-4), helping you to crop and place objects accordingly.

4. **Repeat Step 3 on each of the crop lines you want to move.**

 You can go back and move lines as often as you want until you're satisfied.

5. **When you have the lines set, click the Apply button to set the crop.**

 Figure 8-5 shows the change I made. Not a great photo, but it's certainly a great improvement.

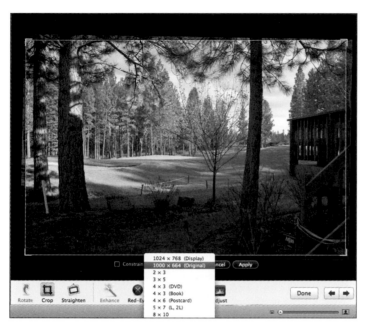

Figure 8-3: You can use the menu to adjust crop size.

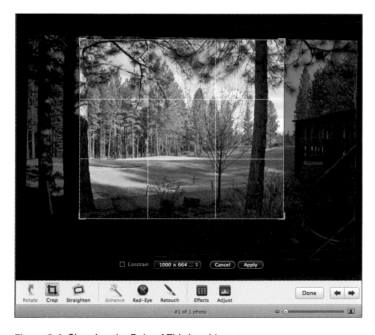

Figure 8-4: Showing the Rule of Thirds grid.

TIP

Press and release the Shift key to alternately look at the original photo and the cropped photo. Remember, you can also revert to the original photo and start again if you like by choosing Photos⇨Revert to Original.

Figure 8-5: The cropped photo.

6. **When finished, click the Crop button again to turn off the Crop tool.**

7. **Click the Done button on the toolbar at the bottom of the Edit pane to exit Edit mode.**

Cropping is a real art, and it can save a photo with correctable flaws. It's certainly better than driving 100 miles to retake the shot!

Straightening

The Straighten tool has a similar effect as the Rotate tool except that it rotates the photo in much smaller increments, with a maximum rotation capacity of 10°. To use the Straighten tool follow these steps:

1. **Select the photo to be straightened and click the Edit button to open it in Edit mode.**

You can also double-click on the photo to open it for editing.

2. **Click the Straighten button on the toolbar at the bottom of the Edit pane.**

 You'll notice a slider bar appear along with yellow grid lines to help determine the direction and extent of any necessary corrections, as shown in Figure 8-6.

Figure 8-6: Correcting the photo with the Straighten tool.

3. **Move the indicator on the slider to the left or right.**

 Moving the indicator to the left tilts the left side down; moving the indicator to the right tilts the right side down. To the right of the slider bar is the number of degrees of rotation that is being applied.

4. **When you have the correction as you want it, click on the Straighten button again to turn off the Straighten tool.**

5. **Click the Done button on the toolbar at the bottom of the Edit pane to exit Edit mode.**

As was true with the Rotate tool, whatever straightening you do to the photo will affect that photo anywhere else it appears in your Library. Make a duplicate if you do not want this to happen.

Correcting the Usual Suspects

The remainder of what I call the basic photo editing tools in iPhoto are Enhance, Red-Eye, and Retouch. With the power of today's computers and careful, patient editing, these tools may be all you need to bring out exactly the look you wanted when you captured your photos.

Perhaps the most consistent error that nonprofessional photographers make is in exposure, and the tendency is to err on the side of *under-exposing,* making photos too dark. This is because lighting is a tricky thing and not really controllable outdoors. Concentrating on the main subject of your photo may cause you to miss the very bright light reflecting off of something at the side. That bright spot can end up fooling the camera's light sensor, causing the photo to be under-exposed.

A problem with flash-lit portraits is *red-eye,* where the subject's pupils are dilated and the flash bounces off the rear of the eye and back out into the camera lens.

Requiring constant vigilance, dust on the lens can cause bothersome spots on the photo, which distract and detract from the beauty of the photo.

In the sections that follow, I show you what iPhoto can do to correct all these problems.

Lightening and darkening a photo

There are always times when, for one reason or another, you underestimate the amount of exposure needed for a particular photo. With digital cameras, the cure is pretty easy; just look at the camera's reviewing screen, spot the problem, adjust the exposure, and take another picture. But what if this was a one-time event. What if it's something that you can't reshoot, and you're stuck with whatever you captured?

Relax. All is not necessarily lost. In this case, the Enhance control in iPhoto can automatically vary brightness and contrast. Actually, it can do quite a bit. To use the Enhance tool, follow these steps:

1. **As is usually the case, select the photo to be enhanced and click the Edit button to open it in Edit mode. (See Figure 8-7.)**

 You can also double-click the photo to open it for editing. As you can see in the example photo, there isn't enough exposure to see detail.

2. **Click the Enhance button on the toolbar at the bottom of the Edit pane.**

Figure 8-7: The original photo of a P-51 Mustang.

Couldn't be simpler. The tool looks at the photo and decides on the best change it can make. There are no adjustments for you to do; just judge if this change is sufficient and has made the photo look the way you intended. If not, you can always choose Edit⇨Undo Enhance Photo. Figure 8-8 shows the result of the enhancement in this example.

3. **Click the Done button on the toolbar at the bottom of the Edit pane to exit Edit mode.**

If the use of the Enhance tool isn't enough, Chapter 10 covers much more advanced ways of correcting exposure.

Removing red-eye

I'm sure you've all seen horrible examples of people with devilish red eyes caused by taking flash pictures in a dark area. The pupils are naturally dilated, and that leads to what we call red-eye. Luckily, iPhoto can cause a significant reduction in red-eye with the use of the Red-Eye tool.

Note that the Red-Eye tool works only on human eyes. Because of differences in the construction of pet eyes, they may look green or yellow rather than red. If you have software than has a paintbrush-type tool you may be able to change the color to look normal for your pet. The iPhoto Red-Eye tool is for humans.

Figure 8-8: P-51 Mustang after using the Enhance tool.

Some cameras and some flash units automatically compensate to virtually eliminate red-eye as the photo is taken.

Here are the steps to take if you're not so fortunate:

1. **Select the photo you want to remove red-eye from and click the Edit button to open it in Edit mode.**

 You can also double-click on the photo to open it for editing.

2. **Zoom in to the area around the eyes using the size adjust slider in the lower-right corner of the Edit window.**

 In order to make the Red-Eye tool work properly, you must zoom in to enlarge the eyes in the photo. For more on zooming, see Chapter 7.

3. **Click the Red-Eye button on the toolbar at the bottom of the Edit pane to open the Red-Eye tool, shown in Figure 8-9.**

 I recommend you click on the Auto button first and let iPhoto try its hand at correcting the red-eye. It usually does a miraculous job. No need to position the cursor — iPhoto finds the eyes. In fact, Figure 8-10 shows the corrected photo using only the Auto button.

Figure 8-9: The Red-Eye tool.

If clicking the Auto button doesn't work, use the Size slider to adjust the cross-hair cursor to the size of the eyes you're trying to correct. A handy shortcut for sizing the cursor is to press the Left- and Right-Bracket keys (they're next to the "P" key) to decrease or increase the cursor size, respectively.

4. **Position the suitably-sized pointer over one of the pupils to be corrected, click the mouse, and then do the same for the other eye.**

5. **Repeat Step 4 for any other subjects in the photo with red-eye.**

 As always, you can press the Shift key to see the original photo for comparison.

6. **When you're finished, click the Close button (the "X") at the left of the Red-Eye control to turn it off.**

7. **Click the Done button on the toolbar at the bottom of the Edit pane to exit Edit mode.**

 This should make whoever was the subject of your photo happy again.

Figure 8-10: The photo after the Red-Eye tool's correction.

Making spots vanish

Dust is definitely the scourge of all photographers. It's also plentiful. Make it a habit to use a brush specifically made for camera lens to clean the lens you're using before shooting your pictures and always put the lens cap back on the lens when you're not shooting. This also helps keep your lens from getting scratched.

Be aware that no matter how careful you are, there will be spots in your photos, especially in blue skies. Or maybe your subjects may have some blemishes they'd like removed (without a visit to the dermatologist).

iPhoto can help. To use the Retouch tool, do the following:

1. **Select the photo to be edited and click the Edit button to open it in Edit mode.**

 You can also double-click the photo to open it for editing.

2. **Move the size adjust slider (in the bottom-right corner of the Edit pane) to the right to enlarge the area you wish to retouch.**

3. **Click the Retouch button on the toolbar at the bottom of the Edit pane.**

 As shown in Figure 8-11, you can choose the size of the Retouch brush by moving the slider. If your guess is off and you need a different-sized brush, just come back to the slider and move it to make it larger or smaller. Figure 8-11 shows the mark to be removed within the cursor. Just like the Red-Eye tool, use the Left- and Right-Bracket keys to change the size of the cursor.

Figure 8-11: The blemish in the photo to be removed.

4. **Position the mouse over the mark that you want to remove and click. If the blemish is large or irregularly shaped, you may find you need to click and drag the mouse to remove it.**

 iPhoto samples what's around the area to be retouched and changes the photo accordingly. It does a remarkably good job. Press the Shift key to view the original and compare the difference. Figure 8-12 shows the result — the mark is gone!

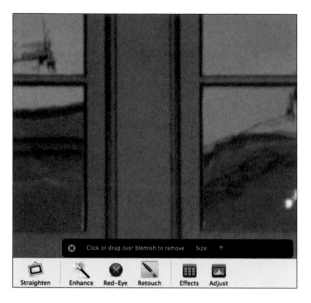

Figure 8-12: The blemish is removed.

5. **When you're finished, click the Close button (the "X") at the left of the Retouch control to turn it off.**

6. **Click the Done button on the toolbar at the bottom of the Edit pane to exit Edit mode. If you make a mistake in clicking with the tool, you can choose Undo Retouch and try again.**

 Of course, you can always revert to the original photo if you're not pleased with the results. Choose Photos⇨Revert to Original.

That's it for basic editing. In the next chapter I start to show you the many advanced techniques in iPhoto to make you photo editing even more enjoyable.

9

Using the Histogram for Advanced Editing

*B*efore you can arrive at your destination, you must know where you're going. To effectively use the power of advanced editing techniques, you need to understand how to determine what corrections need to be made to bring out the best in your photos.

A *histogram* is a great tool that doesn't just tell you what's wrong with a photo — it shows you. A histogram also makes clear what the application of any corrections will do to your photograph. This is key to taking advantage of the power of iPhoto's advanced editing capabilities.

In this chapter, I introduce you to histograms and how to understand what they mean for your photographs, current and future. Learning to interpret histograms helps you correct current photo problems, such as exposure and lighting, and avoid the same photographic problem areas in the future.

Any descriptions of the interplay of light, sensors, and electronics can easily become unnecessarily complex, so I'm going to try and avoid doing that. This means that although the descriptions I give are correct, they might not be complete. For your purposes, though, they'll be enough.

Defining a Histogram

Regardless of the photo format you choose for your camera's output (if you'd like to know more about photo formats, see the "Formats and visual quality" sidebar later in this chapter), the iPhoto histogram (available in the Adjust tool) is an aid that you'll find indispensable. Say what?

Basically, a *histogram* is a graphical way of showing you, the photographer, how the light levels in a photograph are distributed between the shadows and the highlights.

An important fact to remember when taking photos is that your camera's sensor records light (as photons) in a *linear* fashion. If the light reaching the sensor from one area of the photo is twice as bright as another area, the sensor records it as twice as bright (twice as many photons). Our eyes, on the other hand, are non-linear. Look at a scene that is twice as bright as another: We know that it's brighter, but we don't see it as twice as bright. Just be aware that what you sense in a scene, using your eyes, might not be what the camera records. The amount of light is a measure of how many photons were recorded.

If your camera has a histogram, use it to help you in judging exposure — it's always better to get this kind of information when you're taking the photo. If no histogram is available, learn from experience how to compensate for the difference between sensors and your eyes by studying the histogram in the iPhoto Adjust tool. If your camera includes presets for common lighting conditions (indoor, snow, portrait, and so on) take advantage of those.

Your digital camera devotes a large number of levels to the highlight area (where our eyes are not very sensitive to differences) and a much smaller number of levels to the shadow areas (where our eyes are much more sensitive). Each level represents a distinct number of photons recorded, and the higher the number of photons, the brighter the light. Keep this in mind as I discuss the histogram and the Adjust tool.

If your photograph requires using the Adjust tool, I recommend the following plan of action:

1. Use, if necessary, the Rotate, Crop, Straighten, and Red-Eye tools first, as I describe in Chapter 8.

2. Do not use the Enhance tool.

 Using the Enhance tool makes many of the same changes you can make with the Adjust tool, but you won't have any control of them — if you recall, the Enhance tool simply takes a click of the mouse, and it's done (see Chapter 8).

3. Use the Adjust tool to make advanced edits to the photo.

4. Use the Retouch tool last.

Interpreting a Histogram

Experience is the best educator. That said, the best way to look at how to read a histogram is by jumping right in and getting your hands dirty. Roll up your sleeves because here we go.

Figure 9-1 shows the Adjust tool with the histogram of a particular photo at the top.

The histogram for a photo

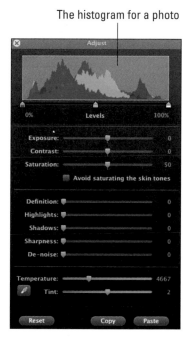

Figure 9-1: The histogram on the Adjust tool.

There are several things in this figure to make note of:

- **The histogram shows the light levels (number of photons) along the horizontal axis for each of the three color channels in the camera: red, blue, and green.** This means the most intense light in the photo — the *highlights* — is depicted on the right of the histogram, with the mid-tones in the center and the shadows on the left. The *color channel information* helps make it possible for the camera to create a color photo from the black-and-white sensor data.

 You can see that there's quite a bit of blue in the shadows (you know that because of the height of the blue curve on the left of the histogram), mostly red and green in the mid-tones, and mostly blue in the highlight

area. This makes sense given the actual photo (see Figure 9-2) this histogram represents.

Figure 9-2: The photo represented by the histogram.

The histogram doesn't tell you whether the photo is boring or not (I think it is), but rather that it's fairly well exposed because the light levels are nicely distributed across the histogram. On the other hand, just looking at the photo, with its familiar shapes and colors, can distract us from analyzing it properly. You figuratively "can't see the light for the trees!" And if there's one thing that's true about photography, it's all about the light.

✓ **The relative number of pixels in the photo at each light level is shown by the height of the curve vertically.** The more vertical the curve, the more pixels there are in the photo at that light intensity. When you compare the histogram in Figure 9-1 with the photo in Figure 9-2, you can see just how much useful information a histogram provides. It shows a lot of pixels in the shadow area, indicating a fair amount of detail there. It also shows plenty of pixels in the mid-tones and a highlight area that isn't overexposed. If you look at the histogram in Figure 9-3, you see a very uneven distribution of pixels.

It's obvious that almost all the pixels in the photo represented by the histogram in Figure 9-3 are in the shadow area, meaning that the photo will be dark and also that there'll be very little, if any, detail in the mid-tones and highlights.

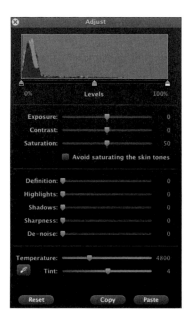

Figure 9-3: A histogram for an underexposed photograph.

You're probably wondering that with the Adjust tool at your disposal, why not just use that to fix exposure problems? And you're right, as long as you keep in mind what "fix" means. Think of it this way. The histogram in Figure 9-3 represents all the light that was captured when the photo was taken. When you use the Adjust tool's Exposure control slider, the light in the shadow area is "stretched" toward the mid-tones and highlights. The total number of pixels in the photo stays the same, but some of them have moved into the mid-tone levels. If you look at the histogram in Figure 9-4, you will see that the height of the curves on the left are now lower, meaning that not as many pixels are located in the shadows.

The danger is that if you move too many pixels, you introduce *noise,* which is a distortion in your image. In some ways it's similar to film grain. Electronic noise shows up as extraneous pixels sprinkled throughout an image. Noise degrades a photo and/or cause gaps in the light levels when it's extreme, thus giving the photo a poster-esque quality. So when using any of the Adjust tool's control sliders, keep your eye on the histogram and the photo to see the results.

Formats and visual quality

Although you don't have to read this, I hope you do as it'll provide some useful photographic knowledge.

Today's digital cameras can deliver various photo formats , and many of them allow you to choose what format to use. It's helpful to be aware of the strengths and shortcomings of each of the three most widely-used digital formats — RAW, JPEG, and TIFF — so you can choose the one that's right for you.

This is a "how-to" book, so I won't bore you with minute detail or history of how these formats came to be. There are plenty of places to get that information if you want it. Instead, I'll show you what using any or all of them means to you in the real world, how they can affect the final photo, and how to handle them in iPhoto.

Raw. The *RAW* format provides the basic or raw sensor information from your camera. This information is the luminosity that the sensor detected. Color information is included, but the output image from the camera is black and white. A RAW converter will use the color information to turn the image into a color photo based on software choices you get to make. All digital cameras use RAW data internally, but not all cameras output in RAW format for you to work on. If your camera does, I recommend choosing RAW as your output format. A drawback can be file size — RAW files can be 2 to 4 times larger than a JPEG file, but RAW gives you more flexibility and doesn't result in loss of visual quality as JPEG does. All in all, I think it's a good trade-off.

JPEG and TIFF. JPEG and TIFF are two other formats used, with JPEG being the most prevalent. Both formats require the software in the camera to modify the RAW data using prescribed algorithms and the included color information in order to output a color photograph. What this means to you is that whatever changes you make in the iPhoto Editor are in addition to ones the camera has already made.

Both JPEG and TIFF formats can save file space by using compression. JPEG is a *lossy* format, meaning that some visual quality is lost in compression and can't be restored. Each time a JPEG is edited and saved more loss is incurred, although to our eyes, the change might be unnoticeable. TIFF, comparatively, is a "lossless" format. The compression factor can still be effective in reducing file size, but no loss in visual quality is ever incurred.

Yes, there are tools in iPhoto to correct your mistakes, but it's always better to make your photos as good as they can be when you capture them.

✔ **The curve in Figure 9-1 doesn't quite go all the way to the right or left.** It comes pretty close, but heck! You paid for the camera and all the light levels it can sense, so why not use them? That statement's not as flippant as you might think.

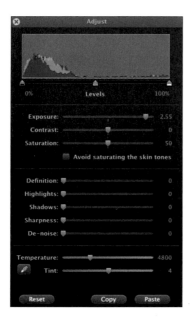

Figure 9-4: Moving the Exposure control slider for an underexposed photo.

Without going through a long technical discussion, take this as fact: Half of the light levels that a digital camera sensor can capture are in the high-lights! Those levels are there to record as much detail in the highlights as possible. So if you're going to err in taking a photo, err on the side of slight overexposure (emphasis on the word *slight*). When looking at a histogram, this means exposing to the right edge or slightly beyond it.

There's a second reason that exposing properly or even slightly overex-posing to the right is important. As I mention earlier in the chapter, our eyes are much more sensitive in the shadow area than the highlights. So if you're going to use the Adjust tool, it's a better situation to have to move the Exposure control slider to the left and push pixels (and more detail) toward the shadows than to move the Exposure control slider to the right, which pushes them into the highlights.

Saying this another way, when using a digital camera (unlike a film camera), expose for the highlights and develop for the shadows. By develop, I mean use iPhoto to finalize your photo. And, if you remember nothing else from reading this chapter, this tip will have made it all worthwhile.

These are three very important observations, and they help to explain why a histogram is so important — and how you can use it to your photographic advantage.

Formulating Your Advanced-Editing Game Plan

Before you start using the Adjust tool and any of its control sliders, just look at the histogram for your photo and "read" what it's telling you. I walk you through using the Adjust tool in detail in the next chapter, but the key to properly using it is to observe first and act second. "Okay," you ask, "what should I observe?" Here's the answer:

- ✒ **Look at the photo in Edit mode.** Is the photo pleasing to your eye? Is it too dark or washed out? Can you see detail in the shadows and in the highlights? Did it turn out how you thought it would when you captured it? In other words, get a sense, visually, of what you want to do to the photo (important for the present) as well as what you wish you had done (important for capturing future photos).

- ✒ **Look at the histogram in the Adjust tool window.** The histogram should confirm your own feelings about the photo. Ask yourself these questions. Do the curves go past the edge in either the shadows (on the left) or highlights (on the right)? Do the curves take up the entire histogram or only a part of it? Are the peaks of the curves very short or near the top (which tells you something about how well the scene was lit)? Are there pixels recorded at every light level across the histogram, or are there long stretches were there are no pixels?

As I mention before, if a photograph is really poorly captured, there might be nothing to do but move on because fixing one thing will make something else worse.

Concentrate on the positives, though, and assume that your photo can be improved. I'm going to show you the approach I take, and I recommend you emulate it until you gain some experience and can make your own modifications.

The approach I describe below mentions using the controls in the Adjust tool window to make advanced edits. Right now, the focus is to give you an idea of the approach to take for determining what advanced edits need to be made. In Chapter 10, I give you the details for actually using the Adjust tool's controls and making advanced edits.

My approach answers the questions posed above and helps formulate a game plan for advanced editing.

1. **Check whether the curves go past any edge of the histogram, as shown in Figure 9-5.**

 When this occurs, the curve climbs straight up. If you look closely, you can see this happened on the right in this case — and, of course, the higher the curve climbs vertically, the more pixels it represents. This tells you that you attempted to capture a range of light beyond the capability of

the camera's sensor. All those different light intensity levels (and there might be lots of them) have simply been piled up on top of each other at the edge, and this is *clipping*. In this case, I would try adjusting the Exposure and Highlight controls in the Adjust window to correct this and reclaim some highlight detail.

The curve extends past the
edge of the histogram

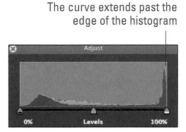

Figure 9-5: A histogram showing blown highlights.

2. **Adjust the curves so they take up all the histogram.**

 This might involve setting the Levels control end points, thus increasing exposure and also increasing highlight and shadow detail.

3. **Although it might be slight, always check for a color cast.**

 This is called "setting the white point" and makes use of the eye-dropper in the Tint control. See Figure 9-6 for an example of a photo with a bluish cast.

Figure 9-6: Blue cast present in a photo.

4. **Make necessary adjustments for color saturation and color temperature.**

 These are really personal choices, but I give you some hints for doing this in Chapter 10. Over-saturation is evident in a histogram if the tops of the curves are flattened against the top of the histogram window. Try backing off on the Saturation control in the Adjust window.

5. **Zoom in on the photo to 100% or higher and apply any needed sharpening.**

 Watch carefully while you apply sharpening to ensure you do only what's necessary.

6. **Zoom in on the photo to at least 100% and check for color or luminance noise and correct for it.**

As you might have noticed, this order of corrections closely follows the layout of controls in the Adjust tool window. Great minds think alike! Actually, it's just a sensible order in which to do things. But be aware, as you gain experience there may be photos where it makes sense to do things in a slightly different order.

My aim, in the guidance I give you, is to help you use iPhoto to your maximum advantage. Part of this comes from understanding the process to use and the tools that can help. Part of the process is developing good techniques for taking well-exposed photos in the first place. After you master that, knowing what to correct is much simpler.

10

Finalizing Advanced Editing with the Adjust Tool

In This Chapter

▶ Adjusting light levels
▶ Correcting color casts in your photos
▶ Changing the Exposure, Contrast, and Definition
▶ Adjusting Highlights and Shadows
▶ Editing Saturation levels
▶ Sharpening techniques
▶ Cutting noise distortions
▶ Playing with Effects
▶ Saving Adjust tool settings

*I*t's time to put iPhoto into hyper-warp drive, so to speak. You've taken your photos and used iPhoto's basic editing techniques. Maybe, though, there are still some corrections to make, and by looking at the Adjust tool's histogram for a particular photo, you see the direction you want to go. (Read all about using histograms in Chapter 9.)

It's important to remember that when you use the iPhoto Adjust tool, you're entering the realm of subjective evaluation. There really aren't any "magic settings" that'll guarantee a great photo. The real questions to ask yourself are whether the settings make the photo look like the scene you captured and also whether you like how the photo looks. If the answers are yes, those are correct settings for you.

In this chapter, I show you a hands-on approach to correcting flaws in your photos to make them the best they can be. Using every aspect of the Adjust tool allows you to become proficient in identifying areas to correct and adept at making proper adjustments. You'll find lots of ways to use this tool.

If you haven't already (or you read it a long time ago), now's a good time to read Chapter 9 and get familiar with the iPhoto histogram and see how crucial it is to the proper and full use of the Adjust tool. Understanding where and why you use iPhoto's Advanced tool's controls is almost as important as how to use them.

Clicking the Reset button in the Adjust pane takes all settings back to their default values; for example, removes any changes you have made to the photo.

As I mention in earlier chapters of this book, editing a photo in the iPhoto Library changes it in every Album, slideshow, book, calendar, or card where it appears. This is true for every Adjust tool control and the Effects tool. If you want to edit a photo without changing it elsewhere, make a duplicate of the photo by choosing Photos⇨Duplicate; then, and only then, edit the duplicate.

Modifying Light Levels

When you look at a particular photo's histogram in the Adjust tool window, you'll notice the three indicators on the Levels sliders directly under the histogram: one on the left, one in the center, and one on the right, as shown in Figure 10-1. These sliders affect the settings for the black point, mid-tones, and the white point, respectively.

Mid-tones slider

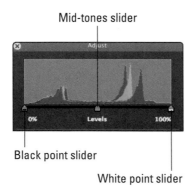

Black point slider

White point slider

Figure 10-1: The Levels sliders.

Even though these are the first controls in the Adjust tool window, I recommend you apply them, if at all, only after you correct for Exposure, Contrast, Highlights, and Shadows because adjusting these controls will cause the histogram to move quite a bit. After gaining some experience with iPhoto, you might choose to do things in a different order.

Changing the black point

If you refer to Figure 10-1, you'll notice a gap between the black point (left) slider and the beginning of the histogram curves. This means there are very few, if any, pixels in the lowest shadow-area light levels — and thus no absolute black. If this is the case, you can do the following:

1. **In the Edit pane, set the magnification of the photo to at least 100% (halfway), using the slider in the lower-right corner.**

 As is true with many of the slider controls, it's best to try moving the black point slider while watching the photo, *with at least 100% magnification,* to see whether you like it better.

2. **Move the black point slider (the left slider under the histogram) to the right until it just reaches the point where a bump in the histogram appears.**

 This moves the black point to a higher value and means that the pixels (if any) lower than the black point slider will be set to 0% luminosity, or *absolute black.* This should enhance the tones in your photo. Don't move the black point slider so far to the right that the shadows lose all their detail.

3. **Now you can press and release the Shift key to compare the current settings with the photo as it existed before you opened the Adjust tool.**

 If you don't like the new setting, you can always choose Edit⇨Undo or use Command+Z.

4. **If you're satisfied with your changes, click the Done button in the Edit pane or continue with other changes, using the Adjust tool.**

My advice on making these advanced changes is that because some controls can affect other controls, you make these changes iteratively. Don't be afraid to go back to something previously set and try changing it a little after you've used another control to make an edit.

Modifying the white point

In a similar way to modifying the black point, you can modify the white point using the slider on the far right of the histogram. In this case, moving the slider to the left sets the level for absolute white. Referring to Figure 10-1, you see there are very few pixels on the far right of the histogram. By moving the white point slider to the left, you're setting any pixels that exist to the right of it to absolute white. Here's how to do this:

1. **In the Edit pane, set the magnification of the photo to at least 100% (halfway), using the slider in the lower-right corner.**

 This will assist you in making sure the highlights don't lose all their detail when you make adjustments.

2. **Move the white point slider (the right slider) under the histogram to the left until it just reaches the point where a bump in the histogram appears.**

 This should enhance the tones in your photo and make the overall photo brighter. As you move the slider, pay particular attention to the detail in the brightest areas of your photo. You don't want to move the slider such that you lose the detail that's already there. Any pixel values above the white point slider are set to 100% luminosity or absolute white.

3. **Now you can press and release the Shift key to compare the current settings with the photo as it existed before you opened the Adjust tool.**

 If you don't like the new setting, you can always choose Edit⇨Undo or use Command+Z.

4. **If you're satisfied with your changes, click the Done button in the Edit pane or continue with other changes, using the Adjust tool.**

Let me give you an idea of what I mean by losing detail. Figure 10-2 shows a photo of part of the peak of Mt. Washington and the photo's histogram with the white point set to 83%. Pay particular attention to the right half of the large snow area.

Now look at Figure 10-3. The white point slider is now set to 97% (much less movement), the highlights are still brightened, but there is also more detail in the snow area. For me, this is a much better setting. This is the kind of trade off you need to be aware of as you make your changes.

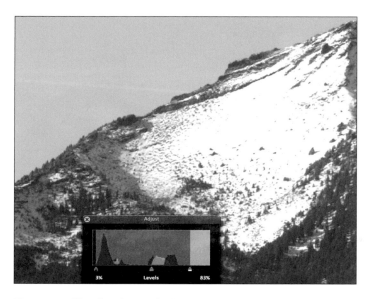

Figure 10-2: Showing the result of a large white point movement.

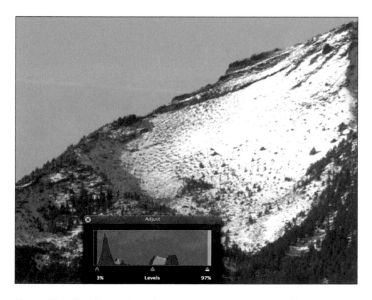

Figure 10-3: Smaller white point movement preserves detail.

Setting the mid-tones

After you adjust the light range for the photo using the two sliders on the ends (making the light range smaller in this example), you can use the mid-tone slider to achieve a balance of brightness and shadow detail. To do so, follow these steps:

1. **In the Edit pane, set the magnification at the minimum value that still allows you to see the entire photo.**

 For adjusting mid-tones, it's best to see all the photo when making adjustments.

2. **Move the mid-tone slider to the left to brighten the photo or to the right to darken it.**

 This adjustment shouldn't require large changes, so move the slider around a little and watch the photo to judge where you want the adjustment to be.

 I've found it helpful to move the Saturation slider all the way to the left to give the appearance of a black-and-white photo. Then adjust the mid-tones, which are grays. When you're satisfied, bring the Saturation slider back to the middle or its previous setting to restore the color.

3. **Now you can press and release the Shift key to compare the current settings with the original photo.**

 At this point, you can then make more changes, accept what you've done, undo your last change, choose Photos➪Revert to Previous (which takes the Adjust settings back to what they were when you opened the Adjust pane this time), or even click the Reset button in the Adjust tool to remove all Adjust settings and try again!

4. **If you're satisfied with your changes, click the Done button in the Edit pane or continue with other changes, using the Adjust tool.**

Fixing a Color Cast

At one time or another, we've all been shocked at seeing a photograph that has an overall distorting color cast that makes many colors in the photo look unreal. It's not a disgrace if this happens to you, but it's important you have the power to correct it. And in iPhoto, you do. This is the point where you should correct this — before making any other corrections.

To fix a color cast, follow these steps:

1. **Open the photo in the Edit pane or in full-screen view, if you haven't already.**

2. **Click the Adjust tool button.**

3. **In the Adjust tool window, click the eye-dropper button just to the left of the Tint control, as shown in Figure 10-4.**

 The mouse pointer will turn into a cross-hair.

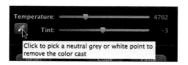

Figure 10-4: The eye-dropper for correcting color cast.

4. **Pick a white or neutral gray color in the photo and click it. If neither white nor neutral gray exist in the photo, try to find a neutral color that will work.**

 Both the Tint and Temperature sliders will adjust automatically, and there'll be no color cast if you chose the neutral color correctly.

5. **If the photo is still not corrected (it might even look worse), don't panic. Pick another area that you feel is neutral and click it.**

 The settings will change, as will the look of the photo. Usually, two or three choices will be all it takes. Sometimes what looks neutral to our eyes has some color in it. You just have to find the part of the photo that removes any color casts. It's often an iterative process.

 When you're satisfied, color balancing is complete. Make sure you don't change the Temperature or Tint sliders after this, or you might have to color balance again.

6. **You can press and release the Shift key to compare the current look with the original photo.**

 If no other adjustments are needed, you're done.

7. **If you're satisfied with your changes, click the Done button in the Edit pane or continue with other changes, using the Adjust tool.**

Adjusting Exposure, Contrast, and Definition

Digital cameras these days are wonderful gadgets; even the least-expensive have electronics that allow them to make exposure adjustments automatically for you. They tend to do an incredible job of making compromises so your photo is at least viewable, even though you might be capturing a scene in the worst of photographic circumstances. These compromises, however, are made in a split second. You, on the other hand, have an opportunity to take your time, use your eyes, and make the changes in editing you wish

you'd made when capturing the shot. Sound great? See how this works by getting acquainted with the controls you'll be using:

- **Exposure:** The Exposure control, as the name suggests, allows you modify the *exposure* (overall lightness or darkness of the photo) almost as though you had changed the shutter speed and/or aperture when the photo was taken. You can think of it as going back in time without having to build a special way-back machine or going through wormholes. I promise you won't feel a thing except pride and satisfaction at what you've accomplished!

- **Contrast:** The Contrast control changes the difference between the light and dark areas of your photo. It affects contrast on all areas of your photo equally.

- **Definition:** The Definition control adjusts local contrast, which can help you improve clarity and also reduce haze in your photos.

The Exposure, Contrast, and Definition sliders are initially set to 0, 0, and 50, respectively, for no effect on the photo, as shown in Figure 10-5.

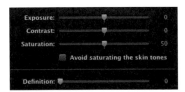

Figure 10-5: Exposure, Contrast, and Definition sliders set to no effect by default.

The Exposure slider provides very critical adjustments, and you can even recover some of the highlights that have been overexposed by using negative values. Remember that half the data values captured by the camera sensor are in the highlight area, so it's important to use as much of that data as possible. (See Chapter 9 for a more complete description of why this is true.)

To recover some highlights and save an otherwise overexposed photo, follow these steps:

1. **Open the photo in the Edit pane and do a color balance.**

2. **Click the Adjust tool button.**

3. **Use the Adjust tool window and perform a color balance. (See the previous section for more details.)**

Figure 10-6 is an example of the overexposed photo I'm using to show you this process. I already applied a color balance to the photo, but there are light levels off the right side of its histogram (indicated in the photo by all the bright areas that have little or no detail).

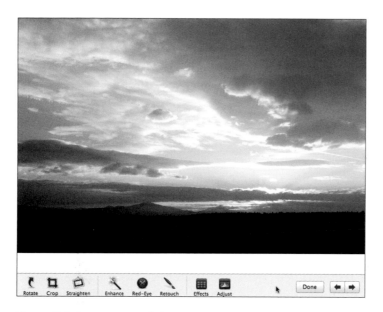

Figure 10-6: An overexposed photo.

4. **Move the Exposure slider and watch the histogram to see what happens.**

 It's best to move the slider with the mouse to get an idea of the direction and amount required. In this example, –0.98 seems to be about right and restores some cloud highlight detail.

5. **Move the Contrast slider to further enhance the photo.**

 I recommend moving the Contrast slider while watching the photo to see what changes to make. For this example, I used a value of +8.

6. **Drag the Definition slider until your photo looks how you want.**

 Try going back and reducing Contrast after you adjust Definition. Iterate, if necessary, between Exposure and Contrast. Always work the controls until you achieve the look you want. Use the Shift key to compare the original with the current look. In this example, the photo is much improved already. Figure 10-7 shows the effect of all three changes.

Figure 10-7: After making Exposure, Contrast, and Definition changes.

7. If you're satisfied with your changes, click the Done button in the Edit pane or continue with other changes, using the Adjust tool.

In Chapter 9, I mention that modifying an overexposed photo is usually preferable to modifying an underexposed one. With the latter, you're trying to stretch the small amount of data in the shadows into the upper mid-tones and highlights, and this can lead to shadow noise and a generally ugly look to the photo. When take your photos in the future, keep in mind the limits to exposure adjustment after the capture.

Balancing Highlights and Shadows

You might have already made changes in the light levels and the overall exposure of the photo. (If not, I recommend doing so before reading this section.) Now your changes will concentrate only on the highlights and shadows. For these changes, you use (you guessed it) the Highlights and Shadows controls. With these two controls, you can work directly on the highlights and shadows to improve the highlight and shadow detail in your photo.

From this point on, you need to really look at your photo and decide whether altering more Adjust tool controls is warranted. You can get to a point where you're doing more harm than good. If you decide to make more adjustments, making them with the photo at a minimum of 100% magnification is crucial. This allows you to see exactly what each change is doing.

To modify the highlights and shadows, you can do the following:

1. **In the Edit pane, set the magnification of the photo to at least 100% using the slider in the lower-right corner.**

2. **Use the small Navigation window to position the photo so you can observe an area of highlights.**

 Figure 10-8 shows the area of the Adjust tool window you'll be using.

Figure 10-8: The Highlight and Shadow controls.

3. **I recommend you begin by moving the Highlight slider with the mouse while watching the photo for changes.**

 This allows you to get a feeling for the amount of highlight darkening you want to apply.

4. **When you're satisfied with the setting in the area you're observing, move to another highlight area and see how that looks.**

 Don't be afraid to make changes in the amount of highlight darkening in this new area to make sure that whatever value you apply is best for the entire photo, not just part of it.

5. **Zoom out to the minimum magnification that allows you to see how the entire photo looks with the change you made. Then go back to 100% magnification and recheck each highlight area.**

 Don't forget you can press on the Shift key to see a comparison of the current version of the photo and the original.

6. **Now you can lighten the shadow areas, if necessary.**

 Again, zoom in to 100% magnification , use the small Navigation window, and concentrate on a shadow area that seems too dark.

7. **Use the same technique of moving the Shadows slider with the mouse to get an idea of how much shadow lightening you want to apply.**

 The idea is to try and provide some detail in the shadows, enough so the eye can recognize there's something there and not just a black smudge.

8. **Make use of the Shift key to see the difference between the current photo and your original.**

9. **If you're satisfied with your changes, click the Done button in the Edit pane or continue with other changes, using the Adjust tool.**

 Figure 10-9 shows how the example photo looks after these changes. More detail is evident in the highlights as well as the shadows.

Figure 10-9: After making Highlights and Shadows changes.

This would be a good time to make changes to the light Levels sliders if you wish. Use the instructions in the "Modifying Light Levels" section, earlier in this chapter.

Modifying Saturation Levels to Enrich Your Colors

No matter how "artsy" the results are described to be, I'm not a fan of cranking up any software editing tools to the point that the colors in a photo scream "unrealistic" to the viewer. On the other hand, as I mention in Chapter 9, what *we* see and feel and what the *camera* records might not be the same. I do believe, as do most professional photographers, that the final photo should represent what the photographer saw at the moment of capture and that corrections made to the digital image are appropriate and recommended based on the histogram.

Three controls can dramatically affect colors — Saturation, Temperature, and Tint, as shown in Figure 10-10.

If you've already done a color balance on a photo (see the "Fixing a Color Cast" section, earlier in this chapter), the Temperature and Tint were automatically adjusted. The Temperature, expressed in degrees Kelvin, is a measure of the color temperature of the light in the photo. Moving the Temperature slider to the left introduces more blue (colder), and moving it

to the right introduces more yellow (warmer). The Tint is just a value with no units. Moving the Tint slider increases or decreases the red/green tint of the photo.

These controls dramatically
affect colors

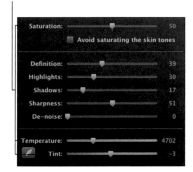

Figure 10-10: The Saturation, Temperature, and Tint controls.

Unless you want to undo the color balance or make very small adjustments to it, *don't adjust the Temperature and Tint controls.* Doing so can introduce a color cast!

I'll concentrate on the use of the Saturation control, which will be the only one you'll use most of the time. Here's what it can do.

1. **Select your photo and click the Edit button in iPhoto.**

 iPhoto displays the photo in the Edit pane.

 It's best to use the other tools already discussed in this chapter first. If you haven't already used them, do so now. That would be the light Levels control; Tint's eye-dropper for color balance; and the Exposure, Contrast, Definition, Highlights, and Shadows controls.

2. **Click the Adjust button to open the Adjust tool window.**

3. **In the Saturation section of the Adjust tool, select the Avoid Saturating the Skin Tones check box if there are skin tones in the photograph.**

 This allows you to increase saturation without destroying the subtle facial and body tones.

4. **In the Edit pane, set the magnification at the minimum value that allows you to see the entire photo. Then, with the mouse, move the Saturation slider to the right to increase color saturation or to the left to decrease it.**

You'll notice in the histogram that this slider mostly affects the mid-tones.

5. **Watch your photo to see the changes that occur.**

 Keep in mind what you saw when you captured the photo so you can make your adjustments to re-create that look for the viewer. Typically, your settings will be between 40 and 65.

6. **Press and release the Shift key to compare the current photo with the original.**

 Happy with the result? Then you're done. Otherwise, continue with adjusting the saturation.

7. **If there are no other changes, click the Done button in the Edit pane.**

At this point, you've corrected both the luminosity and color in your photo. What remains are two tasks that can put the finishing touches on your masterpiece.

Sharpening Adjustments to Make Your Photos Sparkle

Any type of pixel editing, especially when it involves post-capture exposure adjustments, can cause an overall softening of the image. iPhoto provides the Sharpness tool for handling this situation. Figure 10-11 shows the Sharpness (and De-noise, covered in the next section) control in the Adjust tool window.

Figure 10-11: The Sharpness and De-Noise controls.

Here's how it works:

1. **Select your photo and click the Edit button in iPhoto.**

 iPhoto displays the photo in the Edit pane.

2. **Click the Adjust button to open the Adjust tool window.**

3. **In the Edit pane, set the magnification of the photo to at least 100% (halfway) using the slider in the lower-right corner.**

Sharpness is one tool where magnification is absolutely required. Make sure your photo is at least at 100%.

4. **Pick something in the photo with edges (using the small Navigation window to move the photo around), and watch while you vary the Sharpness control.**

 Like other controls, it's best to watch the photo while you move the slider to get a feel for how your photo is responding. As you move the slider, look at the edges of the object you zoomed in on. A sign of over-sharpening is a halo effect along the edges of leaves, mountains, or clouds. If you see this, reduce the amount of sharpening. Otherwise, the rule here is "sharpen to taste" but use only as much sharpening as necessary.

 This control is meant to correct for a softening in the look of the photo. It can't correct for a photo that was out of focus at the time of capture.

5. **Press and release the Shift key to compare the current photo with the original.**

6. **If there are no other changes, click the Done button in the Edit pane.**

Removing Noise Distortion from Your Photos

Noise is a distortion in your image. In some ways it's similar to film grain. Electronic noise shows up as extraneous pixels sprinkled throughout an image. Dealing with noise in the digital age is a fact of life. Eliminating or lowering the amount of noise in your photos is another reason for making correct exposures at the time of capture. An underexposed photo has more noise than one that's correctly exposed. And when performing exposure corrections in iPhoto, that noise can become more noticeable, especially in the shadow areas.

Another fact is that noise is a function of the *ISO,* or sensitivity setting of your camera. This is the digital equivalent of film speed. Keep in mind that setting the ISO to high numbers can make a photo possible in very weak light, but noise can negate the value of such a photo.

All digital photos have noise, but it's important to understand that noise we can see in iPhoto might not be visible when we print. The objective is to reduce noise so it isn't visible or damaging. Because it is very difficult to see noise in print, I'm not showing any examples in the following step list.

Color noise, especially in the shadow areas, looks something like confetti, with color speckles visible even at 100% magnification. To reduce noise as much as possible, do the following:

1. **Select your photo and click the Edit button in iPhoto.**

 iPhoto displays the photo in the Edit pane.

2. **Click the Adjust button to open the Adjust tool window.**

3. **In the Edit pane, set the magnification of the photo to at least 100% (halfway) using the slider in the lower-right corner.**

4. **Using the small Navigation window to move the photo, look in the shadow areas of your photo for evidence of noise.**

 If you don't see noise at this magnification, try a higher magnification. If you still see nothing, it's unlikely any noise will show up in a print, even a fairly large one.

5. **If you do see noise, watch that area of the photo and use the mouse to move the De-noise slider (refer to Figure 10-11) to the right.**

 Don't overdo it because noise reduction also has a smoothing effect on the photo, negating some of the sharpening you might have already done.

6. **Check all areas of the photo to ensure that you eliminated the noise problem as much as possible.**

7. **Use the Shift key to check the current photo against the original to gauge how much noise reduction you have done.**

 If you're finished, click the Done button in the Edit pane.

You've used your skills and your creativity to make your photo the best it can be. There is one more thing that you can decide to do and that requires the use of photographic effects, which is something iPhoto can provide.

Trying Out Effects — Just for the Art of It

The Effects tool is right next to the Adjust tool in the Edit pane. The Effects tool window displays nine photos, eight showing each type of effect applied and one for the original photo. Figure 10-12 shows the Effects tool window.

iPhoto allows you to have multiple photo effects active at the same time. Say, if you click B&W and then click Vignette, both B&W and Vignette are applied to the photo. Only one from the first row of effects shown in Figure 10-12 can be on at any time (B&W, Sepia, Antique). As for the others, the more the merrier! If you want to see what happens with only one effect active after you've tried several, make sure you click the Original effect to cancel any effect you previously turned on before choosing another.

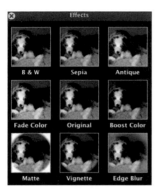

Figure 10-12: The Effects tool window.

The nice thing about the Effects tool window is that you can try each of the effects (except the first row), without having to change any other settings. Keep reading to see what kinds of things you can do.

1. **Choose your photo and click the Edit button to open it in Edit mode.**

2. **Click the Effects button.**

 The Effects tool window opens and shows a thumbnail of your photo with each of the eight effects applied so you have an idea of what each one does. Figure 10-13 shows the photo I've chosen before applying any effects.

Figure 10-13: Photo before using the Effects tool.

3. **Click the B&W (black and white) effect in the Effects tool window.**

 Notice that an ON button appears at the bottom of the B&W effect in the Effects tool window, and you can click it to remove (turn OFF) the B&W effect. Figure 10-14 shows you what this effect looks like when applied to the photo. You can also try manipulating the Saturation slider in the Adjust tool window to augment this effect.

Figure 10-14: Result of the B&W effect.

4. **Click the Original effect, and then click Sepia to turn it on.**

 Once again, an ON button appears; you can click it remove the Sepia effect.

5. **Click the Original effect; then click Antique to turn it on.**

 Notice this time that a number appears, with small arrows on either side, at the bottom of the Antique effect in the Effects tool window. Click the right arrow to increase the power of the effect, and click the left arrow to decrease.

 You can always press the Shift key to alternate between the current photo state and the original.

6. **Click the Original effect; then click the Fade Color to turn it on.**

 Once again, a number appears, with small arrows on either side. This allows you to increase or decrease the power of the effect.

7. Click the Original effect; then click the Boost Color effect to turn it on.

You guessed it! Another number appears, with small arrows on either side. This allows you to increase or decrease the power of the effect.

8. Click the Original effect; then click the Matte effect.

A number appears, with small arrows on either side. This allows you to increase or decrease the power of the effect. Figure 10-15 shows the result of this effect at the lowest level.

Figure 10-15: Result of the Matte effect.

9. Click the Original effect; then click the Vignette effect to turn it on.

A number appears, with small arrows on either side. This allows you to increase or decrease the power of the effect.

10. And last, but not least, click the Original effect and then click the Edge Blur effect to turn it on.

Again, a number appears with small arrows on either side to change the power of the effect.

That takes care of all the single effects . . . but there's more! You can click multiple effects and combine them on a single photo. This obviously takes some playing around to get a desired effect, but the ability to do this in iPhoto really opens the creative doors. As an example, Figure 10-16 shows the same photo with both Sepia and Edge Blur applied.

Figure 10-16: Result of using the Sepia and Edge Blur effects.

This completes your tour of the iPhoto Effects tool. Get creative and have fun with it.

Saving Your Photo Adjustment Settings

Say you completed corrections for Exposure, Contrast, Highlights, and so on, and now you want to take your hard work with the Adjust tool settings and apply them to other similar photos. Do you have to go through the process all over again with each photo? Luckily, the answer is no.

When you take a series of photos at the same time in the same lighting conditions, they often lend themselves to the same Adjust tool corrections. At least, you'll come close to the right settings and can then just make small individual corrections.

Here's what you do to save your Adjust tool settings and apply them to other photos:

1. **Open the Adjust tool from the Edit pane.**

2. **Make all your corrections to the photo.**

3. **Click the Copy button in the Adjust tool window, as shown in Figure 10-17.**

Click the Copy button

Figure 10-17: The Copy and Paste buttons.

4. **Use the arrows next to the Edit pane's Done button to get to another photo. Or, click the Done button and pick another photo to display it in the Edit pane.**

Figure 10-18 shows the arrows' location.

Figure 10-18: Photo selection arrows in the Edit pane.

5. **When you have the next photo in the Edit pane, apply the previous Adjust tool settings by clicking the Adjust tool button and then clicking the Paste button.**

That's it! All your corrections will be applied to the new photo. You can continue to do this as long as you don't quit iPhoto or click the Copy button again.

Part IV
Showing and Sharing Your Photos

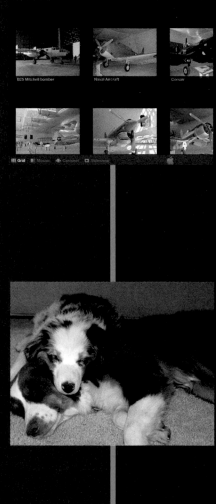

ot some photos that you had a great time capturing in your camera? Want to share them with friends and relatives? iPhoto '09 provides several options for you to do just that, and you find out how in this part.

Chapter 11 shows you how to use good ol' e-mail to share the photos you worked so hard on. For something more permanent and as a way to put a lot of photos in one place, you can burn them to a CD or DVD. For those who have a MobileMe account, I show you all the things you can do to spread the news, visually, far and wide. This includes using Facebook and Flickr, which are easy to use with iPhoto '09.

The iPhone also provides a quick and easy interface to iPhoto, and I show you how to take advantage of that. Chapter 11 covers this as well.

But what if you want to share something that's more permanent? Chapter 12 takes you through the capabilities in iPhoto '09 for printing your photos, and Chapter 13 covers making photo books, calendars, and cards using photos you've taken.

I'm as excited as I'm sure you are, so let's go.

Sharing Your Photos Electronically

In This Chapter

▶ Using Apple Mail with iPhoto

▶ Burning CDs and DVDs for sharing

▶ The power of MobileMe

▶ Interfacing an iPhone and iPhoto

▶ Sharing socially: Facebook and Flickr

▶ Utilizing photo feeds

▶ Exporting to other applications

*T*hese days, the fastest way to share your photographic works of art is electronically. And because working with iPhoto means that you already have your photos in the digital realm, sharing them with your friends and relatives is easy. Burning them onto CDs and DVDs is quick and easy, too.

Depending upon the resolution of your shared photo, the recipient can decide whether to print it. That way, you don't have to worry about shipping hard-copy photos or risking them getting bent or folded (even if you mark them Do Not Bend!)

In this chapter, I show you how iPhoto and Apple Mail work together. Don't want to spend time e-mailing photos to each person in your address book? No problem — put them on the Web and just send an invitation to view. This can be done using social networking applications like Facebook and Flickr and Apple's MobileMe service, all of which I show you in this chapter.

E-Mailing Photos

Many good e-mail clients are available for Mac besides the Apple client, Mail. Eudora, AOL, and Entourage all allow you to send photos. Rather than trying to cover them all, though, I concentrate on using iPhoto with Mail. You may find software available elsewhere that adds other e-mail clients. Also, later in this chapter I show you how to export the photos to a hard drive. From there you can attach them to any e-mail client.

Attaching photos to an e-mail is the easiest, quickest, and least-expensive way to share your photos. Being easy, though, doesn't mean there aren't things to think about to make sure the process works. Take these three things into consideration when e-mailing photos:

- **Photo file type and size:** Remember that you aren't submitting a photo for viewing in an art gallery. To keep the file size down while still maintaining a decent resolution, go with either JPEG or PNG format.

 When you attach a photo to an email, iPhoto automatically converts it to a JPEG. If you export photos outside of iPhoto, you have more choices of format. PNG is a good alternative.

- **Whether the recipient is using Windows or Mac OS:** I find it best to make no assumptions about the recipients machine, so I send attachments that either operating system can read. Make this setting in Mail from the Edit⇨Attachments menu to ensure this; see Figure 11-1. You only have to do this one time.

- **Whether you want all photo attachments to appear at the end of the e-mail message:** This is something else you can set in Mail from Edit⇨Attachments; see Figure 11-1.

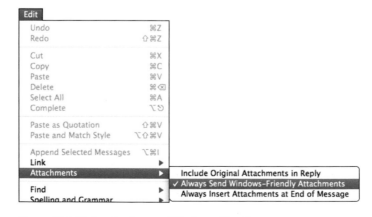

Figure 11-1: Make attachments Windows-friendly.

Because this is a book about iPhoto, I'll stick to showing you how to include your photos in Apple's Mail application using iPhoto. Chapter 2 covers the General Preference pane where you can choose one of the other e-mail clients listed, if you prefer.

Sending photos directly from iPhoto

Here's how to send an e-mail directly from iPhoto. The nice part is you don't have to have Mail or any of the other three email applications open before starting these steps. If you haven't done this already, in Mail, choose Edit➪ Attachments➪Always Send Windows-Friendly Attachments. (See the preceding section.)

With iPhoto open, follow these steps to e-mail a photo directly from iPhoto:

1. **In iPhoto's main window, highlight the photo(s) you wish to e-mail and then click the Email button on the iPhoto toolbar. (See Figure 11-2.)**

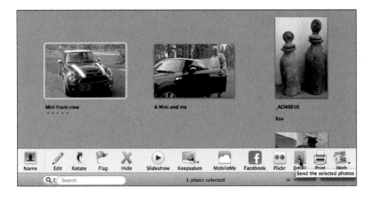

Figure 11-2: Click Email to attach a photo.

2. **In the dialog that appears (see Figure 11-3), make the following selections:**

 • *Size:* You can choose a Small, Medium, or Large photo or choose to send the actual size as it appears in iPhoto. If you make it too large, your Internet service provider (ISP) — or your recipient's ISP — might not accept the e-mail. If the photo is only going to be viewed on the computer and not printed, the small or medium sizes are usually the best. For printing, consider large or actual size to provide the necessary resolution. The photo is converted to a JPEG file for you.

 • *Include:* In previous chapters, I tell you how you can assign titles, descriptions, and location information to your photos. Here, select or deselect the check boxes to indicate your preference on which of this information is sent along with the photo.

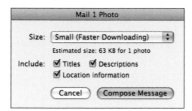

Figure 11-3: Set the attached photo size here.

3. **Click the Compose Message button.**

4. **The photo(s) appear in a new e-mail in Apple Mail, as shown in Figure 11-4.**

Figure 11-4: A new e-mail with an attached photo.

5. **Fill out the e-mail headers (the To and Subject fields) and optional message; then click Send.**

 Your photo(s) is sent on its way.

Using the Mail Photo Browser

Here's a way to send photos from the iPhoto Library without actually open-ing iPhoto: You can use the Photo Browser in Apple Mail. This is a very con-venient way to send photos from iPhoto.

1. **Open Mail and then choose Window⇨Photo Browser.**

 The Photo Browser window opens, displaying the contents of your iPhoto Library. See Figure 11-5.

2. **In Mail, open a new message by choosing File⇨New Message or by pressing ⌘+N.**

3. **Select the photo(s) you wish to send and drag it from the Photo Browser window into the Mail message window.**

4. **At the bottom of the Mail window, set the photo size you wish, fill out the headers, add an optional message, and click Send.**

 See Figure 11-6.

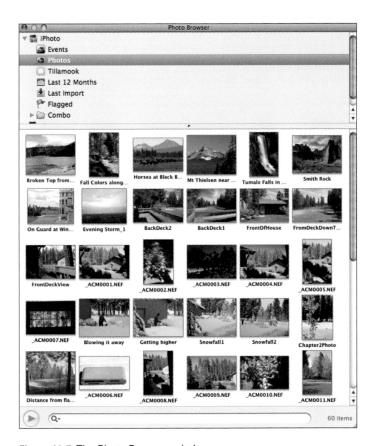

Figure 11-5: The Photo Browser window.

Set the photo size

Figure 11-6: Add photos from the Photo Browser.

Burning Your Photos and Albums to Discs

Although not as fast, creating a CD or DVD with your photos is definitely a more secure way of sharing or even backing up your memories.

If you use the method that follows to share your photos, the person you're sharing them with must also have iPhoto and should be using the same version of iPhoto as you do.

However, to share photos with Windows users, export the photo(s) from iPhoto to your computer, insert a blank CD or DVD, drag the exported photos onto the disc icon, choose File⇨Burn Disc on the Finder menu bar, and then click Burn.

To burn a CD or DVD from iPhoto (remember, this disc can only be read in iPhoto) do this:

1. **Open iPhoto and select the individual photos or Albums you want to burn to disc.**

2. **On the iPhoto toolbar, choose Share⇨Burn, as shown in Figure 11-7.**

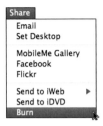

Figure 11-7: The Share menu in iPhoto.

A dialog appears (as shown in Figure 11-8), asking you to insert a blank disc. XX If you have other CD/DVD applications such as Toast that you use for burning CD's/DVD's, you may use them instead of the Finder.

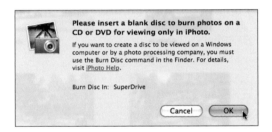

Figure 11-8: iPhoto leads you, step by step.

3. **Insert a blank CD or DVD and then click OK.**

 When your Mac recognizes the disc, information about the CD or DVD appears above the iPhoto toolbar .

4. **In the Name field, change the name of the CD or DVD. Then click the Burn button to initiate the action. (See Figure 11-9.)**

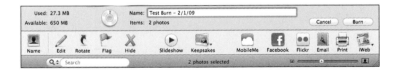

Figure 11-9: Change the disc name and burn.

Before the burn begins, the Burn Disc dialog appears (as shown in Figure 11-10) confirming the number of photos to be burned. The dialog also gives you the choice to cancel the burn, eject the disc, or proceed with the burn.

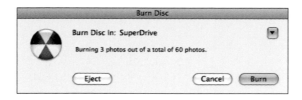

Figure 11-10: The final Burn Disc dialog.

5. **If everything is correct, click the Burn button.**

6. **A burn progress dialog appears (as shown in Figure 11-1), allowing you to see the progress of the disc burn.**

You can stop the burn by clicking the Stop button, but the disc might not be readable after stopping. This process may take some time.

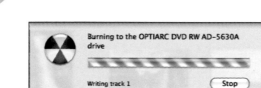

Figure 11-11: Burn, baby, burn.

When the burn process finishes, the new disc appears in the Source list, under Shares, with the title you gave it.

7. **To eject the disc, click the up arrow beside the disc name in the Source list.**

Figure 11-12 shows the recognized disc in my example.

Click to eject your new CD or DVD

Figure 11-12: Look for the new disc under Shares.

Getting on the Web with MobileMe

Perhaps the best way to allow the most people to see your photos is to put them on the Web. If you're fortunate enough to have a MobileMe account, you know it's a great way to keep everything in sync, from e-mail and contacts to calendars.

And with the capability to host your photo Albums in your Gallery, they're accessible anywhere in the world to anyone you authorize — or everyone, if you choose. You can even choose to allow others to download your photos or upload some of their own (maybe some shots from a party or an event that you didn't capture).

Exhibiting in a Web Gallery

Here's how to publish your photos or Albums in a MobileMe Gallery from iPhoto:

1. **Open iPhoto and select the item to publish: an Event, an Album, or some photos from your Library.**

2. **From the iPhoto menu, choose Share➪MobileMe Gallery or click the MobileMe button on the iPhoto toolbar.**

 For this example, I chose an Album of World War II airplane photos, as shown in Figure 11-13. Any location information set for the photos is also present in the Gallery.

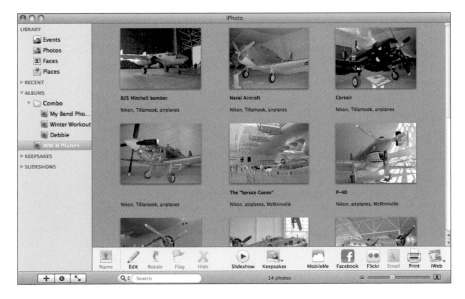

Figure 11-13: Select the photos to publish to MobileMe.

3. Choose the options you desire from the resulting dialog in iPhoto.

Figure 11-14 shows this dialog, where you have the following options:

- *Make the Album viewable by everyone or by only you; or, set names and passwords for individuals to whom you grant viewing rights.* Making the Album viewable by everyone makes it *public* — anyone who has the Web site address can view it.

- *Allow downloading of photos or an entire Album.*

- *Allow uploading of photos via a Web browser.* Select this if you want to allow others to add to the Album. If you do, anyone who can view the Web site can upload any photo they wish.

- *Allow adding of photos by e-mail.* By selecting this, you can create an e-mail address to which you can send photos from your iPhone, some other mobile device, or a computer.

- *Show photo titles.* This will show the titles from iPhoto for each photo in the Album.

- *Show e-mail address for uploading photos.* If you allow adding photos by e-mail, you can also make the e-mail address for doing this visible to all viewers of your Gallery. If you wish to reserve this right for yourself, don't select this option.

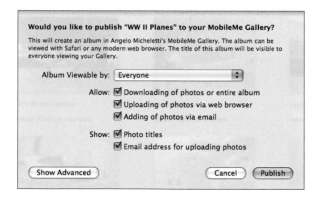

Figure 11-14: Publishing to MobileMe options.

4. Click the Show Advanced button to get more options.

As shown in Figure 11-15, you can choose to Hide Album on My Gallery Page, which means the Album is viewable at its own Web site address but isn't accessible from your Gallery homepage.

Would you like to publish "WW II Planes" to your MobileMe Gallery?

This will create an album in Angelo Micheletti's MobileMe Gallery. The album can be viewed with Safari or any modern web browser. The title of this album will not be visible to everyone viewing your Gallery.

Album Viewable by: [Everyone ▲▼]

Allow: ☑ Downloading of photos or entire album
 ☑ Uploading of photos via web browser
 ☑ Adding of photos via email

Show: ☑ Photo titles
 ☑ Email address for uploading photos

Advanced: ☑ Hide album on my Gallery page
Download quality ✓ Optimized (faster uploading, prints up to 16" × 20")
 Actual Size (slower uploading, larger file sizes)

(Hide Advanced) (Cancel) (Publish)

Figure 11-15: Advanced settings.

5. **Set the size and quality of any downloaded photos.**

 This setting affects how long it takes to upload to your Gallery, but it also sets the size of photos when anyone downloads them.

6. **Click the Publish button.**

 When the publish operation is finished, the window in iPhoto contains the Gallery Web site address — and, in my example, the e-mail address for uploading photos. Figure 11-16 shows the iPhoto main window after the publish.

Gallery Web site

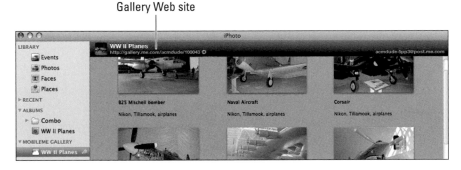

Figure 11-16: The iPhoto main window after you publish you photos.

Click the Gallery Web site address (at the top of the main window in iPhoto) to go to your MobileMe Gallery and see the result of the Publish operation, in your browser, as shown in Figure 11-17.

Click to announce your Gallery

Figure 11-17: Your new MobileMe Gallery.

7. **Click the Tell a Friend icon (on the top-right side of the Gallery page) to send an e-mail to friends and family announcing your Album and giving them the Web address.**

 Figure 11-18 shows an example.

 Great stuff, right? All you need to give folks is the MobileMe Web site address, and they can see your photos. And you can update Albums as often as you like, doing it all within iPhoto. But that's not all; keep reading.

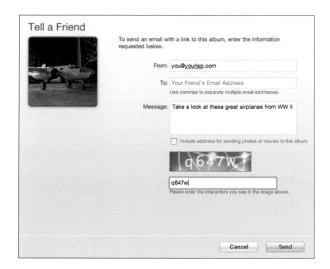

Figure 11-18: Announce your new Gallery.

Creating a photo Web site with iWeb

If you installed Apple's iWeb application (another component, along with iPhoto, of the iLife suite of applications), you can create either a photo Web page or a blog and allow friends and relatives to access your photos that way. In the last section of this chapter, you see how you can still make photo Web pages even if you don't have iWeb.

For now, see how easy it is to get your photos onto the Web.

1. **Open iPhoto and select the item to publish: an Event, an Album, or some photos from your Library.**

2. **From the iPhoto menu, choose Share⇨Send to iWeb⇨Photo Page.**

 You can also click the arrow on the iWeb button on the toolbar and select Photo Page from the drop-down menu.

 This exports your photos to a page that's designed to display images.

 Alternatively, you can choose Send to iWeb⇨Blog to create a blog page using your photos.

If your copy of iWeb wasn't already open, iPhoto automatically opens it. There are many choices you can make within iWeb to create the photo page or blog of your desires. To get detailed information about using iWeb, check out *Macs All-in-One Desk Reference For Dummies,* by Wallace Wang (Wiley Publishing). For now, Figure 11-19 shows an example of what a photo page might look like in iWeb.

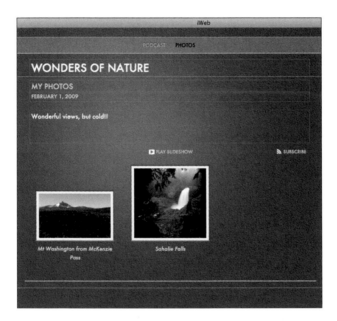

Figure 11-19: A typical iWeb photo page, ready for editing.

Now all you have to do is let everyone know the Web address for your photo page or blog.

Interfacing with an iPhone

For those of you (like myself) who are fortunate enough to have an iPhone, you can import your iPhone camera photos directly into iPhoto. If you have iPhoto open, as soon as you connect your iPhone to your Mac, iPhoto recognizes it and shows it under Devices in the Source list and puts iPhoto into Import mode. Figure 11-20 shows an example of this. As you can see, my iPhone is named just that: My iPhone.

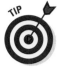

What if you don't have iPhoto open and you want to make sure it doesn't automatically open when you connect your iPhone? There is a way. An application on your Mac, called Image Capture, controls this. Find Image Capture on your hard drive and double-click it to launch it. Choose File⇨Preferences. The first item is for your camera. Change the pop-up menu to say No application. Then close the Preference dialog and quit Image Capture. The downside of this is that Image Capture will not automatically open when you plug your camera into your computer; but neither will iPhoto. And if you open iPhoto first and then plug in either your camera or iPhone, iPhoto will recognize them and allow imports. So not a bad compromise.

To download the iPhone camera's photos into iPhoto, here's all you have to do:

1. **Fill in an Event Name and Description in the iPhoto window. (Refer to Figure 11-20.)**

2. **(Optional) Select the two check boxes.**

 See Chapter 3 for an explanation of these options.

iPhone displayed in the Source list

Figure 11-20: My iPhone is recognized in iPhoto.

3. **Select which photos you want to download and then click the Import Selected button; or download them all by clicking Import All.**

4. **When the dialog appears, choose to either Delete Originals from the iPhone or retain them.**

 That's it! Your personal photos are now securely in the iPhoto Library, ready for you to use all your iPhoto skills.

If you took advantage of MobileMe to upload your photos into your Gallery, and if you allowed e-mail updating of your Gallery photos (see the "Exhibiting in a Web Gallery" section earlier in this chapter for details), you can create an e-mail with photos attached, on your iPhone, and see them appear, almost magically, in your Gallery.

Using Facebook and Flickr

Facebook and Flickr are two of the most popular social networking Web sites today. They're a great way to share photos of yourself and friends with a world-wide audience. A real bonus is that you don't need to get any plug-ins to make the interfaces between iPhoto and Facebook or iPhoto and Flickr work because they're built in. And if you choose to view them (you do this by choosing iPhoto View⊅Show in Toolbar), Facebook and Flickr buttons appear on the iPhoto toolbar. (See Figure 11-21.) For more details on Facebook and Flickr rules and operations, see their respective Web sites.

The Facebook and Flickr buttons

Figure 11-21: Facebook and Flickr on the toolbar.

Working with Facebook

Here's how to publish photos in Facebook:

1. **Open iPhoto and select the photos, Events, or Albums you want to publish; then click the Facebook button on the toolbar.**

2. **The dialog shown in Figure 11-22 appears and asks if you want to enable this copy of iPhoto to publish to Facebook; click Set Up.**

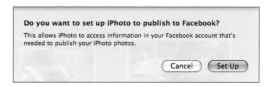

Figure 11-22: Set up iPhoto to publish to Facebook.

3. **Either log in or sign up for Facebook. (See Figure 11-23).**

 After you're logged in for the first time, a dialog appears, requesting you to allow iPhoto Uploader to operate.

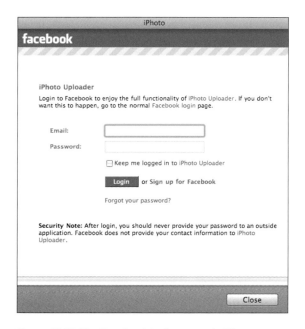

Figure 11-23: The Facebook login screen in iPhoto.

4. **Click the Allow button, and then close the dialog.**

 The next dialog asks if you want to publish to Facebook and who should be allowed to view your photos.

5. **Choose Everyone, Friends of Friends, or Only Friends. Then click the Publish button. (See Figure 11-24.)**

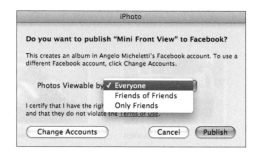

Figure 11-24: Ready to publish in Facebook.

Your photos appear in the Source list as a published Album under Facebook. Figure 11-25 shows this.

6. **Select the Album to see your photos within iPhoto; click the Web site address at the top of the window to see how they appear in Facebook. (See Figure 11-26.)**

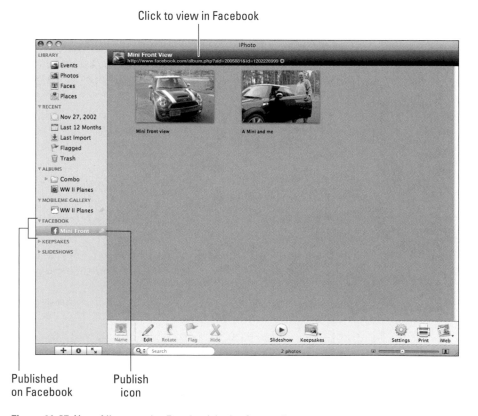

Figure 11-25: Your Album, under Facebook in the Source list.

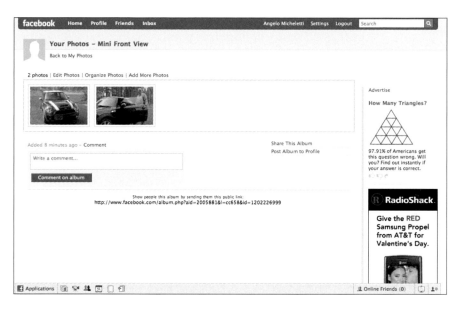

Figure 11-26: See your photos in Facebook.

7. **(Optional) You can now add photos or Events to the Album by drag-ging them from your Events or Photos to the Facebook Album in the Source list. You can also remove photos from the Album by dragging them to the iPhoto Trash.**

Any time you make a change to the Facebook Album, click the Publish icon to sync with Facebook. The icon is next to the Facebook Album name and looks like a radio beam. (Refer to Figure 11-25.)

You can also make changes in Facebook. The next time you sync the Facebook Album in iPhoto, any additions appear as Web-sized versions in your Facebook Album.

To stop publishing your Album in Facebook, select the Album and press Delete.

When you delete the Album, it no longer appears on Facebook or in iPhoto, but the photos are still be in your iPhoto Library.

Working with Flickr

Publishing your photos with Flickr works in a similar way to publishing in Facebook. Follow these instructions:

1. **Open iPhoto and select the photos or Events you want to publish; then click the Flickr button on the toolbar.**

2. **The dialog shown in Figure 11-27 appears and asks if you want to enable this copy of iPhoto to publish to Flickr; click Set Up.**

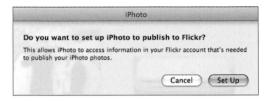

Figure 11-27: Set up iPhoto to publish to Flickr.

3. **Either log in or sign up for Flickr.**

 After you've logged in for the first time, a dialog appears (see Figure 11-28), requesting you to allow iPhoto Uploader to operate.

4. **Click the OK, I'll Allow It button and then close the window.**

 A dialog appears in iPhoto, confirming whether you want to publish the photos or Events you selected.

5. **Choose to make them viewable by Anyone, Only You, Family, or Family and Friends. Then select the Photo Size.**

 See Figure 11-29.

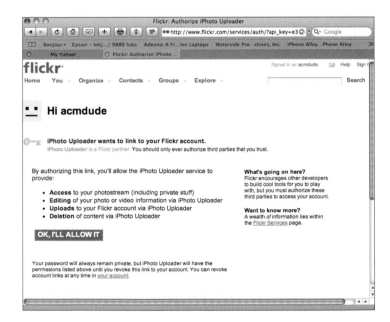

Figure 11-28: Allow the iPhoto Uploader link.

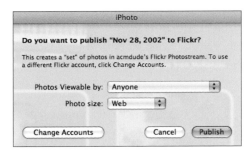

Figure 11-29: The Publish parameters dialog.

Your photos appear in the Source list as a published Album under Flickr. (See Figure 11-30.)

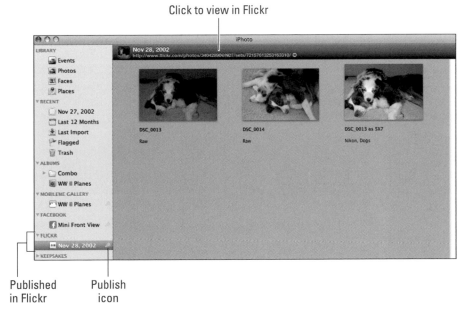

Figure 11-30: A Flickr Album in the iPhoto Source list.

6. **You can select the Album and see your photos within iPhoto; or click the Web site address at the top of the window to see how they appear in Flickr. (See Figure 11-31.)**

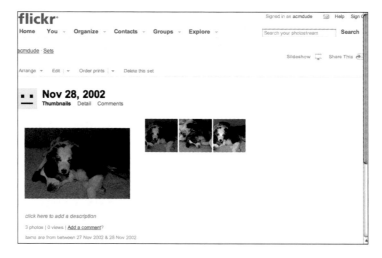

Figure 11-31: View your photos in Flickr.

7. **(Optional) You can now add photos or Events to the Album by dragging them from your Events or Photos to the Flickr Album in the Source list. You can also remove photos from the Album by dragging them to the iPhoto Trash.**

Like in Facebook, any time you make a change to the Flickr Album, click the Publish icon to sync with Flickr. The icon is next to the Flickr Album name and looks like a radio beam. (Refer to Figure 11-30.)

You can also make changes in Flickr. The next time you sync the Flickr album in iPhoto, any additions appear as Web-sized versions in your Flickr Album.

8. **To stop publishing your Album in Flickr, select the Album and press Delete.**

The Album no longer appears on Flickr or in iPhoto, but the photos are still in your iPhoto Library.

Pretty straightforward stuff but with a lot of power for sharing. And best of all, it's free.

Subscribing to Photo Feeds

Although this section is about showing and sharing your photos, you're on the receiving end. In this case, it isn't *your* photos being shared; rather, it's a friend or relative sharing his through a *photo feed*.

Whether your friends use MobileMe, Facebook, Flickr, or other similar Web services to post their photos, iPhoto makes it convenient for you to enjoy them — and all within the confines of the iPhoto application. No matter where they post their photos, as long as they provide you with the host URL address (that thing that starts with "`http://`"), here's how to subscribe to a photo feed.

1. **In iPhoto, choose File⇨Subscribe to Photo Feed.**

2. **In the dialog box that opens (see Figure 11-32), paste or type the URL that was given to you.**

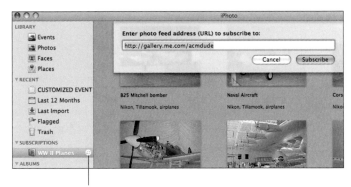

Click to refresh the subscription

Figure 11-32: Subscribe to a photo feed.

3. **Click the Subscribe button.**

 iPhoto handles the communication with the site, and you see the Subscriptions heading appear in the Source List as well as the name of the photo file under it.

4. **Click the name of the photo file.**

 The photos appear in the main iPhoto window.

5. **(Optional) To refresh the subscription, click the circular icon at the right of the name. (Refer to Figure 11-32.)**

 That's all there is to it.

Exporting to Other Applications

Even with all this capability, sometimes you just want to create something else using your photos. The good news is that in iPhoto, you can.

Using the iPhoto's standard export capabilities allows you to do things like these:

- Export your photos to your hard drive so that you can burn them to a CD or DVD and use them outside of iPhoto. From your hard drive, for instance, you can attach the photos to any e-mail client you use, not just the ones I mentioned earlier.

- Create a QuickTime movie of selected photos.

- Create an MPEG-4 slideshow, complete with music, for a range of devices.

- Save a group of photos as a simple Web page that you can then upload to a server for display in a Web browser.

You can also use third-party software (available on the Web; also see Chapter 14) written especially for the Export dialog to expand the choices you have.

The following sections take a look at the standard choices for exporting from iPhoto.

Exporting to your hard drive

Earlier in this chapter, I mention that if you want your photos available to use outside of iPhoto, you must export them and use the Finder or other application such as Toast to burn a CD or DVD. Here's how to do the export:

1. **Open iPhoto and select an Event, Album, or group of photos in iPhoto to export.**

2. **From the iPhoto menu, choose File⇨Export.**

 The Export Photos dialog appears.

3. **Click the File Export button at the top of the Export Photos dialog.**

 See Figure 11-33 for the location of this button.

4. **In the File Export portion of the Export Photos dialog, you can choose the format of the exported photos.**

 Your choices, in the Kind field, include JPEG, TIFF, PNG, the Original format, or the current photo format.

 The dialog also provides these options:

 - *JPEG Quality:* If you're exporting JPEGs, you can choose the quality.

 - *Include:* Select the Title and Keywords check box to include the title and keywords you've assigned to the photos in the export. Select the Location Information check box if you've assigned location information to the photos and want that information to travel with them.

- *Size:* Choose the size of the exported file.

- *File Name:* You can choose what to use as the filename.

 If you choose Sequential, enter the prefix for the sequence in the Prefix for Sequential field. For example, say you use *Airplanes.* Then iPhoto assigns sequential filenames, like this: Airplanes1, Airplanes2, Airplanes3, and so on.

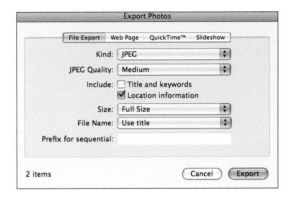

Figure 11-33: The File Export portion of the Export Photos dialog.

5. **Click the Export button.**

6. **When you see a list of locations where the exported photos will be stored, make a choice and then click OK.**

Saving photos as a simple Web page

Saving a group of photos as a Web page that you can then upload to a server is easy to do in iPhoto. If you don't want to use iWeb, this provides a very quick and simple way to provide your photos for viewing in a Web browser. Here's how:

1. **Open iPhoto and select the photos you want to appear on your Web page.**

2. **Choose File⇨Export from the iPhoto menu.**

3. **Click the Web Page button at the top of the Export Photos dialog. (See Figure 11-34 for the location of this button.)**

4. **When the Web Page portion of the Export Photos dialog opens, you can choose the title, columns and rows, the template to use, the size of the thumbnails and images, and whether to include location information.**

5. **After you make your choices, click Export.**

 A dialog appears, allowing you to choose where to store the Web page.

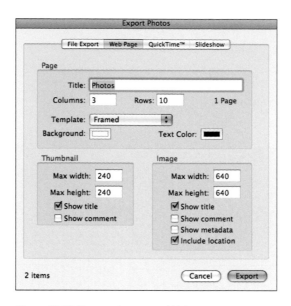

Figure 11-34: Export photos to a Web page.

6. **Click OK.**

 To preview your page in a browser before uploading it to a server, go to the location you chose in Step 5 and double-click the `index.html` page.

Saving photos as a QuickTime movie

Another standard way to present your photos is by creating a QuickTime movie file. This is a slideshow movie that you can playusing the QuickTime Player or any application that supports QuickTime. Here's how easy it is:

1. **Open iPhoto and select the photos you want to appear in your QuickTime movie.**

2. **Choose File⇨Export from the iPhoto menu.**

3. **Click the QuickTime button at the top of the Export Photos dialog. (See Figure 11-35.)**

4. **Change the options to suit your purposes:**

 • *Images:* Set the maximum dimensions for your movie and the display interval for each photo.

 • *Background:* Select the Color radio button and then click the preview swatch to pick your color. To select an image, select the Image radio button and then click the Set button.

 • *Music:* Choose whether to include the same background music selected in the Slideshow Settings window (described in Chapter 13).

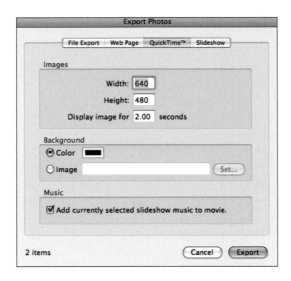

Figure 11-35: Show photos in a QuickTime movie.

5. **Click the Export button.**

6. **In the dialog that appears, asking where to store the movie, choose a location, and then click OK.**

To view your movie, use QuickTime Player or any application that supports QuickTime.

Saving photos as a slideshow MPEG-4 video

The final, standard way of exporting your photos involves exporting your slideshow project as an MPEG-4 movie that you can view on your iPod with a color display, an iPhone, Apple TV, or your computer display. To do this follow these steps:

1. **Open iPhoto and select a slideshow from your Source list.**

2. **Choose File⇨Export from the iPhoto menu.**

3. **Click the Slideshow button at the top of the Export Photos dialog. (See Figure 11-36.)**

4. **Choose a size that corresponds with the intended device.**

 Notice, in Figure 11-36, the blue dots in the columns for each size that's appropriate for each device. I chose Mobile in my example.

5. **Choose whether to automatically send the slideshow to iTunes.**

 If you're going to sync to an iPhone or an iPod, this is imperative.

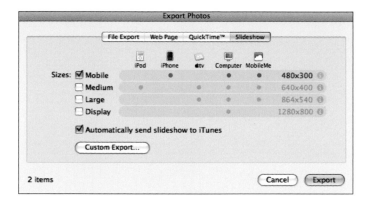

Figure 11-36: Export a slideshow of photos.

6. **(Optional) You can specify a number of custom settings (such as video and sound settings) by clicking the Custom Export button.**

7. **After you make your choices, click the Export button.**

 A dialog appears, asking where to store your file. The default is a folder named iPhoto Slideshows.

8. **Choose the location and then click OK.**

 For syncing your devices, see each manufacturer's instructions.

12

Printing Your Photos

In This Chapter

▶ Choosing the correct paper for printing

▶ Trying out different themes, backgrounds, and borders

▶ Printing multiple photos on one sheet of paper

▶ Using the Adjust tool to make changes prior to printing

▶ Using default and customized printer settings

▶ Using iPhoto's printing service instead of a personal printer

*P*hotographers, whether professional or amateur, really seem to enjoy capturing important events as photos. Then, when you edit your shots to bring out as much quality as possible, you certainly want a print that reflects all your hard work. After all, a lot of the fun of photography is taking the finished photos and making prints that you can hang on the wall, proudly displaying the results.

As you might guess, the print process is what I cover in this chapter, along with ways to create elegant photo books, calendars, and cards. Generating a hard copy can be the most stimulating and rewarding part of the whole creative process of photography.

Printing Photos from iPhoto

I have to get this disclaimer out of the way: With the large number of printer styles, prices, and manufacturers available, I can't discuss the ins and outs of every type. Yes, printers are critical hardware, but they have so many variations. Let me just say that with all the considerations that go into making a printer-purchase decision, don't forget this overriding thought: Get the best you can afford. You won't regret it. In the long run, the cost of consumables (paper and ink) is far greater than the hardware cost. If you

can, stick with brands that you have experience with and know their reputation. For me that's Epson, HP, and Canon. Printing is where you show off your creativity, so don't short-change yourself.

There is no one, absolute, and correct process to follow in choosing and printing your photos. Make sure you first consult your printer's manual so you get all the details on how to get the best results with that particular model. But here are some useful ideas to keep in mind while you set out to do your printing, regardless of which type or brand of printer you're using.

- ✔ **If you have a large number of photos to print, first print a *contact sheet*. Think of this as a sheet of *thumbnail* (small) images.** Making a contact sheet allows you to see what the photos look like on the paper you're using. Too, you can mark up each photo with things like crop marks, photo adjustment notes — and, in fact, decide whether to even print a particular photo.

- ✔ **Try different papers, both glossy and matte.** It's amazing what a difference the paper can make in the final print. You can do this economically by printing a few contact sheets with different papers.

- ✔ **After printing, let the print dry for a couple of hours, at least.** Prints tend to darken slightly when they dry, and what looked good at first might require more adjustment for the final print.

Here's another thought to keep in mind: In iPhoto, you can select one or more photos — or an entire Event — and print using just one execution from the Print dialog. Note, though, that when you batch print, the settings in the Print dialog apply to *each of the selected photos,* unless you select a photo, hold down the Option key, and then make an individual change of the background, borders, and layout for that photo.

As you learn the capabilities of iPhoto, sharpen your editing skills, and understand your printer's capabilities, your printing process will become second nature.

Choosing print themes and backgrounds

Start by making theme and background choices.

1. **Select the Event or photos that you want to print, and then either click the Print button on the toolbar or choose File⇨Print from the iPhoto menu.**

 Figure 12-1 shows the Print pane that opens. Notice that your default printer is selected, but every other printer that Mac OS X recognizes as available to your computer or network is listed when you open the Printer pop-up menu. Of course, you may choose from this list another printer to use. Also, in this window, you can select the paper size and print size you want.

Themes

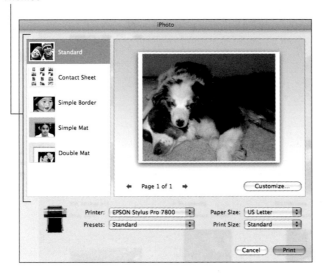

Figure 12-1: The Print pane.

2. **Select the theme listed on the left that will work for you.**

 Here's some information to help you select a theme:

 - *Standard:* Prints the photo with a white edge around it.
 - *Contact Sheet:* Prints all the selected photos in thumbnail size on one page.
 - *Simple Border:* Prints the photo with a box around the edge.
 - *Simple Mat:* Prints the photo with what looks like a traditional photo mat around it.
 - *Double Mat:* Prints the photo to look like you put a double-mat around it.

 The preview picture changes to show you what your photo looks like with that theme.

3. **(Optional) To tweak your print, click the Customize button.**

 Figure 12-2 shows you the Customize pane, from which you can make changes with the Themes, Backgrounds, Borders, and Layout buttons. You can also access the Adjust tool here to make changes to the photo without going to Edit mode. Click the Print Settings button to return to the default Print window.

 At the top of the window showin in Figure 12-2 is a viewing strip with two buttons at the left. The top button will show you all the pages to be printed. The bottom button shows all the photos to be printed.

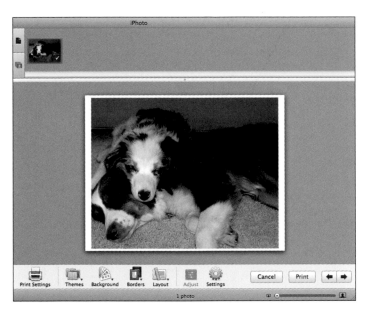

Figure 12-2: Customize prints before printing.

For any of the first three themes (refer to Figure 12-1), the choices in the other toolbar buttons are minimal, so I'll concentrate on choices that exist for the Double Mat theme.

4. **Click the Background button on the toolbar and select one of the 26 choices.**

 For this running example, I chose number 3. See the results in Figure 12-3.

Figure 12-3: The background choices and the application of option 3 with Double Mat.

Resuming the print process

Once you have started to print, a Printing icon appears i the Source List. If you're interrupted before you finish printing, iPhoto helps you out. Clicking this icon makes it very convenient to do other work in iPhoto. Or you can even quit iPhoto, start iPhoto again, and then simply click the Printing icon to return to where you were in the printing sequence.

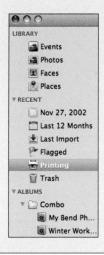

Picking the border and layout

When you selected a Theme you set the basic look (in this example, Double Mat), the next task is to pick a specific border and layout. If you haven't already picked a theme and background, do so. (See the previous section.) then follow these steps:

1. **Click the Borders button on the toolbar to open the Borders menu, then choose one of the seven types.**

 I chose number 6. Figure 12-4 shows what the example looks like so far.

2. **Click the Layout button on the toolbar to open the Layout menu, and then select one of the 24 choices.**

 I chose entry one, and then the second one in the submenu, and I created a line of text for the photo. Figure 12-5 shows the results.

The Layout menu is very comprehensive and even allows you to work with multiple photos and arrange them on a single sheet of printer paper. This can save you some cash because you can get more than one print from one sheet of photo printing paper. Or you just might want to combine photos in different panes on the single sheet of paper for artistic reasons.

Figure 12-4: Photo, with background and border choices applied.

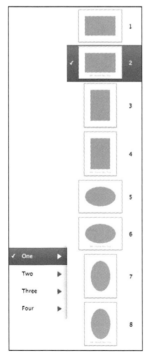

Figure 12-5: Result of the Layout choice.

But what if you decide you don't like the order the photos appear in? Luckily, this kind of thing is easy to correct and doesn't require you to start over. Follow these steps if you change your mind:

1. **Place the mouse over the photo you wish to move.**

2. **Click and drag the photo to the area desired.**

 The photo you drag and the one you drag it over change places. This makes it much easier to try out different arrangements before proceeding with the printing. Figure 12-6 shows this change being made.

Here are some other handy things to bear in mind:

- ✔ **At any time, you can go back and try different combinations of backgrounds, borders, and layouts until you're satisfied.**

- ✔ **If you choose one of the layouts that has text, use the Settings button on the toolbar to change the formatting of the text.**

- ✔ **When you're printing just one photo, clicking the Settings button also allows you to make Multiples of the Same Photo per Page when you choose a layout that allows this.**

 This helps you make enough copies for friends and relatives and still save photo paper.

- ✔ **Photos in the viewer that you've used in a multiphoto layout sport a white check mark.**

Figure 12-6: Move photos to your heart's content.

Making final changes with the Adjust tool

After you settle on all the aesthetic changes to the look of the to-be-printed sheet, you have the chance to make final corrections to the photos.

Thanks to the inclusion of the Adjust tool in the Customize pane, you don't have to return to Edit mode to make these corrections. To make photo corrections in the Customize pane (see the previous sections to get there), follow these steps:

1. **Select the photo(s).**

 • *If you're working with only one photo:* Select it by clicking it with the mouse; then click the Adjust button on the toolbar.

 • *If you have multiple photos (refer to Figure 12-6):* Select the photo to work on and then click the Adjust button. If you want to make the exact same adjustments to all the photos, you can select them all (hold down the Shift key and click on each photo) and then click the Adjust button. Moving any slider or size control now affects all the photos.

 Figure 12-7 shows one photo selected and the Adjust tool window open.

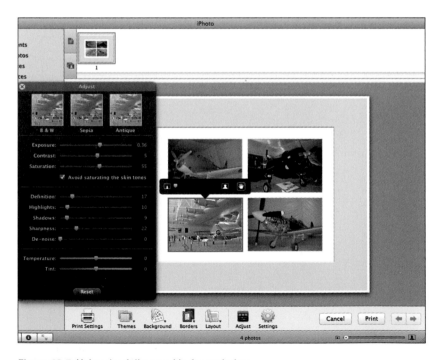

Figure 12-7: Using the Adjust tool before printing.

2. **(Optional) Increase or decrease the photo size.**

 Check out the slider control just above the photo in question. Use this slider to increase or decrease the size of the photo within the confines of the layout. And by clicking and dragging, you can move the photo around. Figure 12-8 shows the result of increasing the size and moving the photo.

3. **When you're satisfied with the result of your changes, click the Print button to proceed with the printing process.**

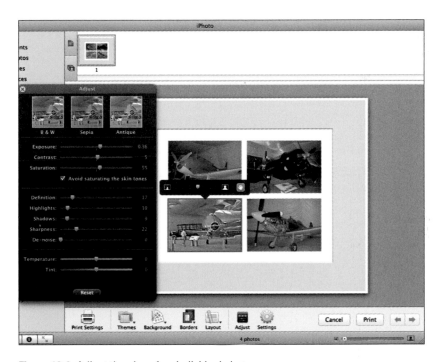

Figure 12-8: Adjust the size of an individual photo.

Printing Your Photo on Your Home Printer

At this point in the chapter, you've made some decisions regarding how you want your photo to look in the final print. Don't forget, however, that you can always change these decisions any time before you actually click Print.

Unlike other operations in iPhoto, printing changes that you make in the Customize pane — including resizing, as described in the preceding section — apply only to the print operation. These changes don't appear in your Library, Albums, books, cards, calendars, or slideshows.

The printer settings that you choose ensure that what you want to see in a print is the result that you get from your printer's hardware and software.

As I mention earlier, each printer is different, and I can't go into detail on each one. Make sure you read your printers manual for guidelines on using it. In this section, however, I give you a general idea of the choices you'll see during the print process, and I tell you what each means. Remember, though, that, the dialogs shown here will likely be slightly different, depending on your particular brand and model of printer.

Choosing printer settings

Up to this point in the chapter, you've finished at least the first pass at setting up your photo for printing — and you might have had your printer crank out a few test prints. Here's what comes next: You make the final choices in the printing process, choices regarding things like print quality, paper size, and color settings. I use an example photo to take you through the steps.

1. **Click the Print button, located on the bottom-right side of the iPhoto main window.**

 This sends the project to your selected printer and starts entering printer-specific information.

 You see a Print dialog showing the name of the printer, a thumbnail of the photo to be printed, and a pop-up menu in the middle that shows the default iPhoto setting.

2. **Click the pop-up menu and choose Print Settings. (See Figure 12-9.)**

 In the Print dialog that opens (see Figure 12-10), you can change things like the media type, whether you want color or black and white, the color space to use, and some print-quality settings that will vary, depending on the type of printer you have. Figure 12-10 shows the choices for my example and my printer.

Selecting paper type and color settings

Now you choose paper type and make color setting choices.

First, examine the default values and see whether they meet your needs. Back in Figure 12-10, you can see the basic default values for my example print and my particular printer. If you like these values, just go ahead and click the Print button.

In my running example, though, I want to change the Media Type because the paper I'm using is different than the default, and I want the Color Settings set to use the larger color space called Adobe RGB. This should allow for more accurate colors in the print. See Figure 12-11.

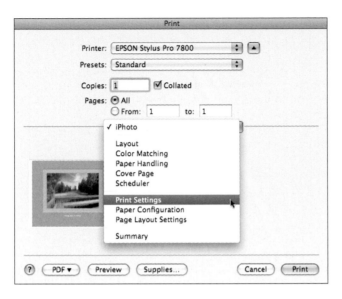

Figure 12-9: The first Print dialog, with defaults.

Figure 12-10: Change print settings here.

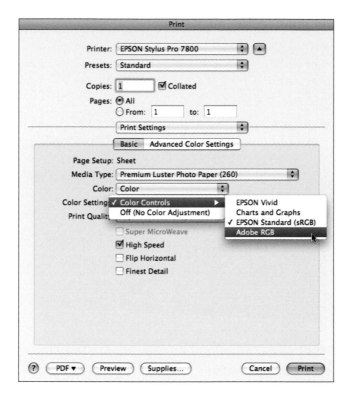

Figure 12-11: I changed some default print settings.

Now look at the Print Quality setting. (Refer to Figure 12-10.) Although I chose not to do so in my example, you can also change the Print Quality to get the resolution you desire, understanding that choosing a higher resolution takes longer to print, uses more ink and may not make a noticeable difference.

The Big Moment. Just click the Print button to complete your print project.

Sounds easy enough, but you don't really know if you'll like the print until you see it.

When you view a photo on your computer screen, you're viewing it with transmitted light. Looking at a print means that you're viewing reflected light from paper, which can produce quite a different look. If necessary, go back and use the Adjust tool to make corrections or change the type of paper you're using. It can make a lot of difference.

Using a printing service

If you don't have a printer that you feel is up to the task of printing your photos, another option is available directly from iPhoto: the Kodak Print Service. You still make all the photo-editing changes, such as cropping, straightening, removing red-eye, and using the Adjust tool to get the photo looking how you want. But you don't have to mess with multiple printer settings to figure out how to get your specific printer model to produce the look you want.

To use the Kodak Print Service, do the following:

1. **In iPhoto, select the photos or Events you want to print.**

2. **From the menu bar, choose File⇨Order Prints.**

 The Order Prints dialog appears, as shown in Figure 12-12. The dialog shows thumbnails of all the selected photos.

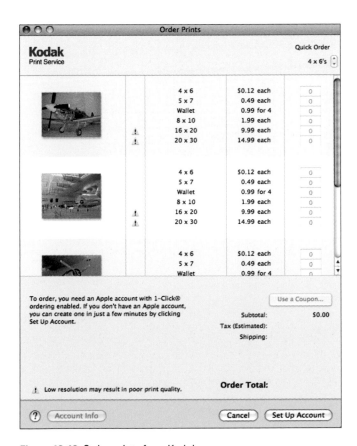

Figure 12-12: Order prints from Kodak.

3. **For each photo, select the print size and number of copies.**

 If you're ordering only 4" x 6" prints, use the Quick Order arrows at the top-right side of the dialog to specify the number of sets you want.

 For any sizes where the resolution of the photo is such that poor print quality will likely result, a yellow alert triangle appears. Select a smaller print size.

 If you don't already have an account, you must click the Set Up Account button before you can make any other selections.

 A series of dialogs take you through all the required financial information. You can even choose the shipment method.

4. **After reviewing your order choices, click the Buy Now button to place your order.**

 To check the status of your order, go to Apple Photo Services Support at `www.apple.com/support/photoservices`.

Now just sit back and wait for your prints to arrive.

Showcasing Your Photos

In This Chapter

▶ Crafting and customizing a photo book

▶ Adding travel maps to a photo book

▶ Creating a photo calendar

▶ Designing your own cards

▶ Creating high-quality slideshows

▶ Printing and distributing your work

*T*raditionally, when you want to share your photos, you make some prints to show people when you see them, or you e-mail those photos to friends and family because that's quick and easy to do. But what if you really want to make a statement with your photos and enhance the entire presentation so that they don't just get lost in the shuffle or erased along with the e-mail that brought them?

In this chapter, I show you four other ways to share your photos via iPhoto: photo books, calendars, cards, and slideshows. Some of them will require a little cash to bring them to fruition, but for the right occasion and for the right photos, the results can be priceless.

Have a look.

Creating a Photo Book

You have quite a few choices at your disposal when creating a photo book. From the overall look and feel, to whether the photo pages are printed double- or single-sided, you get to decide on a design that works for you.

In particular, you can decide on the following characteristics — and change them at will:

- **Book type and theme**
- **Page background and layout — per book or on a page-by-page basis**

 This includes placing a map showing the photo's location on the layout.

- **Picture placement on each page, manually or automatically**

Because this process is integrated into iPhoto, your book creation experience is quick and easy.

Picking a book type and theme

The two really great things about picking the book type and theme are that both are easy to do, and you can change your choices right up to the last minute. Here's how it works.

1. **Select one or more Albums or Events, or a group of photos, for your book.**

2. **Click either the + (Add) icon on the small toolbar and then choose Book; or you can click the Book icon on the toolbar or (if the width of the iPhoto window is below a certain size, click on the Keepsakes icon in the toolbar and then choose Book).**

 Figure 13-1 shows the dialog that appears, from which you can choose the book type and size as well as the book theme. The preview on the right side of the dialog shows you what your choices look like.

 Check out the various options and prices before you start by clicking the Options + Prices button. You do have to be online, first, though.

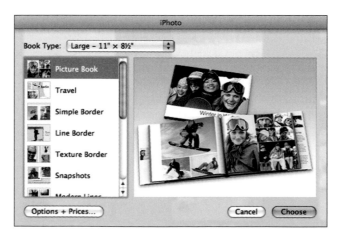

Figure 13-1: Start by choosing the book type and theme.

3. **After you make your choices, click the Choose button.**

 Notice that some themes allow text to be entered along with the photos.

 Figure 13-2 shows the result of choosing a type and theme. A new heading, Keepsakes, appears in the Source list, and the book appears under that heading. You can edit the book title at any time. By default, the title is the name of the Event being used as content plus the word Book or Untitled Book in the event you just chose a group of photos.

Across the top of the Book window, shown in Figure 13-2, is the photo browser, which looks like a film strip. In the photo browser, you see the photos that will appear in the book, in the order in which they'll appear. The first photo on the left side of the photo browser will appear on the cover. Just click and drag the photos to change the order at any time. As each photo is used, a check mark appears in its lower-right corner. In the middle pane of the Book window, you see the cover of your book and any text allowed. This text can be edited at any time. On the toolbar is a row of buttons, where you can (from left to right) perform the following actions:

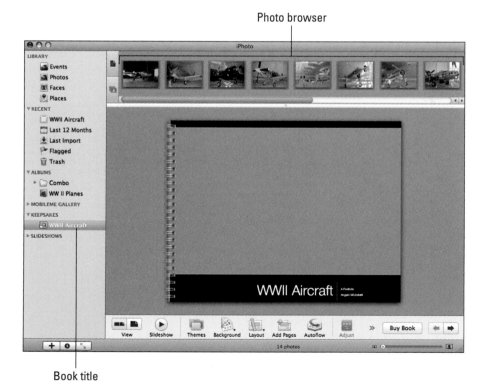

Figure 13-2: The Book window.

- Alter how you view the pages, either full-spread or single.
- Play selected photos as a slideshow.
- Change the theme.
- Modify the page background on individual pages.
- Change the layout on the various pages.
- Add pages to the book.
- Autoflow all your photos into the book automatically.
- Use an Adjust palette that is a combination of the Effects and Adjust palettes in the iPhoto Editor.
- Crop and move each photo on each page.
- Modify the formatting for the text on each page.
- Change the display size of the page using the slider on the bottom-right side of the window.

Wow, that's a lot of finessing! Keep reading to see how to use each button.

Changing your book backgrounds and layout

The choices provided by the Background and Layout buttons change, depending on the Theme you chose. To change the background, follow these steps:

1. **Use the right- and left-facing arrow buttons (on the far-right side of the toolbar) to move to the page you want to change.**

2. **Click the Background button to see what choices you have and then choose one, such as white, black, or a photo.**

 For this example, Figure 13-3 shows the choices for the current page.

3. **Continue using the right- and left-arrow buttons to change other pages as necessary.**

The Layout button works in much the same way but with more choices, depending on the Theme you're editing.

1. **If necessary, use the right- and left-arrow buttons to move to the page you wish to edit.**

2. **Click the Layout button to see your choices, and then make one.**

 In Figure 13-4, you can see the choices for the page I made. Your layout choices also include the name of the particular page type, such as an About page or a Contact page. You're free to choose any of them.

3. **Continue using the right- and left-arrow buttons to change other pages as necessary.**

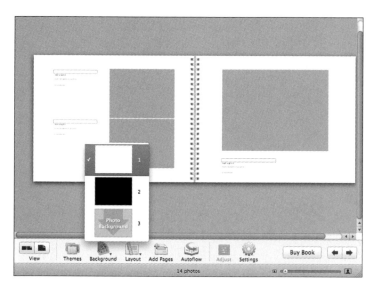

Figure 13-3: Make your background choice.

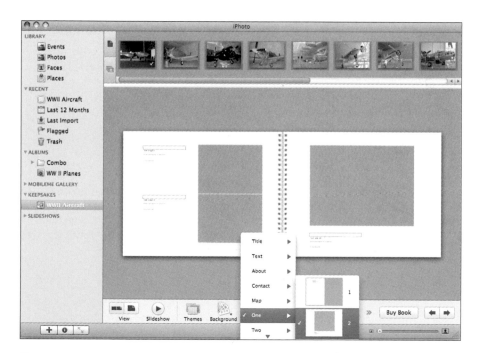

Figure 13-4: Make your layout choices.

Placing your photos

Of course, background and layout are only part of what goes into making a great photo book. The main ingredient is your photos — and, equally important, the order in which they're placed on the pages.

To order and place photos manually

1. **Go to the page where you wish to place your photo(s).**

2. **In the top part of the iPhoto Book window (refer to Figure 13-2) is the photo browser, showing all the photos you designated for this book. Click and drag the photo you want to the photo location on the opened page.**

 iPhoto sizes the photo properly for the size of the location.

3. **Continue with each page until you place all your photos.**

To let iPhoto arrange the photos for you

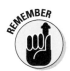

1. **Make sure to arrange your photos in the photo browser in the order you desire.**

 You can reorder (just click and drag) your photos in the photo browser at the top of the iPhoto Book window. This is especially important if you have a photo on the front cover because the first photo in line is the one that iPhoto will use on the cover.

2. **Click the Autoflow button on the toolbar.**

3. **Look at each page in your book to make sure that you still like the order of the photos.**

 If not, you can click and drag photos on facing pages to different locations on those pages.

4. **(Optional) iPhoto books are a minimum of 10 pages for single-sided pages and 20 pages for double-sided pages. If you have too many pages for the number of photos, click on the Page View button (which is the top one at the left of the photo browser) then click the extra pages, one by one, in the photo browser at the top of the window and press the Delete key.**

Finessing your book: Editing photos, adding a map, and adding text

Time for some last-minute editing. Figure 13-5 shows one of the facing pages. When you click the Adjust button on the toolbar, the Adjust tool window

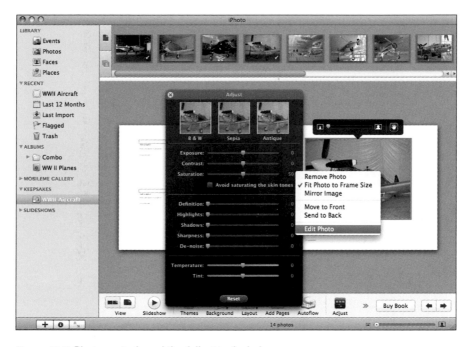

Figure 13-5: Photo controls and the Adjust tool window.

opens. Right-click or Control-click the photo to bring up a menu that allows you to mirror the image (the photo looks like the reflection in a mirror) and also go directly to the iPhoto Editor (select Edit Photo) to use all its tools. (See Chapter 7 for more details.)

When you finish in the Editor, you return to the page you left in the book. You also see a black box at the top of the photo that allows you to resize the photo as you wish and move it in the frame.

If you have location information for your photos, you can place a travel map on a book page. (See Chapter 3 for more about adding location information to photos.) Click the book page; then click the Layout button on the toolbar and choose Map. Figure 13-6 shows the menu choice and the result. You can click and drag the map to orient it to your choice.

In my running example, there are two locations shown because I took some of the photos at a different site. You can always change how many locations are shown. Click anywhere on the map, and a small dialog appears, letting you change the map size and remove any of the locations you don't want. See Figure 13-7.

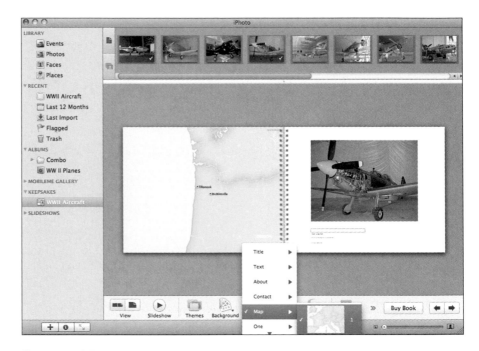

Figure 13-6: Add a map.

Uncheck to remove location

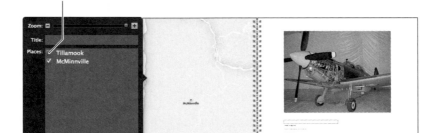

Figure 13-7: Hiding a map location.

If you have more than one location, you can impose lines indicating the direction of travel on the map. Click the map; in the dialog that appears, select the Show Lines check box. If the directional arrow goes in the wrong direction, simply drag the location names in the dialog into the proper order, and the arrow changes accordingly. Figure 13-8 shows this. To dismiss the dialog, click away from the map.

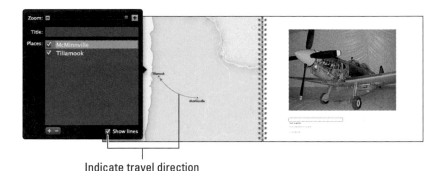

Indicate travel direction

Figure 13-8: You can show direction of travel.

As I mention earlier, some layouts allow you to add text to accompany a photo. This is handy when you want to add a caption, titles, headings, and much more. Here's how:

Click the Settings button on the toolbar to change the various text formats in the book. This dialog is shown in Figure 13-9.

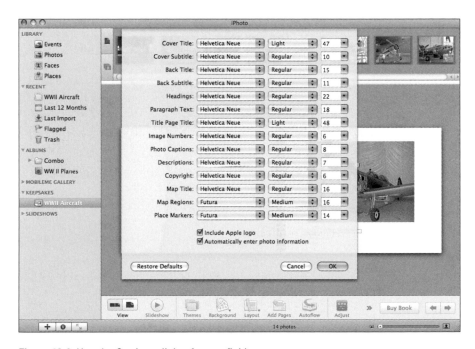

Figure 13-9: Use the Settings dialog for text fields.

Buying your photo book

Not much point in creating a photo book if you can't hold it in your hands and share it, now, is there? Purchasing a book is very simple. Just take a minute to preview it for one last perusal, and then buy online!

I do want to mention, though, that you need an Apple ID and a valid credit card to purchase a photo book.

1. **When you're finished creating and editing pages, preview your photo book by right-clicking in the gray area around your book and choosing Preview Book.**

 A PDF file is generated, which opens for your inspection. When you're finished with the preview, just quit the application you're using to view it.

 Alternatively, you can click the Slideshow button on the toolbar and watch a slideshow presentation of your book.

2. **Click the Buy Book button to begin the ordering process.**

Nice job!

Creating a Custom Photo Calendar

Something that can display your photos, make a nice gift, and be useful at the same time is a photo calendar. And iPhoto offers an easy and convenient way to make one. Use preset themes and layouts, modify each calendar page to make it just the way you want it, and then let iPhoto place the photos for you — or add them yourself manually. Here's how.

Pick your calendar design

Start by choosing your photos.

1. **Select the Albums, Events, or photos you want to use in your calendar.**

2. **Click the Calendar button in the toolbar or (if the width of the iPhoto window is below a certain size) click on the Keepsakes icon in the toolbar and then choose Calendar.**

3. **From the dialog that appears, select the theme you want and then click the Choose button.**

 Figure 13-10 shows some of the selections, which range from Formal to Kid's Cutouts.

Figure 13-10: Choose your calendar theme here.

4. **In the next dialog that appears (see Figure 13-11), you can select the**

- Start month and year for the calendar.
- Number of months (up to 24).
- Whether you want the national holidays of a particular country to appear.
- Where to get other information (such as iCal events and birthdays) you want placed in the calendar.

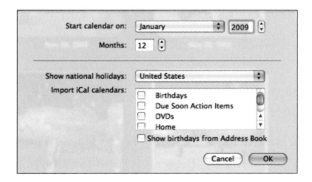

Figure 13-11: Add special dates to your calendar.

5. **When you're finished with these choices, click OK.**

6. **Your calendar will appear under Keepsakes in the Source list with either the name of the Event used for content plus the word Calendar**

or the name Untitled Calendar if you used a group of photos for con-
tent. Click twice on the name of the calendar to highlight it, then type
the name you wish and press Return.

In the photo browser running vertically, you can see all the photos you
selected for the calendar. Figure 13-12 shows this for my example.

Use the right- and left-arrow buttons on the far-right side of the toolbar to
scan through the various months to see where and how many photos will be
placed in each month. You can modify the individual page layouts as follows.

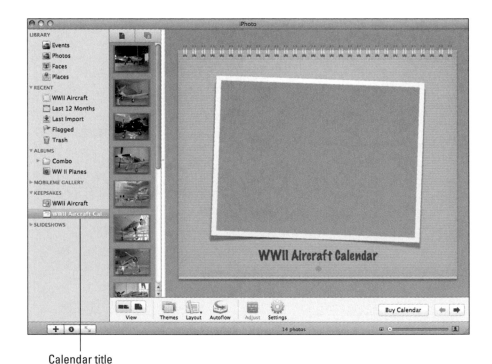

Calendar title

Figure 13-12: Review your calendar cover page.

Modifying calendar page layout

After you choose your photos and decide on a theme, you can tinker with the
design layout by doing the following.

1. **At the top of the photo browser, click the single-page icon (the one on
 the left) to see the pages of the calendar in the photo browser.**

2. **Pick the month you want to modify, click it in the photo browser, and then click the Layout button on the toolbar to choose a new one.**

 Figure 13-13 shows the choices. Currently, there is room for seven photos, but I think that's too many. I changed it to three.

Click to see pages

Click to see photos

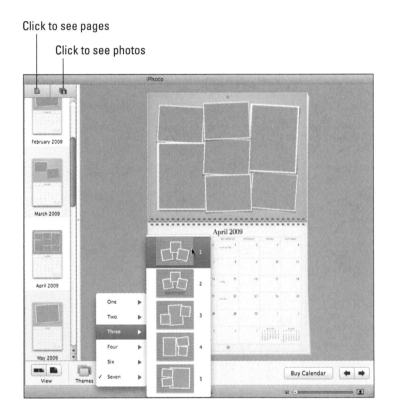

Figure 13-13: Make your calendar month layout choices.

3. **When you're finished with the layout changes, click the photos icon at the top of the photo browser (it's the one on the right) to again see all your photos.**

Setting the photos for each month

Now set the photos for each of the months in your calendar. There are two ways to do this. Here's how to do it manually:

1. **Use the right- and left-arrow buttons on the toolbar to get to the month you wish to modify.**

2. **Drag the photo or photos of choice from the photo browser and drop them on the photo placeholders on each month to be edited.**

 For months with multiple photos, click and drag photos to rearrange them at will.

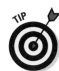

 Each photo that you're using has a white check mark in the lower-right corner.

You can also let iPhoto set the photos for you. Just click and drag the thumbnails in the photo browser to get them in the order you prefer. iPhoto uses them from top to bottom in order. (The top photo is the cover photo.)

To let iPhoto place the photos for you, click the Autoflow button on the toolbar. After that, you can still manually click and drag the photos where you wish within the month they appear. Figure 13-14 shows the result of this.

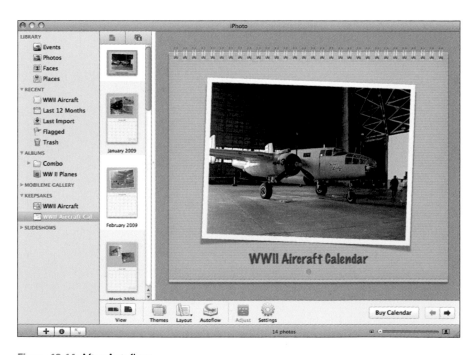

Figure 13-14: After Autoflow.

Photos for special calendar dates

Because iPhoto allows you to mark things like birthdays and anniversaries on your calendar, you might also want to place a photo on those special occasions. It's easy to do.

1. **If the photo you want to use isn't already in the photo browser simply click Photos in the Source list, find the photo you want, and drag it onto your calendar listed under Keepsakes.**

 Your photo now appears at the end of the photo browser.

2. **Go to the month in which the special occasion occurs. Drag and drop the photo from the photo browser onto the day in the calendar.**

3. **Double-click that day to bring up the editing dialog for the photo. (See Figure 13-15.)**

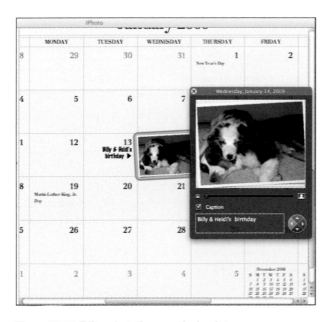

Figure 13-15: Edit a photo for a particular date.

4. **You can adjust the size of the photo with the slider.**

5. **(Optional) To create a caption**

 a. *Select the Caption check box.*

 b. *Type the caption in the text box.*

 c. *Use the four-point symbol to specify whether the caption will appear at the left, right, top, or bottom of the day's square.*

6. **Click the Close button at the top left of the editing dialog to close it.**

That's all there is to it.

Buying your calendar

After you make all the changes and additions, preview your calendar and then buy it.

You need an AppleID and a valid credit card to purchase a calendar.

1. **Right-click or control-click anywhere in the gray area surrounding your calendar in the iPhoto window.**

2. **In the pop-up menu that appears, you have two choices: Save Calendar as PDF and Preview Calendar. Choose Preview Calendar.**

3. **Your calendar opens in Preview for your inspection. When you're finished, simply close the application you used for viewing.**

4. **Click the Buy Calendar button to begin your purchase.**

 You're connected to Apple to enter all the details.

Imagine how happy everyone who receives your very personalized calendar for the coming year will be when they receive it!

Designing Custom Cards

It seems these days that almost every day on the calendar has an occasion set aside for it. I know, that's stretching things a bit, but we all have special days that we celebrate each year. What better way to do so than by sending a card, using your own photos. iPhoto makes it easy to do.

Choosing the occasion

Start by choosing the occasion. After all, you don't want to send a 50th wedding anniversary card sporting a photo of your three-year-old dressed like a witch at Halloween? (Well, maybe for a Happy Divorce card.)

1. **Select the Event or photos you wish to use for your greeting card or postcard.**

2. **Click the Card button in the toolbar or (if the width of the iPhoto window is below a certain size) click on the Keepsakes icon in the toolbar and then choose Card.**

 A card project appears under Keepsakes in the Source list.

3. **A dialog appears, allowing you to choose either a greeting card or a postcard, the theme for the card, and a listing of types of cards; make your selections and click the Choose button.**

4. **Your card will appear under Keepsakes in the Source list with the name Untitled Card. Click twice on the name of the card to highlight it, then type the name you wish and press Return.**

 There isn't much difference between the greeting cards and postcards from an editing standpoint, so I just use a greeting card example. Figure 13-16 shows the dialog.

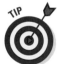

 Some themes allow only one photo.

Figure 13-16: Choose the type of card and occasion.

Editing a card

Time to edit the card.

1. **With the card you chose in the center pane, use these buttons on the toolbar:**

 - *Background:* Choose from a number of colored backgrounds.
 - *Design:* Choose from several ways of displaying the photo scene (with a border, with a mat, with a title, and so on) and whether to have text.

 You can also choose to change the card's orientation; set it to horizontal or vertical.

2. **Click the photo and then click the Adjust button on the toolbar to modify your photo. Figure 13-17 shows the usual sliders in the Adjust tool window and a slider for changing the photo size above the photo.**

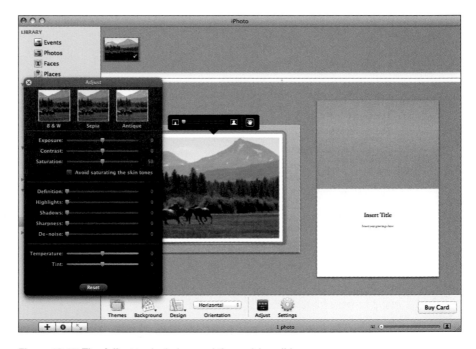

Figure 13-17: The Adjust tool window and the resizing slider.

Modifying card text

What card would be complete without some text? Happy Birthday! Happy Groundhog's Day! Happy Tax-Free Day!

1. **Click the Settings button on the toolbar to bring up a formatting dialog.**

 Depending on the card design, the dialog shows the types of text fields that you can modify, as shown in Figure 13-18.

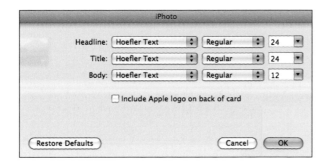

Figure 13-18: The Modify Text dialog.

2. **Make your selections.**

 You can choose the font and size for the headline, title, and body text. You can even have the Apple logo printed on the back of the card, if you wish.

3. **Click OK.**

Buying your cards

After you made all your changes, take a preview look at your card and then buy it. If you have some card stock that you want to use for printing your card you can certainly do that. Use the PDF file described below and the techniques in Chapter 12 for printing at home.

As with photo books and calendars, you need an AppleID and a valid credit card to purchase a card.

1. **Right-click or Control-click anywhere in the gray area surrounding your card in the iPhoto window.**

2. **In the pop-up menu that appears, you see two choices: Save Card as PDF and Preview Card. Choose Preview Card. If you're going to print this yourself, you would Save Card as PDF.**

3. **Your card opens for your inspection. When you're finished, simply close the application used for viewing.**

4. **Click the Buy Card button to begin your purchase.**

 You're connected to Apple to enter all the details.

Imagine how happy everyone who receives your very personalized card for a particular occasion will be!

Creating a Slideshow

Ever watched a program on TV that used photographs to tell a story and wondered whether you could do that with your own story? Of course, you can — with iPhoto, which makes it pretty easy to do. You can even add effects, transitions, and your favorite music just like the pros. When you're finished, you can run the slideshow on your computer or export it to your hard drive or iDVD to share with others or post it to your MobileMe Gallery or a Web page. Here's how.

1. **Select the Albums, Events, or photos you want to make into a slideshow.**

2. **Click the Slideshow button on the toolbar or click the + (Add) button on the small toolbar.**

3. **Click Slideshow and add a title.**

 Figure 13-19 shows the slideshow window you'll see. The slideshow window will open in the iPhoto main window.

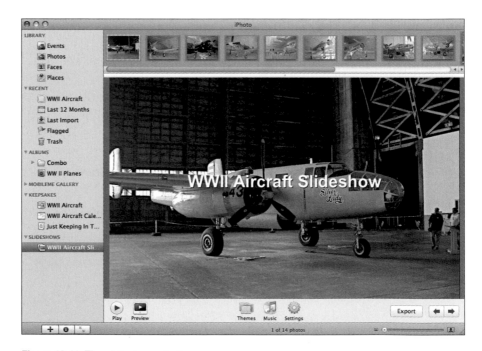

Figure 13-19: The slideshow window.

Choosing settings for the entire slideshow

You can change the name of your slideshow at any time by highlighting the current name and typing a new one. The Preview button on the toolbar allows you to sample your slideshow with the current settings so you can quickly try them out. Here's how to select settings for your slideshow.

1. **Click the Themes button, located in the middle of the toolbar. Figure 13-20 shows the dialog that appears.**

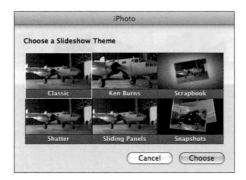

Figure 13-20: Choose a slideshow theme.

2. **Click a theme to assign it to your slideshow and then click the Choose button.**

3. **Click the Preview button on the toolbar to see how you like the theme (and the music attached to the theme by default).**

 Honestly, I think the hardest part of creating a slideshow is choosing which theme you want to use. They're all fantastic.

4. **Time for tunes. Click the Music button, also located in the middle of the toolbar.**

5. **When the Music Settings dialog shown in Figure 13-21 appears, you can choose your own music on your computer, choose one of the six tracks under Theme Music, or create your own playlist. When you're satisfied, click the Apply button.**

6. **Click the Settings button on the toolbar.**

 The Slideshow Settings dialog shown in Figure 13-22 appears.

7. **Change settings for each slide or for all slides.**

 • *This Slide:* Click this to set a Black & White, Sepia, or Antique tone for the slide.

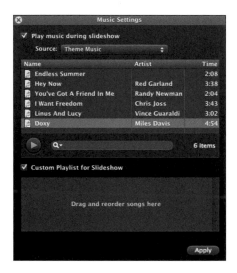

Figure 13-21: Pick your music.

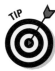

You must do this for each slide that you want to change.

• *All Slides:* Click this to set the minimum play length for each slide.

In the example, it's set for 5 seconds.

If you select the Fit Slideshow to Music radio button, the duration of slides is adjusted so that the slideshow and the music end together, automatically.

Figure 13-22: Set your slideshow settings.

8. **Still in the Slideshow Settings dialog, select the check boxes for your choices.**

• *Show Title Slide:* Select this check box if you want a title slide. Click on the small arrow in the circle next to this selection. This

will bring up the Title Slide. Click on the text twice and change as you wish. When you're finished, click away from the text field and you're done.

- *Repeat Slideshow:* Select this check box to make the slideshow repeat upon completion.

9. **Set the aspect ratio from the pop-up menu, depending on where you plan to display the slideshow.**

 For example, you can set the slideshow to work with the current display or HDTV (16:9), TV (4:3), or iPhone (3:2) displays.

10. **When you're finshed, click the Close button (the X in the upper-left corner).**

Distributing your slideshow

So, your slideshow masterpiece is finished. You can run the slideshow on your computer or TV screen. If you want to send it to others, you can export it by clicking the Export button at the right side of the toolbar. (Refer to Figure 13-19.) That will take you through the process I describe in Chapter 11.

Part V
The Part of Tens

The 5th Wave By Rich Tennant

ORKHTENNANT

"Hey—let's import photos of ourselves into iPhoto and see if we can make ourselves look weird."

*W*elcome to the Part of Tens, that conclusion of all For Dummies books where you can find all sorts of additional gems of wisdom. Here, you can find great iPhoto '09 additions and also discover marvelous places to get even more tips, techniques, and information on iPhoto '09.

Chapter 14 gives you some Web sites that are great resources for iPhoto. This chapter also introduces you to some add-ons that can prove very productive with iPhoto — additions that can allow you to derive even more enjoyment from iPhoto. Some of these additions allow you to enhance your photos and provide the kind of extra capabilities that make an iPhoto session even more fun.

Chapter 15 provides a convenient and centralized location for helpful hints and shortcuts. These hints and shortcuts are in addition to any tips contained in the various chapters of the book.

Ten Terrific Web Resources and Software Add-ons for iPhoto

*1*f you haven't guessed already, I think iPhoto is a great Apple tool for bringing the best out of your photos and for giving you, the photographer, several ways to enjoy and share your hard work and great photos.

No matter how much capability is put into software, though, more can always be added. Although books are fixed in what they can present at any one time, there's nothing static about the ideas and solutions you find online. In this chapter, I give you ten excellent iPhoto resources, but there are certainly more. I encourage you to look around on the Web for your own terrific resources.

Take the time upfront to make sure that any software you try works with the version of iPhoto that you have.

TechRepublic

http://search.techrepublic.com.com/search/apple+iphoto.html

The TechRepublic Web site is a terrific source of white papers, Webcasts, ideas, discussions, and downloadable software to enhance your iPhoto use. This site also covers lots of other products, so it might turn into a real gold-mine for you. Just use the Search box on the TechRepublic landing page.

Shutterfly Export Assistant for iPhoto

www.shutterfly.com/downloads/features_mac.jsp

This is a Web service available to you from within iPhoto. Export Assistant — free! — modifies the iPhoto Export dialog so that you can select Shutterfly directly. When you download Shutterfly and install it, it modifies the iPhoto Export dialog and puts the Shutterfly button at the top with the other buttons so you can select it easily.

Shutterfly gives you access to a large selection of photo books, calendars, cards, and other printing services, in addition to those within iPhoto.

iPhoto to Archive

www.ubermind.com/products/iphototoarchive.php

In Chapter 11, I talk about exporting your photos. You might have a number of reasons for doing this, one of which is saving space in your iPhoto Library by archiving photos that you don't often use. Space is space, and saving space anywhere is important, including on an external hard drive.

iPhoto has no way to compress an exported file directly — until now, that is. iPhoto to Archive is a downloadable product from Übermind that modifies the Export dialog so that you can archive, using four choices of packaging and compression formats from within iPhoto.

You can choose to save the photos as JPEG, TIFF, PNG, or the photo's Original format it had at the time of import, in several sizes; and you have several naming choices. A 15-day free trial is available. After the trial period, the current price is $9.95.

iPhoto Library Manager

www.fatcatsoftware.com/iplm

In Chapter 3, you can read about the advantages in having multiple iPhoto Libraries. However, it can become complex to try to use iPhoto alone to handle them. Relax! Here's a great answer, available for free from Fat Cat Software.

There is an advanced version for which you pay, but there's also a free version that I recommend you try first. With this software, you can

- **Create and/or add new libraries.**
- **Easily switch between libraries without restarting iPhoto.**
- **Check the Library database file size easily.**
- **Rebuild the Library easily.**

I mention a few of the capabilities, but there are more, some of which work only in the paid ($20) version. For example, the version that you purchase lets you click and drag albums to copy to a new Library, including metadata.

PictureItPostage by Endicia

www.pictureitpostage.com

Get a kick out of the reaction of friends and family to your gorgeous photos? You can get an even bigger kick by using your photos to create personalized U.S. postage stamps! Now, your announcements and invitations can have a personalized look even on the outside of the envelope.

The PictureItPostage software is free and integrates beautifully with iPhoto. You choose the photo, its orientation, any special effects (the software provides a palette of these), rotation, and colors. Then just click the Buy PictureItPostage button and tell Endicia the stamp's denomination and how many sheets you want. A few days later, your stamps arrive. You might not want to use this for everyday postage, though: The cost of the stamps includes Endicia's fee, so a sheet of twenty 42 cent stamps is about $19.

Duplicate Annihilator

www.brattoo.com/propaganda

Sounds like a video game, doesn't it? Actually, Duplicate Annihilator is software that's useful rather than just entertaining and only $7.95. Duplicate Annihilator takes on the time-consuming task of comparing the images in your iPhoto Library to make sure that no duplicates escape. You can choose from several courses of action for the program to take when it finds them, including marking them for a later search.

Essentials 2.1

www.ononesoftware.com/detail.php?prodLine_id=37

Although iPhoto was conceived as a tool to help "point-and-shoot" photographers achieve the most from their photos, it can also be productive for those who want to use more powerful tools while retaining an easy-to-use interface.

Essentials 2.1 for iPhoto might be just what you're looking for to extend iPhoto's capabilities. It's a collection of four tools that help you correct color, add depth of field by realistically blurring the background, add creative borders, and resize your photos to get larger prints.

Although onOne Software offers a free demo version, you can buy the complete Essentials 2.1 for $69.99.

Keyword Manager

www.bullstorm.se/KeywordManager.php

If you like to use lots of keywords to find photos, using Keyword Manager can help you manage your keywords so you can quickly and easily tag all photos in your Library, regardless of how many photos you have and how many keywords you want to use.

Because Keyword Manager uses iPhoto's own keyword system internally, it's completely safe. Even if you decide to stop using Keyword Manager, all your keywords will remain! It isn't free ($20), but if it's what you really need, it might be worth the cost.

iPhoto Buddy

www.iphotobuddy.com/index.html

Here's another iPhoto Library manager, but this one is totally free. If you find the software does help you, it's a good idea to make a donation to the software's author, which you can do right on the site.

iPhoto Buddy is a *universal application* (it runs on PPC and Intel Macs). With it, you can create, manage, and switch among multiple iPhoto Libraries. Depending on how many photos you have, there are real advantages to splitting your current iPhoto Library into multiple smaller ones where, perhaps, each new Library contains photos of only particular kinds of events, or photos taken in the same year or by the same camera. The possibilities for efficient organization are endless.

When you pick a new Library with iPhoto Buddy, it automatically quits iPhoto and restarts it with the Library you chose. It can also display details such as size; number of images in the Library; and a listing of Albums, folders, books, and more — all without opening the Library.

iPhoto Mini

www.macupdate.com/info.php/id/20214

I'm sure that most of you use widgets in Dashboard on your Mac. Clever, small, and instantly available on your screen, you can also put widgets away quickly when you're done. Enter the iPhoto Mini, which is one handy widget.

Suppose you want to quickly look at some or all the contents of your iPhoto Library but don't want to start iPhoto. iPhoto Mini to the rescue! Open it to see a listing of all your folders and Albums. Choose one, and the photos are automatically scaled to fit into the widget's window.

From left to right, use the icons at the bottom to

- **Display a list of all folders and Albums letting you choose one.**
- **Allow you to make the active photo your Desktop picture.**
- **Allow you to open the photo in several applications, such as Preview, Mail and Safari.**

 ✔ **Navigate through the album you chose.**

 ✔ **Refresh the display.**

Quite a lot for a small package.

Widgets you download are usually shareware, and a donation is requested.

Ten Helpful Hints, Tips, and Shortcuts

In This Chapter

▶ Improving the composition

▶ Maintaining high resolution

▶ Utilizing a color card

▶ Making a new button — Reset becomes Revert

▶ Removing individual photos from an Event

▶ The importance of being organized

▶ Working with multiple Libraries

▶ Comments — a picture is worth a thousand words

▶ Improving iPhoto's startup time

▶ Customizing iPhoto keyboard shortcuts

*P*hotographers, whether professional or amateur, love to find and exploit little tricks with the hardware or software they use. Sometimes, the tricks are undocumented, which makes finding them even more enjoyable. There are also skills learned at the "school of hard knocks" which I love to pass along. You'll find some of those in this chapter.

Before You Import into iPhoto: When You're Shooting

Regardless of the sophistication of the software and hardware a photographer chooses to use after a photo shoot, there are things that can and should be done before taking a picture. Things that'll help ensure a good photograph and make the task of editing your photos simpler and more rewarding. Here are a few I'd like to pass along.

Composition: Get closer, change your angle

One simple tip to help you get better photos to start with is to get close to your subject. Of course, sometimes, getting physically closer to your subject is impossible, if not downright dangerous. With the availability of true (optical) zoom lenses on many less-expensive cameras, though, you can now get closer — and better — shots in some locales. For example, if you're shooting at the zoo, zoom in on that monkey's face instead of always taking a wider-angle shot.

And although people tend to stay in one place while shooting photos and let the zoom "transport" them to closer to their subject, don't be afraid to see what the shot looks like from different vantage points. That's something a zoom lens can't do. I've often found that a shot that was marginally good from one angle becomes really exciting from another, opening up all kinds of creative possibilities.

As is true with all composition "rules," they aren't hard and fast. I've broken a few of them on occasion but always with a purpose; the scene just appealed to me more by breaking a rule. But don't do it just because you didn't know any better.

Don't be afraid to try things. It's how we learn what we like and what we don't.

Keeping your resolution high

Depending on the sophistication and price of your camera, you have choices regarding the format of the captured photos. The camera's resolution, on the other hand, is set by the capabilities of the sensor being used. My guideline is that you can never have too high of a resolution! But the photo format choice — RAW, TIFF, and JPEG to name a few — can ultimately affect resolution as well.

In the sidebar in Chapter 9, I discuss the advantages of capturing in RAW format. If your camera can do so, I highly recommend using that format for any photos that you plan to print at larger than an 8" x 10" size.

If your camera can't capture in RAW, choose TIFF, if available — and if not, use the highest quality JPEG capture you can. Doing so will give you the most leeway when it comes to editing your photos in iPhoto.

Using a color card

At one time or another, I'm sure you all had the rude shock of taking a photo of a beautiful scene, only to discover that the captured photo has a color

cast in it. For instance, photos taken indoors where incandescent bulbs are prevalent often have a yellow cast. Our eyes and brain make an adjustment and we may not notice this, but the camera does. And, you may find, there aren't any neutral colors in the photo to use for white balance in the Adjust tool window. You can certainly guess at what changes need to be made, but I know a better way.

I use a pocket-sized color card that I always take with me to ensure that I have a neutral color to correct with. (Figure 15-1 shows my 3¼" x 2¼" card.) I also have a larger version for use in large landscape scenes.

Figure 15-1: Don't travel without a color card.

Here's how to use a color card while you're shooting:

1. **Place the card near your subject.**

 If you're doing a portrait or photographing a group of people, have a person in the shot hold the card.

2. **Take the shot.**

 You'll use this to set the white balance.

3. **Take the card away and take the actual photo.**

4. **Later, in iPhoto, use the photo with the card in it. When you use the Adjust palette, click the White Balance eyedropper on the second square from the left in the bottom row. Refer to Figure 15-1.**

 This tells you the white balance for the real shot.

5. **Use that value as you use the Adjust tool window to edit the real photo.**

These cards aren't inexpensive, but if getting the color right is important, color cards are a great tool and convenient to carry. You can still use the small card for a landscape scene provided you ensure the card is in the same light as the subject of your photo (not always easy to do).

After You Import into iPhoto: Editing and Organizing

Now that you have taken your photos, it's time for using the iPhoto tools to make them even better. Here are some tips I've found helpful for this process.

Changing the Reset button into the Revert button

In Chapter 10, I show you the wonderful capabilities of the controls in the Adjust tool window. (See Figure 15-2.) With them, you can change the exposure, contrast, highlights, shadows, and several other characteristics of your photo. Being totally interactive, you can move the various sliders around to your heart's content, always knowing that by clicking the Reset button, you could go back to the default values and undo any mistakes you had made.

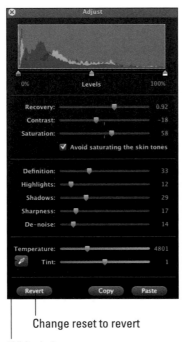

Change reset to revert

White balance

Figure 15-2: The Adjust tool window with its handy Revert button.

Being able to use Reset provides you with a great safety net — that is, provided these were the first editing changes you were making. But what if they weren't?

Look at Figure 15-2 again. All these values were saved for this photo. If you now try to make some additional changes and then decide you don't like them and want to return to the ones shown here, you have a problem. Clicking the Reset button puts all values back to the defaults, but these are not default values. Arg. You really want to revert to previous values.

Luckily, there's an easy way out. You can, of course, choose Photos⇨Revert to previous in the iPhoto menubar. But here's a quicker and easier way. With the Adjust tool window open, press and hold the Option, and the Reset button becomes the Revert button. Clicking it now will remove your latest changes and return you to the previous values. Whew! When you let go of the Option key, the button again says Reset.

Culling photos of an Event

If some photos in a particular Event aren't worth keeping, you'll probably want to trash them. Just open the Event (read about Events in Chapter 4) so that you can see each individual photo. Then pick the one(s) to delete and drag it (them) to the Trash.

If you decide to save the photo after all — before emptying the Trash, that is — no a problem. Just drag the photo and drop it over the Events icon in the Source list. It knows where its home is and will return to its rightful place in the Event it belongs to.

Organizing is key

As the size of your iPhoto Library grows, employing some important organizational techniques become even more important. After all, the real test of the usefulness of your Library is how quickly, accurately, and easily you can retrieve the photos you want.

Although you do have to invest a little upfront work, adding keywords to your photos directly after importing them really pays off. Everything about the photos is fresh in your mind, and assigning accurate and descriptive keywords will never be easier. Even with the addition of Faces and Places capabilities and the help they give in retrieving photos of interest, keywords are still the bedrock of any search.

I also highly recommend using Albums and Smart Albums. With appropriate naming of the Albums, retrieving whole groups of related photos is a cinch. And, of course, iPhoto handles automatic updating of Smart Albums. Read more about Albums in Chapter 5.

Living with multiple Libraries

There's no firm rule defining when a single iPhoto Library is so large that it should be saved and a new one started. For me, I think a safe rule is that a Library nearing 700MB is a prime candidate because not exceeding that size means that you can save it to a regular CD. You create an archive as well as a quick and easy way to switch libraries. In addition, Library size does affect iPhoto performance, so keeping them manageable will enhance your iPhoto experience and performance.

If you have a large amount of free external hard drive space, you can also archive the Library to that drive unless you feel more secure using a CD.

No matter which method you use (hard drive or media), here's a tip to help you sleep better:

- **If you write the library to a CD,** be sure and verify that the write operation was successful. If you do the burn to a CD/DVD in the Finder or any of the commercial burn software packages, a Verify operation is begun after the burn, if you wish. I recommend doing that each time you do a burn.

- **With either storage medium, immediately make sure you can use the archived library with iPhoto.** (Remember: You're counting on it!) Press and hold the Option key when starting iPhoto and then choose the archived Library as the one to use. Or, use the iPhoto Library Manager (as I describe in Chapter 14) to do this.

Never assume that your copy is successful until you test it!

Comments, comments, comments

Adding a description (or as I call them, *comments*) to a photo can be a chance to add a narrative that more extensively explains the circumstances of the photo than you can accomplish by using a few keywords. Photos are the video recording of an event, but to explain what led to the event or what happened just before the photo was taken requires some text. For such photos, I recommend taking the time to add comments when you're importing them. As a reminder, the easiest ways to do this are:

- Click Photos in the Source list. For any photo, click on the small information icon in the right corner. When the photo flips over, you'll see the area labeled Enter Description. Start typing.

- Highlight a photo in the iPhoto main window, then click the information icon in the center of the small toolbar. At the bottom of the information window that pops up is the area to type a description.

Another nice thing is that editing a photo's description changes it in the photo Library as well as in all Albums and books where it appears. Do it once in the photo, and the rest is taken care of by iPhoto.

Speeding up iPhoto startup time

This particular tip will be helpful regardless of the speed of your computer although it will certainly have a greater effect on a slower machine.

Ever wonder why it takes applications, including iPhoto, so long to start? A lot of necessary activity takes place, but in the case of iPhoto, there's also something wasteful going on. It has to do with languages, and here's how to trim down the memory required to load them:

1. **In the Applications folder on your hard drive, click the iPhoto icon.**

2. **Choose File➪Get Info or press ⌘+I.**

 In the iPhoto Info dialog that appears (see Figure 15-3), see how (under Languages) that every box is checked. I don't know about you, but I speak only English (and a little Italian), so having all these other languages loaded each time iPhoto starts really takes time and for no purpose.

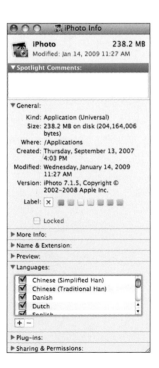

Figure 15-3: The iPhoto Info dialog.

3. **In the Languages section, clear (uncheck) each check box for each unneeded language.**

 In my case, I leave only English loaded.

4. **Close the Get Info dialog.**

 The next time you start iPhoto, you should see at least some improvement in loading speed, at least a second or two — perhaps a lot. You also will see between a 15–20% decrease in the real memory used by iPhoto.

A simple thing, but it does make a difference.

Customizing iPhoto keyboard shortcuts

Using keyboard shortcuts can save you a lot of time and wasted motion when working with an application like iPhoto. Instead of moving your hand to use the mouse and select from a menu, you can just type the necessary shortcut.

The nice thing on Macs is that you can set your own shortcuts in OS X for particular applications, like iPhoto. Here's how:

1. **In System Preferences, click the Keyboard & Mouse icon.**

2. **Click the Keyboard Shortcuts tab.**

3. **Click the + (Add) button just below the list of current shortcuts. See Figure 15-4.**

 In the dialog that appears, you can select the application you're creating the shortcut for (in this case, iPhoto) and the menu title (which, in this case, must be the exact name of the iPhoto command). So before you go any further, you need to find the command in the iPhoto menu so you know exactly what it says.

4. **In the Keyboard Shortcut field, just press the keys you want, in the order you want.**

 I used Option+⌘+B. See Figure 15-5. First, though, I checked all the current iPhoto shortcuts to make sure that I didn't duplicate one. An easy way to do this is to look through each iPhoto menu and see what's being used.

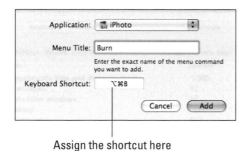

Click to add a keyboard shortcut

Figure 15-4: Adding a keyboard shortcut.

Assign the shortcut here

Figure 15-5: Assigning your shortcut.

5. Click Add.

The Keyboard Shortcuts pane now contains your new shortcut. If, after all your careful checking, you have chosen an already used shortcut in iPhoto, the shortcut will be removed from where it was so your shortcut will work. For instance, if I wanted the Share⇨Email choice to have

Shift+Command+E as a shortcut, I can do that but since it used to be the shortcut for File⇨Export it won't be any longer. If that's okay with you, it's okay with iPhoto. Check it out in Figure 15-6.

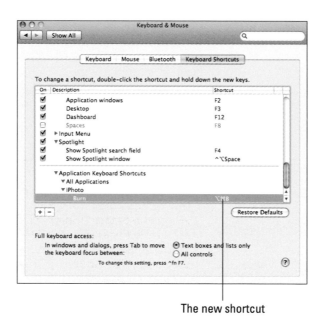

The new shortcut

Figure 15-6: See your added keyboard shortcut.

6. **Try out your new shortcut to make sure it works.**

If the shortcut didn't work, maybe you used a combination for the shortcut that isn't allowed. Try something else and repeat the process.

Index